SOPHIA LOREN
A Life in Pictures

First published in Great Britain in 2008 by Pavilion Books
An imprint of Anova Books Company Ltd
10 Southcombe Street, London W14 0RA

© Anova Books Company Ltd 2008

First published in France in 2008 by YB Editions
Biography © Candice Bal, 2008
Other text © Yann-Brice Dherbier, 2008
Cover photography © Rue des Archives/BCA
Layout © Renaud Sauteret (sauteret@free.fr)
Editor (UK): Kate Burkhalter
Translation: JMS Publishing

ISBN : 978-1-86205-831-6
Reproduction: Ateliers du Regard
Printed and bound by EBS, Italy
10 9 8 7 6 5 4 3 2 1

www.anovabooks.com.

SOPHIA LOREN

A Life in Pictures

An unsatisfied desire for the limelight, the shadowy image of a father and the strength of maternal love: this was the strange trinity that surrounded the birth, on 20 September 1934, of a frail little girl – an illegitimate child without fortune or future – in a fascist Italy, which was inexorably moving towards the darkness of World War II.

SOPHIA LOREN

Sophia Loren's life is a history of her country, Italy, and of the movies, on which her unforgettable silhouette has left its mark. It is also the story of a destiny: harsh and cruel in the early years, hard-working but successful in maturity. In sum, it is the portrait of a passionate and sensitive woman, of a mother, and of a legendary beauty.

The man approached her in the street. He said he was a producer searching for new faces. He paid her several compliments, then smiled at her with laughing eyes while waiting for her response. The young woman was far from her family, alone in a strange city, hoping to break into show business. He was charming, courteous and seemed respectable. She wasn't sure of his intentions but was attracted to him and agreed to meet him again.

The scene could have been played by the great Italian actress herself but at the time Sophia had not been born. The two protagonists were her parents, Rome was the backdrop and this first act might be called 'the encounter'. However, the blossoming idyll would not have the happy ending of a romantic comedy and it would leave its sad mark on the fruit of that union, Sofia Scicolone.

Sofia's mother, Romilda Villani, had just arrived from Pozzuoli, about 20 km (12 miles) from Naples. Her working-class background, the poverty of her family and the meagre existence in that seaside suburb had awoken in the young woman a wayward, rebellious and energetic temperament. She had studied piano and dance at the Conservatoire and now dreamed of becoming an actress as famous as Greta Garbo, whom she closely resembled. It was this resemblance that had brought her to Naples in the early 1930s, where Metro-Goldwyn-Mayer was organizing a competition for look-alikes of the 'divine' Swedish actress. Romilda was chosen from a host of young beauties. She was offered a ticket to Hollywood, the opportunity to become Garbo's double and a chance to change her destiny. But she was only seventeen and her mother's obstinate prejudices roughly demolished this hoped-for future: Luisa Villani categorically refused to allow her daughter to go to the USA. Romilda was bitterly disappointed and decided on an even fiercer artistic ambition – as soon as she turned 21 she left to try her luck in Rome.

The little provincial girl did not find fame in the Italian capital, but she did encounter love in the person of Riccardo Scicolone. Nothing would quench her passion for this self-proclaimed producer – who, it turned out, was out of work after abandoning his engineering studies – neither his lies, his egotism, his refusal to marry her, or even his abandonment of her when she became pregnant. Nonetheless he gave his name to the child born in the ward for unmarried mothers in Rome's Clinica Regina Margherita. It was the first thing he did for his daughter – but, sadly, also the last.

Sombre years

As in all tearjerkers, Riccardo abandoned his woman and child a few months after the baby's birth. Romilda had no resources and could not find work. It must be remembered that in Mussolini's Italy a woman was not expected to find work and was supposed to confine herself to child-bearing and housekeeping. Romilda did not have enough milk to feed her daughter, whose health suffered. According to the pessimistic doctors the child would not improve unless she was taken to a milder climate than the Roman winter. There was nothing to keep Romilda in Rome; despite the shame that was attached to her 'fall', she went back to the south, to Pozzuoli.

To be an unmarried mother in the puritan, Catholic and conservative Italy of the inter-war period was an outrage to morals; in a small town where everyone knew each other, it was a provocation. Romilda was courageous, however, and after several short-lived tensions the Villani family solidly took her side and that of little Sofia.

As if the volcanic air of the Gulf of Naples had given her back her strength, the child's health quickly improved although she always had a delicate constitution. Space was tight in the three-room flat on the second floor of a little red house: the Villani grandparents, aunt Dora and uncles Guido and Mario squeezed up a bit to welcome the two 'Romans' and the little girl's earliest years were sunnier than her first months. The family didn't have much money but everyone worked and they managed, more or less. While Romilda gave piano-lessons or played in a Neapolitan restaurant, Sofia was cared for by her grandmother Luisa. The fierce heat of the day was spent in the kitchen, the sacred temple of her loving Nonna. It was a tranquil, reassuring time for Sofia, although sometimes punctuated by lively disputes that quickly blew over. Like the clichéd image, Luisa was a hot-blooded Neapolitan with a heart of gold.

Vague news of Riccardo Scicolone occasionally reached them; Romilda, still in love with him, sometimes met him in Rome, hoping all the while that he would marry her. Once again she became pregnant. Maria, a sister for Sophia, was born in 1938. Far from increasing the father's affection, this second birth simply reinforced his indifference and this time he refused even to recognize the child.

The two little girls grew up against a background of increasing political tension. Mussolini led Italy to join the Axis forces and soon the country was at war. Although war did not come to the Neapolitan suburb until 1941, the Villani family grew accustomed to rationing, to deafening sirens and panic-stricken times. The Nazis were recruiting Italians of working age to carry out their sinister aims. To avoid being sent to Germany, uncles Guido and Mario abandoned their work and hid in the countryside. At night Allied bombings forced the population of Pozzuoli to shelter in the Cumes railway tunnel; by day everyone was on guard, ready to flee at the slightest alert. The aerial conflict intensified and in summer 1943 the inhabitants were evacuated to Naples where Romilda and her daughters found

refuge with distant cousins, but the Mattia's hospitality extended only to their lodgings and Romilda had a hard struggle to feed her children.

While they perched on the balcony of the apartment watching the bloody uprising of the Neapolitan people against the army of the Reich during the historic *Quattro giornate di Napoli* (four days of insurrection that earned the city a Gold Medal for military valour), in Rome, Ricardo Scicolone married a young Milanese woman – further proof, if it were needed, of this father's cruel indifference.

In 1944 Naples was liberated by soldiers in skirts! At least that's what Sofia thought when she saw the kilted Scottish troops. There followed the return to Pozzuoli, an exhausting 25-km (15-mile) walk, where they found their house bombed but still standing. Next came a long period of reconstruction, the post-war time of making-do and the daily search for basic needs.

Life resumed in the province. The girls went to school and back to their games and songs in Nonna's kitchen but the war had stolen Sofia's carefree childhood. When her life exploded into violence and deprivation, she had been old enough to understand, old enough to remember. Those tragic moments would stay in her memory; she never forgot the hunger and thirst, and the fear. According to those around her she was a reserved, silent, serious child. At home she could be boisterous when playing with Maria but when in contact with the outside world she would become taciturn and retreat into herself. Their schoolmates were not kind to the two girls, who suffered a great deal because of their illegitimacy, which was constantly thrown in their faces. Sofia learned early that life was a struggle; although quieter than the combative Romilda she quickly armed herself with a thick skin and a courageous nature. Photographs taken at the time show a tall, skeletal girl, so thin that the local tearaways nicknamed her *Stuzzicadente* (Toothpick). Only her large eyes and that hypnotic, astonishingly mature gaze hint at the icon of femininity she was about to become.

First glimmers

This tough apprenticeship was sometimes alleviated by a visit to the cinema. Hitherto banned by the totalitarian regime, Hollywood films now brightened up Italian cinemas. There were musicals with Fred Astaire and Ginger Rogers, Gene Kelly and Frank Sinatra; *films noirs* where femme fatale Veronica Lake partnered Alan Ladd; films starring the great Clark Gable or Cary Grant – these were the mythical actors who dazzled the young Sofia. As often as she could she dragged her aunt Dora, a fan of the silver screen, to the suburb's only cinema. Sofia was so fascinated by the movies that she often saw the same film three or four times in a row. Her chaperone would snooze gently while Tyrone Power – the young girl's hero – left the gentle, brown-haired Linda Darnell for the fascinating Rita Hayworth in *Blood and Sand*.

As it had done for her mother a few years earlier, the movie star ideal (all shining hair and doe-like eyes, swathed in furs and diamonds) replaced that of the fairytale princess. However, in addition to simply worshipping these American stars, Sofia was above all fascinated by the emotions they portrayed. The complex, introverted adolescent vaguely recognized the magic of acting that, for the duration of a film, allowed one to slip into another skin, to express with exuberance the limitless gamut of emotions, to come out of your shell without embarrassment. The cinema seemed to be a kind of freedom, a way of escaping the triviality of the real world,

as much for the spectator as for the actor. Faced with the dull existence of her small province the young girl responded avidly to this alchemy. At first it was an inchoate and confused desire but gradually, fostered by her mother's cinematic fantasies, it took a firmer hold.

Although she reached puberty late (Neapolitans are often precocious in this respect), when Sofia matured she exploded into sensuality. She was only fourteen when her gym teacher, who was thirteen years older, asked her to marry him. This was the first in a long series of proposals. Romilda firmly refused. She had other ambitions for her daughter than a future as a housewife or teacher.

Confronted with Sofia's burgeoning beauty, Romilda's energetic and stormy personality saw to it that her own youthful frustration was not repeated; instead, her dreams of glory revived. She heard about a beauty contest in Naples and decided to enter her daughter, ignoring the fact that Sofia had not yet reached the age required for election as 'Queen of the Sea'. Divided between feelings of hope and revenge, she watched her daughter parade in an evening gown (made from the pink curtains of the small Pozzuoli living-room) on the podium of the smart *Ciccola della Stampa* (Press Circle) club. When called to 'enter the arena', the timid Sofia was paralyzed with fright but, against all expectations, once in front of the jury her apprehension disappeared. This phenomenon, the impression of blossoming in front of the cameras, would remain with the actress throughout her career.

Sofia did not win this time but she was one of the twelve Princesses 'fished out' by the jury. Mother and daughter returned home in triumph, laden with the prizes awarded to the competition's runners-up: a train ticket to Rome, several thousand lire, a set of table-linen and … eight rolls of wallpaper! Confronted with 25,000 lire (the equivalent at the time of nearly two month's salary for a Neapolitan workman), the Villanis thought better of Romilda's passion for show-business. So much so that Sofia embarked on her first appearance in front of a camera, making a background appearance in *Cuori sul mare (Hearts on the Sea)*, arranged by her intrepid mother while the crew was shooting exteriors in the streets of Naples. Accordingly, nobody in the family raised any objection when Romilda decided to enrol Sofia in a Naples acting school. No matter that the 'lessons' consisted of the professor, a retired actor, trying to teach his students the gamut of emotions by pulling faces at them while they grimaced back. Romilda believed in her daughter and was determined to drag her to the top.

Getting there

Launched in 1937, Cinecittà aimed to become Europe's biggest cinematic complex but it was not until the early 1950s that it entered its golden age. Having promoted propaganda films in the age of Mussolini, followed by the advent of neo-realism – brilliantly illustrated by directors Roberto Rossellini and Vittorio De Sica – 'Cinema City' then threw open its doors to American super-productions. As production costs were much lower than in Hollywood, a wave of costume dramas flooded the Roman studios and kept coming for fifteen years.

The first of these spectaculars was *Quo Vadis?*, a love story set in the reign of Emperor Nero. To recreate this historical epic of antique Rome, the producers needed to recruit thousands of extras. They came from all over Italy for 'cattle calls' at Cinecittà, hoping to earn a few seconds of glory. Romilda saw this as

a golden opportunity to introduce Sofia to the world of cinema, and decided, as she said herself, 'to march on Rome'. They had barely 2,000 lire remaining from Sofia's beauty-contest winnings, plus the train ticket to Rome. It was a big gamble to leave with so little money and no certainty that they would find board and lodgings. When they arrived Riccardo Scicolone (whom Romilda had asked to help them out for this short stay) was of little assistance. Faced with abandonment for the nth time, they appealed to a distant relative who took them in. The two Neapolitans soon found themselves queuing for a casting call, with Sofia repeating her 'words', which consisted of the only English word she knew, 'yes'. On her mother's advice, therefore, she answered in the affirmative to all the questions asked by the American director Mervyn LeRoy. He quickly realized that the young woman didn't understand English but nevertheless gave her and her mother small parts as extras; lost in the crowd and disguised as a young Christian slave, Sofia applauded the hero's triumphal return.

The fifteen-year-old was thrilled by her two nights of filming in the electric atmosphere of the movies but the following weeks spent doing the rounds of Roman film producers in search of more work were discouraging. Despite Romilda's intensity, new cinema opportunities did not present themselves and Sofia began to model for *fotoromanzi*, mawkish comic-strip romances with photographs instead of drawings that were very popular at the time. These *fumetti* ('little puffs of smoke'), so-called because of the bubbles of dialogue emerging from the mouths of the characters, exploited the young woman's sultry beauty and she was assigned secondary roles as a dark temptress.

These photo-sessions brought in some money, which was useful when Romilda was obliged to return to Pozzuoli to care for little Maria, who had contracted typhoid. Sofia began to realize how much her small earnings meant to her family.

The photo-romance publishers began to promote Sofia's image, but her name posed a problem: Scicolone was difficult to remember. It may or may not be true that the publisher of *Sogno*, who had her under contract, admired her sculptural figure and suggested that it could 'raise the dead', like Lazarus – and so she became *Sofia Lazarro*. The biblical surname soon became famous: Sofia appeared in close to 80 magazines and her face was known all over Italy. She received many marriage proposals and earned a regular salary, enabling Romilda and her sister Maria to join her in Rome. But Sofia wasn't interested in these sugary romantic stories and her dream of the cinema led only to rapid rejections or a few walk-on parts. Nevertheless she pursued her ambition whole-heartedly, throwing herself into a frenetic work routine, entering beauty contests and making the rounds of casting offices, always accompanied and supported by her intrepid mother.

The encounter

In summer 1951, a few friends from the *fumetti* studios dined at an open-air restaurant where they discovered that a beauty-contest to find 'Miss Latium' was about to begin. These events were often sponsored by the film industry, which needed to supplement its roster of starlets: Silvana Mangano, Lucia Bosé, Gina Lollobrigida and Eleonora Rossi Drago had all gone in for such contests before making careers in the movies. During the evening Sofia caught the eye of one of the jury, who suggested she should enter the contest. At first she refused but on learning that the unknown man was a big name at Cinecittà she finally gave in.

Although she only came second the producer, Carlo Ponti, came over to talk to her. He had produced more than twenty films and had launched many young women who starred in films of the period, such as Gina Lollobrigida, to name but one. He told Sofia he was interested in her face, her expressions, her allure, and he invited her to come to his office next day for a screen test.

Although the encounter remained professional, the scene was a strange remake of Romilda's adventures nearly twenty years earlier. Sofia was touched by the admiring and protective gaze of the small, charismatic man but she had learned from her mother's mistakes and an affair with this almost 40-year-old did not enter her mind. Was his proposition serious or was he another Riccardo Scicolone? The following morning Sofia first thought she'd been conned when she turned up for her screen test and found herself at a police station. The matter was quickly put right when she realized she had mistaken the address. Ponti put her in front of the cameras to see how she photographed. At seventeen, Sofia was a beautiful girl of 5ft 7in (1.75m) with generous curves. With her queenly carriage and flashing eyes she could not pass unnoticed. According to the cameraman, however, her physique did not photograph well. The mouth was too wide, the nose too long, the eyes too slanted. Her face was asymmetrical and too short, the opposite of the starlets of the period with their perfect oval faces set off by wide foreheads, big doll's eyes and snub noses. Faced with this verdict, Ponti suggested a bit of dieting and some plastic surgery on her nose. Sofia's response was contrary to her reserved temperament and to the usual reaction of girls of her age, ready to do anything to land a part. She said it was out of the question, the studio must take her as nature had made her or not at all.

'Had Cleopatra's nose been shorter, the whole face of the world would have been changed', wrote Pascal in his *Pensées*. Without that little Neapolitan moment of revolt, Sofia's destiny might also have been changed. It was precisely these little faults, each feature emphasizing the exuberant sensuality, which set her apart from other candidates. Despite the failed screen test, the young woman's stubbornness and maturity impressed the Milanese producer. He wished her luck and promised to keep an eye out for her.

The actress and the producer

Indeed, Carlo Ponti would follow Sofia's first steps from a distance, often using his influence to get her auditions for low-budget films. Although she was disappointed by her first screen test, the episode gave her a bit more self-confidence. Until then, only Romilda had the faith to put her in front of the camera and, as Sofia affirmed, without her mother she would have been quickly discouraged. Hard work and persistence strengthened her determination to break into the movies. Hers was a very adult willpower, sometimes bordering on audacity, as she showed in her first real role in *Africa sotto i mari* (*Africa under the Seas*), where three-quarters of the filming took place underwater – and Sofia did not know how to swim.

The film crew realized the trick she had played when their leading actress was asked to dive from a boat and come up in front of the camera during filming on the edge of the Tyrrhenian Sea. Catastrophe! But Sofia quickly saved herself by learning to swim in record time. Although the film was coolly received, it featured many shots of the sculptural young woman in a swimsuit in front of superb landscapes. Most importantly, the name of Sophia Loren appeared on posters

for the first time. The producer thought that his film's 'siren' should lose her too-Italian name and changed Sofia to Sophia, and this second baptism gave Carlo Ponti the opportunity to disassociate his protégée from the world of the *fumetti*. Perhaps the 'ph' in Sophia's new name brought her luck since she landed the role of Aida in a film of Verdi's opera. The film went around the world. Her career was launched and she got her first big billing.

As an Egyptian slave, covered with sparkling jewels, her complexion darkened by makeup, the young actress's fierce beauty was dazzling. Sophia worked hard at synchronizing her lips with the voice of soprano Renata Tebaldi and critics acclaimed her expressivity. Her reception vindicated Ponti's intuition and he offered her an exclusive twelve-month contract.

This marked the symbolic end of Romilda's collaboration and although she was not happy with her daughter's relationship with the producer she allowed her to go her own way. But this did not mean separation; Sophia had a very deep sense of family and needed her mother and Maria beside her. The ties that bound them were important to her equilibrium. And so, in every new Roman apartment that the rising star moved to, rooms were reserved for her two loved ones.

In the year she turned nineteen, Sophia made around a dozen minor films. The roles of temptresses, passionate or dishonest women that she was offered were uninspiring but she learned her craft conscientiously and made many contacts that would prove useful to her future film career.

The Loren-Ponti collaboration inevitably brought them closer together and it was at this time that their secret liaison began. Ponti was quite the opposite of a Don Juan, unlike Achille Togliani, a former *fumetti* partner and ten years Sophia's elder, whom she had been seeing a few months earlier. The Milanese producer had (on paper) his 'bad' points: an unattractive exterior not helped by an initial unapproachability, he was 22 years older than Sophia, he had a wife, two children and a reputation as a ladies' man. But the experienced Milanese man knew how to talk to the young Neapolitan woman. He gave her what she had always lacked: a sense of security, a tranquil strength and a paternal affection. It was this paternal figure that haunted her early years of success. When Romilda and her two daughters last had any contact with Ricardo Scicolone, on one occasion they were arrested (he accused Sofia of appearing in pornographic photo-romances); and the last occasion took place in the courts, when Sophia bought the name of Scicolone for Maria, which her father had refused to give her. Abandonment, indifference, outrageous accusations and a self-interested attitude: this was the painful paternal legacy Sophia inherited. It is easy to understand that, as Sophia has said, she searched for a father-figure in all her relationships, romantic, friendly or professional.

For Sophia, Carlo Ponti was the first person outside her family in whom she had absolute confidence. He provided a reassuring and protective shoulder for her to lean on. She had mapped out for herself an ambitious goal in life – to become an actress – and she found someone to guide her along her way.

Always respecting the authentic naturalness that made up the young woman's charm, Carlo Ponti took on the task of making Sophia less provincial, of creating an off-screen image that would elevate her to stardom. He made her read the classics, helped her to lose her Pozzuoli accent and hired experts to teach her how to behave in society or in front of the press. He spent a fortune on publicity, swamping Italy with her image. Through him, Sophia gained a clearer idea of her femininity and became more aware of the effect it produced. Her allure and self-confidence increased; she abandoned the too-obvious makeup and reorganized her wardrobe more simply. Photographs show the rather tensely posed former *fumetti* pin-up giving place to a supremely natural, unrestrained woman.

The making of a pizzaiola

After these lessons in sophistication, Carlo Ponti arranged for Sophia to be auditioned by Vittorio De Sica, who was searching for an actress to appear in one of his multi-episode films as the wife of a Neapolitan pizza baker – called Sofia! It seemed almost as if she were destined to play the character created by Giuseppe Marotta, author of *L'Oro di Napoli (The Gold of Naples)* on which the film was based.

For Sophia, working with this avant-garde film-maker was an opportunity to show her talent at last. Along with Roberto Rossellini, Luchino Visconti and the scriptwriter Cesare Zavattini, De Sica was one of Italy's greatest film-makers of the time. A leading actor in the 1930s, this apostle of neo-realism (which dealt realistically with events surrounding the war) was the creator of the unforgettable *Ladri di Biciclette (Bicycle Thieves*, 1948), *Miracolo a Milano (Miracle in Milan*, 1950) and the moving *Umberto D*, his masterpiece, made in 1952. After the bitter poetry of that period, he turned to more light-hearted films, grouped together by critics as 'rose-coloured' neo-realism. In depicting the various preoccupations of Italians of the time, he captured the new values and thinking that surged from the economic revival, creating accurate and trenchant characters from national clichés.

For one of the episodes, entitled *Pizze a credito (Pizza on Credit)*, the director wanted a woman of volcanic temperament. He wanted to show on screen the verve, fire and whole-hearted exuberance of his native region. Gina Lollobrigida was considered for the part but Vittorio De Sica sensed that his Pozzuoli compatriot had the vitality and ardour he was searching for. The director's intuition and humanity immediately put Sophia at her ease. Abandoning all her defences, the actress liberated herself totally before the camera. Shouting, laughing, gusting with temperament, she gave an unforgettable impersonation of the provocative and enticing *pizzaiola* (pizza-seller) from the popular quarters of Naples.

Of the six episodes that made up the film, this was the most successful. Even the great Silvana Mangano was eclipsed by the newcomer. *The Gold of Naples* was a huge hit in Italy and its success extended far beyond the Alps. The acting talent of Sophia Loren was no longer in doubt; when she promoted the film in London, where she met Queen Elizabeth, and at the Cannes Film Festival, she was hailed as a star.

Italian comedies and dreams of America

Sophia's progress corresponded with a triumphant period for Italian cinema, both as an industry (with the growing prosperity of Cinecittà) and in the eclectic and sparklingly inventive films that were made. Concurrent with De Sica's 'rose-coloured' neo-realism another Italian speciality was earning international acclaim: Italian comedy. A kind of politically incorrect reworking of *Commedia dell'arte*, this genre specialized in ironic social satires, treating serious themes

with an acerbic, burlesque tone. Many directors rushed to make films in this vein or developed screenplays around it.

Now acknowledged by her peers, Sophia acted in several of these films, demonstrating that laughter and her untamed beauty were not irreconcilable. The Neapolitan temperament is a paradoxical mixture of melancholy, fierce and terrible fits of rage and facetious pranks. Despite her shyness, which was gradually dissipated by her success, Sophia never lost her Neopolitan characteristics. In life as on the screen, they were the source of her incomparable seductiveness and her overflowing vitality.

For Alessandro Blasetti's *Too Bad She's Bad*, 1954, she was partnered by Vittorio De Sica and acted for the first time with Marcello Mastroianni. The three Neapolitans worked wonderfully together and would come together again several times. Sophia received her first award (Best Actress at the Festival of Buenos Aires) for her sparkling characterization of a thief. From now on not a year would pass without her acting achievements being rewarded.

Surfing this propitious wave, Carlo Ponti moved to a higher level. His press team worked tirelessly to promote the actress's image, going so far as to stir up rivalries with another star (Gina Lollobrigida) to create publicity. Screenwriter and film maker, Michel Audiard, said: 'A gentleman is someone who is able to describe Sophia Loren without making gestures.' But Ponti aimed to extend his protégée's fame beyond Italy. 'La Loren' had in fact become what the Italians called a *Ragazza* (girl), an actress famous enough to be exported throughout the world, especially Hollywood. However, her repertoire lacked a dramatic role and Ponti decided to produce a film especially for her. Although otherwise unremarkable, Mario Soldati's *Woman of the River*, fitted Ponti's plans and caught the attention of American producers.

In 1955 Sophia made films at a frenetic pace, including Mario Camerini's *The Miller's Beautiful Wife*, Dino Risi's *Scandal in Sorrento*, Blasetti's *Lucky to be a Woman*; frequently her screen partners were De Sica or Mastroianni, who had become loyal friends.

In view of the international career envisaged by her mentor, she learned English. Like a well-oiled machine, this was the moment when the American producer-director Stanley Kramer offered her a leading role in *The Pride and the Passion*. 'Two hundred thousand dollars, take it or leave it', he told the flabbergasted Ponti, who kept his cool. Sophia was to star in this epic of the Napoleonic wars with two of her childhood idols, Cary Grant and Frank Sinatra.

Cary Grant

Filming of this colossal epic began in April 1956 in southern Spain. Ten thousand extras took part in the battle scenes and Kramer even organized sporting contests to decide on the secondary roles (150 actors would support the three stars). Sophia was terrified of not being able to match up to the distinguished cast, especially as her English was still rudimentary. Nor was Cary Grant enthusiastic at having to share billing with someone he considered just another Cinecittà starlet but he soon fell for the Italian's charm and, despite their 30-year age difference, an off-screen idyll sprang up. In the land of Cervantes, in the little restaurants they frequented after long working days, the two fell in love. When filming was nearing its end, Cary Grant suggested to Sophia that they should get married.

Still in love with her Milanese producer, the young woman was torn between the two men. Despite the tumultuous life of an actress Sophia dreamed of a stable life and a quiet home, the sort of family atmosphere she had been denied from birth. On screen, she skilfully played a capricious and passionate seductress; in private, she aspired to the simple, traditional values of her background. She was torn between the attractive, three-times divorced American and her uncertain future with Ponti, the married father of two children, in Catholic Italy where separation was not permitted.

The Pride and the Passion was to be completed in the USA, leaving her a few months for reflection. As usual when her personal life was overshadowed with problems, she flung herself into a frenzy of work, embarking on a new American film, *Boy on a Dolphin*, playing opposite Alan Ladd. Her spirited interpretation saved the film from banality and confirmed her talent in the eyes of the critics. Having played a Spanish camp-follower and a Greek sponge-diver, she next put on the rags of an Arab gipsy for *The Legend of the Lost*. Filming in the Libyan Desert was testing but it gave her the chance to meet the impressive John Wayne.

'You want to be American, 'merican, 'merican ...'

While Italians were not too happy about the Americanization of their favourite star, Hollywood flung open its doors to her. In 1957 Carlo Ponti negotiated a four-film contract with Paramount and when Sophia disembarked from her plane at Los Angeles she was given a triumphal welcome to the New World. The studios threw a cocktail party in her honour, attended by the most distinguished members of the Hollywood community. An eloquent photograph immortalizes this gathering and illustrates the coveted position accorded to Sophia: it shows her shocked face on being confronted with the exhibitionistic décolletage of Jayne Mansfield. Her reputation as a Latin sex-bomb of fascinating dimensions had preceded her and Hollywood's most famous sex-symbols tried to measure up to her.

But the need for Sophia to employ her magnificent 38-24-37-in (95-60-95-cm) figure for publicity was over. Her burgeoning international career ensured that she was offered plenty of work. Among her other qualities, Sophia was always aware that it was in fact her naturalness and simplicity, her sensitive and spontaneous character that made her stand out from the host of American pin-ups.

This did not, however, prevent her from enjoying the advantages of her star status, notably in the form of sumptuous presents from Carlo Ponti. The producer spoiled her. Ever since *Woman of the River*, a piece of jewellery would arrive to celebrate the end of each film, and the important stages of their courtship were marked by the purchase of princely residences: a Roman apartment with a view of the capital and later the beautiful Villa Marino; the peaceful chalet in Bürgenstock, Switzerland, that became their European 'crash-pad'; and the hotel apartment overlooking Central Park in New York.

Sophia enjoyed her new way of life although she was sometimes criticized for this ostentatious luxury. But she never lost sight of her fundamental values: first of all, the family – she supported close relatives all her life – followed by work, which she never shirked and which became almost a religion.

Until she arrived in California, the parts she was offered relied more on her looks than her acting. In consultation with her Milanese mentor she decided to change

direction and to extend her career by taking on more sophisticated films with more ambitious screenplays.

Desire under the Elms (directed by Delbert Mann and adapted from a play by Nobel laureate, Eugene O'Neill) was her first major dramatic role. From film to film Sophia developed and asserted herself, even taking some parts against the advice of her producer-lover. This is how she came to make *The Key*, a dark drama by British director, Carol Reed, despite Ponti advising against it. Of all the torrid melodramas she made, *The Black Orchid*, directed by Martin Ritt, brought her first real triumph, playing a gangster's widow with whom Anthony Quinn falls in love. She was awarded the Volpi Cup for Best Actress at the *Venice Film Festival* in 1958.

Husbands and wife

The mood was lighter in *Houseboat*, a comedy directed by Melville Shavelson, in which she starred with Cary Grant, who was still in love with her and equally pressing. Sophia had never responded to his marriage proposal, as she was too attached to Carlo Ponti to leave him. His marriage was now a sham, he and his wife continued to live in the same house, although each wanted to be free. Italian law did not allow them to separate, and 'living in sin' was still a penal offence, a legal situation that lawyers for all parties tried to untangle. Sophia was in love but tired of this clandestine liaison. Not only her childhood scars but also her Catholic education fed her unwillingness to play the role of 'home-wrecker–mistress'. She was devoted to her European background and was not drawn to life in the USA but, faced with the persistence of the attractive Grant, she began to have doubts. Well aware of his love-dilemma, Carlo Ponti kept his counsel and allowed the young woman time to reflect, although he pushed his lawyers to regularize their precarious situation.

While breakfasting tranquilly on the terrace of her Beverly Hills apartment one morning in September 1957, Sophia learned from her newspaper that she had married Carlo Ponti – the day before, in Mexico. Although the news should have filled her with happiness, her new talent for ubiquity was rather unsettling. In reality, a Mexican court had granted Carlo a divorce, freeing him to wed Sophia, and their lawyers had immediately stood in for the couple in a proxy wedding in Juarez. Ironically, while the young bride was receiving congratulations on her marriage, the last scene for *Houseboat* was about to be filmed: her wedding. She wore a white dress to be married to Cary Grant, the defeated lover but good loser. What was the verdict in faraway Italy? While Sophia was torn between happiness and apprehension, the reaction of the Vatican, barely a month later, was much more severe than she had imagined. A thunderous article condemned divorce and civil remarriage unequivocally, pronouncing them illicit 'before God and the Church'. It was a question of public sin, bigamy and excommunication. Carlo and Sophia were by no means the first Italians in this situation but the powerful Catholic lobby used their celebrity to reaffirm its authority and direct the strayed sheep back to the fold. In Italy the affair unleashed high passions; there were calls to boycott Sophia's films and prayers for the souls of the accursed lovers.

Sophia was deeply upset by this first falling-out with her public and by her national pillorying. For the second time in her young life she was called to account by Italian society in the name of moral and religious values. Not only was she refused

the right to bear the name of the man she loved but he risked imprisonment for bigamy if he set foot on Italian soil.

The passion for acting

From now on, Sophia and Carlo became exiles, shuttling between the USA, France and Switzerland. Fortunately the scandal did not affect their film projects or the success of the movies. One year after the Mexican marriage, in defiance of the conservative and Catholic class that had demonized the actress, the jury of the Venice Film Festival honoured Sophia for her performance in *The Black Orchid*. After understandable hesitation, she returned to her homeland to receive the Volpi Cup. Although she had imagined herself being handcuffed by the *carabinieri*, her compatriots gave her a very warm welcome. Despite all the attacks her public loved her even more and it was a radiant Sophia who received the prestigious trophy.

That Kind of Woman marked a turning-point in her American career. For the first time she was cast as an Anglo-Saxon by the avant-garde director Sidney Lumet, moving away from the picturesque clichés of Italian immigrants or Mediterranean beauties. Sophia loves a challenge and she worked hard on her diction to eliminate all trace of an accent.

This ability to learn, the energy with which she pitted herself against herself, in film after film, is typical of the actress. On a film set, even at the peak of her fame, 'La Loren' never indulged in inconsiderate caprices. She arrived on time, learnt her lines meticulously and listened conscientiously to the directors' instructions. From producer to the humblest technician, everyone who worked with her appreciated her professionalism, her patience, her politeness and her abounding vitality. All the same, she was not just a 'good pupil': her interpretations were highly intuitive and she needed a certain amount of freedom to unleash her personal artistic momentum.

Sophia found this necessary space for spontaneity notably lacking in the direction of George Cukor when she filmed *Heller in Pink Tights*, a light-hearted Western in which she had to wear a blonde wig. It was the last film in her Paramount contract but she immediately embarked on a new Hollywood project.

Although the setting (the beautiful island of Capri) and cast (including her friend Vittorio De Sica) of *It Started in Naples* were Italian, the director, leading actor and producer were all American. Sophia was reunited with Melville Shavelson, who had directed her in *Houseboat,* and co-starred with one of Hollywood's legends, Clark Gable. The frothy romantic comedy was only successful in English-speaking countries, as was Sophia's next movie, *The Millionairess*, a 'British' farce directed by Anthony Asquith. Always seeking to extend her range, in *A Breath of Scandal* she played a resourceful aristocrat, a crinolined princess of Imperial Vienna.

Her almost four-year Hollywood interlude had been hugely influential for Sophia. She had learned much from her co-stars: Cary Grant, Frank Sinatra, John Wayne, Anthony Perkins, William Holden, Trevor Howard, Anthony Quinn, George Sanders, Peter Sellers, Clark Gable and John Gavin. Although she had become one of the best-paid actresses in the world, she was not content to achieve international success simply by flaunting her sexuality. Armed with these American experiences she had also enriched and sharpened her technique, developing her own acting style of subtle interpretation. She could now undertake any kind of film, not only thanks to the unequalled quality of her filmography and the diversity of

the characters she played but also to the genres she had undertaken. No longer typecast by the character of the *pizzaiola* from *The Gold of Naples*, Sophia Loren had become a universal actress. The only thing lacking was 'the' career-defining role of her life, the one that would place her at the top of cinema. And it was a Neapolitan, a friend, another father who would offer it to her.

Two Women

La Ciociara (Two Women), a novel by Alberto Moravia, deals with the debacle at the end of World War II by telling the story of a young widow, Cesira, and her daughter, Rosetta, who flee Rome in the face of the invading German army. They take refuge in their native village in the mountains. Cesira and Rosetta escape danger during their stay there, but the Liberation of Italy proves tragic for them. On their return to Rome, they are attacked and raped by North African soldiers, who are part of the liberating forces.

Carlo Ponti initially thought of going to Paramount for this adaptation of history, with George Cukor as director and Anna Magnani and Sophia Loren in the leading roles. But the project was abandoned in the face of the stubborn refusal of 'La Magnani' – as she was called by the Italians since her Oscar-winning performance in *The Rose Tattoo* (1956) – to share billing with the too 'invasive' Sophia. Ponti bought back rights to the novel and offered the film to Vittorio De Sica; the screenplay was rewritten by Zavattini and the part of Cesira went to Sophia and that of her daughter to a thirteen-year-old actress.

Once again, the actress was playing a woman of the people, an uneducated peasant, confronted by the violence and cruelty of war. But this role was not made to measure; above all, it was that of a woman older than Sophia was in 1960. De Sica carefully prepared his young friend for the difficult characterization that lay ahead of her. From this instinctive complicity between the director and his actress sprang a genuine work of art.

On screen, the drama's pathos is purged to good effect and the acting reduced to brutal realism. In a magisterial demonstration of her talent, Sophia ranged between sound common sense, black rage and an almost animal tenderness for her daughter Rosetta. Dishevelled, without make-up, in a dusty dress, her dazzling beauty was still portrayed by the camera but the revelation did not destroy her ability to confront history. It was all down to her subtle acting, to the way in which she infused the part of *la Ciociara* with her characterization of an unsophisticated, courageous and desperate woman.

The film was an international success and soon Sophia Loren was deluged by a shower of awards. Accolades came from the Cannes Film Festival, the Italian Cinema Academy (David di Donatello), the Taormina Film Festival (Silver Riband), the New York Film Critics' Circle (NYFCC Award); awards from Argentina, Japan, Belgium, Germany, the UK, Spain – the world's most distinguished cinematographic institutions unanimously voted her their Best Actress prizes.

The ultimate accolade

The Academy of Motion Pictures, Arts and Sciences had never given an Oscar to an actress starring in a foreign-language film and so, in 1962, Sophia did not expect this ultimate accolade. She did not go to Los Angeles for the ceremony but she couldn't resist waiting by the telephone in her luxurious Roman apartment. Carlo, Romilda, reporters and photographers were all worn out by the suspense and when the news came (it's said that Cary Grant made himself the happy messenger), Sophia's joy erupted like Vesuvius.

Sophia Loren did not have an 'easy physique' for the cinema. To some extent her enduring beauty and her exuberant sex-appeal militated against her ambition to become a great actress. The provincial Neapolitan who achieved fame through her dazzling physique had to work hard to prove her acting talent. She gamely pushed herself and with *Two Women* she at last achieved her objective. 'Her interpretation is so perfect that one forgets she is a very beautiful woman', noted one English critic. Clutching the precious American statuette to her heart, Sophia was fully aware of the honour that had been granted to her.

It's not surprising that this life-changing film is one in which male figures are absent – the characters played by Raf Vallone and Jean-Paul Belmondo are secondary to the story. It is true that men are omnipresent in the violent scenes – the war and the rape scene in the church – but maternal love remains the epicentre of the drama. In this role, Sophia was clearly inspired by her mother Romilda (and by her own memories of the war), but she also brought out her own deep maternal feelings. This was a dimension that would have a strong influence on her personal life.

Being a mother

At almost 30, Sophia Loren had everything the little girl from Pozzuoli had dreamed of: a more than comfortable lifestyle, interesting work, universal recognition of her talent (immortalized by leaving her handprints on the celebrated pavement outside Grauman's Chinese Theatre) and finally the love of a man, Carlo Ponti, who gave her great joy. But one thing was missing to cap it all – motherhood. And this crowning wish took time to fulfil.

The complications of her private life also threw a shadow over the picture. After an interminable procedure, the Mexican marriage was declared void (the lawyer-proxies had neglected to provide the obligatory two witnesses) and the charges of bigamy were dropped. But on returning to Italy the couple were again forced to lead their lives in secrecy.

Anthony Mann's *El Cid*, in which she played opposite Charlton Heston, Christian-Jaque's *Madame Sans-Gêne* and Anatole Litvak's *Five Miles to Midnight* (in which she co-starred again with Anthony Perkins), received mixed notices but confirmed Sophia's reputation. From now on, her name only had to appear in the credits of a film to ensure that audiences would flock to see it. Her acting also managed to save some films that suffered from a weak script or poor direction.

Punctuated by American super-productions such as the grandiose, *Fall of the Roman Empire*, directed by Anthony Mann, the 1960s also saw Sophia's return to European films, especially Italian ones. After the happy experience of *Two Women*, she worked on four films with her favourite director. While Vittorio De Sica got decent results with his multi-episode *Boccaccio '70* and then with an adaptation of Jean-Paul Sartre's *The Condemned of Altona*, it was above all *Yesterday, Today and Tomorrow*, followed by *Marriage Italian Style* that became hits. The success of the latter two films is essentially due to the incomparable pairing

of Loren and Mastroianni. Together, hamming it up or unbearably moving, they formed a unique cinema couple. In their charming Neapolitan versions, they showed themselves to be as great as the most mythical star pairings: Fred Astaire and Ginger Rogers, Katharine Hepburn and Spencer Tracy or Loren Bacall and Humphrey Bogart.

Yesterday, Today and Tomorrow, featured a striptease scene that became a cult (reprised 30 years later in *Prêt-à-porter*): with adorable shyness and provocative sensuality, Sophia strips while dancing before an enamoured Marcello who howls like a wolf.

While filming in Milan, Sophia had plenty to make her happy; she had just learned that she was pregnant. But her joy was short-lived for she miscarried a few weeks later. It was a cruel irony: in one of the three episodes she played for De Sica (*Adelina,* inspired by a real-life story) her character, a cigarette smuggler, gets pregnant seven times so as to escape prison – Italian law does not permit the arrest of a pregnant woman.

To recover from this setback, she immediately went to work in Israel on the film *Judith*, directed by Daniel Mann. It is the story of a Jewish woman survivor of a concentration camp who seeks revenge on her Nazi husband who denounced her. Her next film was *Operation Crossbow*, a spy film directed by Michael Anderson, which took her to London. At the end of 1964 she packed her bags, went to Paris and prepared to film *Lady L.*

Although it might seem likely, this film was not the reason that Carlo and Sophia bought a luxury triplex with a terrace, near the Champs-Élysées. The acquisition of a Parisian apartment was a brainwave of Ponti's wife who, being a lawyer by profession, had eventually found a way to resolve their inextricable marital situation. The 'plan' consisted of the three protagonists taking French nationality so that the Ponti couple could legally divorce in France. From now on there was nothing to prevent the French marriage of Sophia with the man she loved.

Chaplin's countess

While awaiting this happy ending, Sophia worked on *Lady L.*, adapted from a novel by Romain Gary and directed by Peter Ustinov. The excellent screenplay concerned the reminiscences of an elderly aristocratic lady in Victorian times. Thanks to the magic of makeup, Sophia played this surprising personality at every stage of her life and while there was little chemistry between her and co-star Paul Newman the film sparkled with originality and exuberance.

While filming the comedy thriller, *Arabesque,* for Stanley Donen, alongside Gregory Peck, Sophia rented an English country house and soon had a visit from one of cinema's legendary figures, Charlie Chaplin. He had admired her work in *Lady L.* and wanted to offer her the lead in his next feature film, *A Countess from Hong Kong.* The unsolicited offer from the director of *Modern Times* was more than an honour; it was the dream of a whole generation of actresses, from Marilyn Monroe to Brigitte Bardot.

The celebrated Chaplin had not made a film since he had fled the USA ten years earlier having been a victim of McCarthyism. He was now 77 and this project, which was his first colour film, was likely to be his last, a kind of 'cinematic testament', was how he described it. Chaplin, Sophia and Marlon Brando met in the director's Swiss manor-house for the first script run-through. Sophia was impressed by the

little man's energy: he acted all the parts, punctuating his interpretations with snippets of piano music he had composed for the occasion. Conversely, she was shocked by the attitude of Brando, who spent the time half-asleep, or pretending to be, in front of the little genius.

The Hollywood bad boy proved more attentive during filming but light comedy did not suit his acting style, which was better adapted to drama. In *A Countess from Hong Kong,* Brando plays an American ambassador obliged to hide a stowaway Russian in his cabin on the liner taking him to New York. Despite the two actors' best efforts, Chaplin's comedy never really found its feet; hesitating between farce and romance, it was an uneasy mixture.

Sophia had considerable admiration for Chaplin but she sensed that the film would be a failure. Her intuition was confirmed by the critics and the poor reception it got from the public.

Setbacks and great happiness

Despite this setback, 1966 was a very happy year for Sophia. The scheme devised by Ponti's wife had succeeded: after eight years of legal manoeuvring, denunciation by the Church, scandal and exile in the USA, the Pontis were granted a French divorce. The producer was at last free to marry his muse and the wedding took place in spring in the intimacy of the town-hall of Sèvres, a suburb of Paris.

The new Madame Ponti radiated happiness at the Cannes Film Festival, over which she presided that year. Her happiness also shone through in her playing of a Russian peasant who marries a prince, Omar Sharif, in the romantic fairy tale *Happily Ever After*, directed by Francesco Rosi. When the Italian shoot ended, she discovered that she was pregnant once again.

Once filming was over, she cloistered herself in her Marino villa – a 50-room Roman palace given to her by Carlo three years earlier – and stayed in bed throughout her pregnancy, attended by an army of doctors. Romilda, Maria and Carlo surrounded her with tender care but Sophia, aged 32, suffered a second miscarriage in January 1967.

She was plunged into deep depression by this tragic event. Romilda, Maria and her children (from her unhappy marriage with the musician Romano Mussolini, son of Il Duce) tried to console her by suggesting adoption, but nothing could comfort her. Crushed too, Carlo saw his courageous Sophia plunged in misery. This adored woman, born to laugh and be happy, became anxious and subject to uncontrollable mood-swings.

Normally work was the only cure for Sophia's misery although now, confronted by her deep suffering, Carlo doubted if a new film could lift her depression. All the same, he offered her the female lead in *Ghosts, Italian Style*, a farcical comedy of errors by the talented playwright Eduardo De Filippo. Despite the participation of the excellent Vittorio Gassman and the faithful Marcello Mastroianni, Renato Castellani's adaptation was disappointing. However, at this time it mattered little to Sophia what people thought of her films. Even the abandonment of a coveted film project for Luchino Visconti left her indifferent. She was obsessed by one thing, her inability to have a baby.

The woman (and the actress) was finding it extremely difficult to get over these two miscarriages and the thought that she would never succeed in giving birth. Hope began to rise when she consulted a Swiss gynaecologist, Dr Hubert de

Watteville, who, after lengthy examinations, thought he had found the cause of her unsuccessful pregnancies. Sophia seemed to suffer from a hormonal imbalance that could certainly be cured by treatment. When she became pregnant for the third time the Swiss doctor prescribed total bed rest. While France and Europe were shaken up by the student protests and general strike of May 1968, the actress spent the last six months of her pregnancy in a luxurious suite at the Hotel Intercontinental, Geneva, rented especially for her by Carlo. It's not hard to imagine the prayers she must have addressed to the vast panorama of the lake and Mont Blanc, seen from the windows of her 18th floor apartment.

On 29 December 1968, Sophia Loren-Ponti gave birth to little Carlo, the second of that name.

Her fans around the world sent their congratulations. Thousands of women were touched by the birth of this child, who was also given the names of his godfather Uberto, the Swiss doctor who had accomplished the miracle, and Leone, after his paternal grandfather. That year Sophia was unanimously recognized as the most popular and best-loved actress in Great Britain, Germany (with her eighth consecutive Bambi Prize) and the USA (with a Golden Globe). In the hearts of Italians who had been offended by the American escapade and the Pontis' marital convolutions, the young mother finally regained her place of honour. For the first time in her life Sophia was utterly content.

Six months later, as if to celebrate the happy event, she returned to films and to her two Neapolitan 'stooges', Vittorio De Sica and Marcello Mastroianni. Her performance in *Sunflower*, which was filmed in Russia, earned her the David di Donatello Award for best actress in 1970, a scenario that would be repeated four years later when she starred with Richard Burton in *The Voyage*, the last film to be directed by De Sica.

Between 1970 and 1973, she acted in several of her husband's productions, although *The Priest's Wife*, *Lady Liberty* and *White Sister aka The Sin* were less inventive than the comedies of earlier years. Only *Man of La Mancha*, a musical based on Cervantes' *Don Quixote*, stood out, but audiences did not like it and the adventures of the Don, played by Peter O'Toole (famous for his role in *Lawrence of Arabia*), was a box office flop.

The end of filming was crowned by happy news: for the second time, Sophia would be a mother. During her pregnancy she took the same precautions as for Carlo Jr. and at the beginning of 1973 she gave birth to little Edoardo.

Metamorphoses

This second birth slowed down Sophia's rate of filming; the actress gave way to the woman transfigured by maternal love. She felt a visceral need to cherish her little boys. All her attention was focussed on their care and education and she could not bring herself to leave them for several weeks.

While she was enthusiastic about the idea of acting in her friend De Sica's new film, it was the fact that it would be filmed locally that persuaded her to go back to the studios; every evening she would be able to return to the Roman palace where her little ones slept.

Filming of *The Voyage* did not begin under the best auspices. First, there was the eventful detoxification regime of her co-star Richard Burton. His marriage to Elizabeth Taylor was floundering and the British actor was finding it difficult to quit drinking; the caprices of Taylor (who spend several days at the Villa Marino) did nothing to help his concentration. Above all, the health of De Sica, an inveterate smoker, was worrying. Diminished by illness, his eloquence and spirit were extinguished and his direction of the actors was rather wooden; on screen the drama did not come through.

Although *The Voyage* brought another award to its leading actress, this nth success was overshadowed by the death of Vittorio De Sica. Sophia was deeply saddened by this loss. Her Neapolitan friend had directed her in eight films and co-starred with her in six others. He had been a partner for her beginnings and the architect of her triumph with *Two Women*. He had been both a friend and a father.

This loss coincided with the end of an era. In the mid-1970s, Italian cinema effectively turned a page of its history. The taste of the new generation of movie-goers had changed and the golden age of Italian comedy was over. From now on, television was the prime medium of entertainment, while the cinema turned to epics.

Although it didn't tarnish the legend forged by 25 years of hard work, this new tendency inevitably affected the career of Sophia Loren but the intuitive Carlo Ponti had already anticipated the change in public taste. After *The Verdict*, in which Sophia played opposite Jean Gabin, and a final Italian-style comedy, *Poopsie & Co.*, he produced a made-for-television version of *Brief Encounter* and the disaster movie *The Cassandra Crossing*.

A special role

Sophia turned 40 but time seemed to have passed her by; every decade confirmed the illusion of eternal beauty.

To escape the paparazzi and fearing the kidnappings that were currently endemic in Italy – two attempts had been made to kidnap Carlo Ponti – the Ponti family moved to Paris. Devoting herself to her growing children, Sophia was happy and the cool reception for her latest films did not affect her much. As she always said, her best role was as mother to Carlo Jr. and Edoardo.

It was in this vein – magisterially demonstrated in *Two Women* – that she felt able to extract the quintessence of her acting talent. And in filming Ettore Scola's *A Special Day*, Sophia repeated that feat. She played Antonietta, a housewife neglected by her husband in fascist Rome of 1938. On 8 May 1938, Mussolini held a parade in honour of Adolf Hitler, to celebrate their summit meeting in Rome. The film deals with the encounter between Antonietta and Gabriele, an intellectual radio announcer who has been fired for his political leanings and his homosexuality. These two people with nothing in common – the downtrodden woman and the 'subversive' man, a victim of ideology – strike up a friendship based on the same suffocating feeling of loneliness.

Thanks to Scola's brilliant direction and the proven chemistry between Loren and Mastroianni, *A Special Day* is another masterpiece in the actress's filmography. This tired, ageing woman, the complete opposite of the real Sophia, became one of the incontestably great interpretations of her career.

It was another award-laden triumph, although when she received the David di Donatello and the Silver Ribbon for Best Actress her curtsey seemed to be something of a farewell. From 1980 onwards, all the distinctions she received were honorary lifetime achievement awards.

After *A Special Day*, Sophia's films were spaced more and more widely apart. For the last 30 years, films as diverse as Roger Hanin's *Soleil*, or the American *Grumpier Old Men*, demonstrate that she refused to be confined to a role or a genre. She made several well-regarded television movies (*Saturday, Sunday and Monday* and *The Fortunate Pilgrim*) and even appeared in an adaptation of her autobiography, *Sophia Loren: Her Own Story*, playing her mother Romilda. Some projects particularly appealed to her: for example, in 1984 she appeared with her son Edoardo in Maurizio Ponzi's *Aurora*; she repeated the experience eighteen years later but this time her son directed her in *Between Strangers*, which was shown at the Venice Film Festival.

Fatalism and daring

Apart from her deliberate choice to put her children before her career, the end of the 1970s brought new ordeals in Sophia's private life.

First came the death of Riccardo Scicolone, her estranged father, whom she nevertheless visited in hospital with Maria and Romilda. Next, Carlo had problems with the Italian tax authorities, who seized Villa Ponti and its art collection. Badly advised by a tax specialist, Sophia herself was sentenced to a month in prison in 1982 for income tax evasion going back to the 1960s. Against all expectations, the international star returned to Italy to serve her penal sentence. She wanted to see her mother, she could not bear the thought of exile.

Despite all her trips around the world, her bases in Switzerland, France and the USA, deep down Sophia remains fiercely Neapolitan: superstitious, mischievous, food-loving, melancholic, passionate and fatalist.

When, for instance, she contemplates the success of her two children (one is a musician, the other a director), she doesn't forget that nothing can shield her from unhappiness. Sophia lost Romilda, her adored mother without whom La Loren would never have existed. Her beloved Carlo, her passion and the man who had orchestrated her incomparable career, died in January 2007. She also lost friends including Blasetti and her ideal co-star, Mastroianni.

Even at her zenith, she never felt herself to be untouchable. Perhaps because of her education, certainly because of the scars of her past, she remains vigilant, aware that everything might collapse from one day to the next. It's a state of mind that explains the energy and tenacity that have informed every stage of her life.

Rumours, scandals and love affairs: the price of fame is proportional to the degree of notoriety attained. Sophia Loren is a living legend, an institution, the archetype of the star that the 21st century cannot replicate. The smallest whispers, therefore, are broadcast worldwide. For example, throughout her career the tabloids have persisted in accusing her of having countless love affairs with her screen partners (Frank Sinatra, Rossano Brazzi, Peter Finch, Maximilian Schell, Richard Burton, etc.). But Sophia Loren has never been anything but a one-man woman. Scandals or truths, nothing can tarnish the Italian star's sparkle.

What drives this extraordinary woman is defiance, permanently. Even in her senior years she is still capable of every kind of daring. In 1994, in Robert Altman's *Prêt-à-porter*, she recreated the striptease from *Yesterday, Today and Tomorrow* before an aged Mastroianni who falls asleep at the end. This humorous nod to the earlier film was filmed 40 years on and Sophia comes out of it with honours. At the 'respectable' age of 72, she still made a sensation posing for the 2007 edition of the Pirelli calendar. Nothing scares La Loren, who elegantly assumes her status as a living fantasy, disdaining the ultimatums of the years. Here is her recipe for this legendary seductiveness: 'Fifty per cent of sex appeal is what you've got and fifty per cent is what people think you've got.'

Sophia Loren has led a full life. From an unhappy childhood in Pozzuoli to international fame, her story – such a great screenplay – is one that can be called a destiny, in the full sense of the word. Some people may find it too romantic, too cinematic to be true. But imagine Sophia faced with sceptics: 'Eh!!!', she would say, shrugging her shoulders in a fatalistic gesture, her eyes flashing – Neapolitan style.

"The two big advantages I had at birth were being born wise and to have been born in poverty."

Sophia Loren

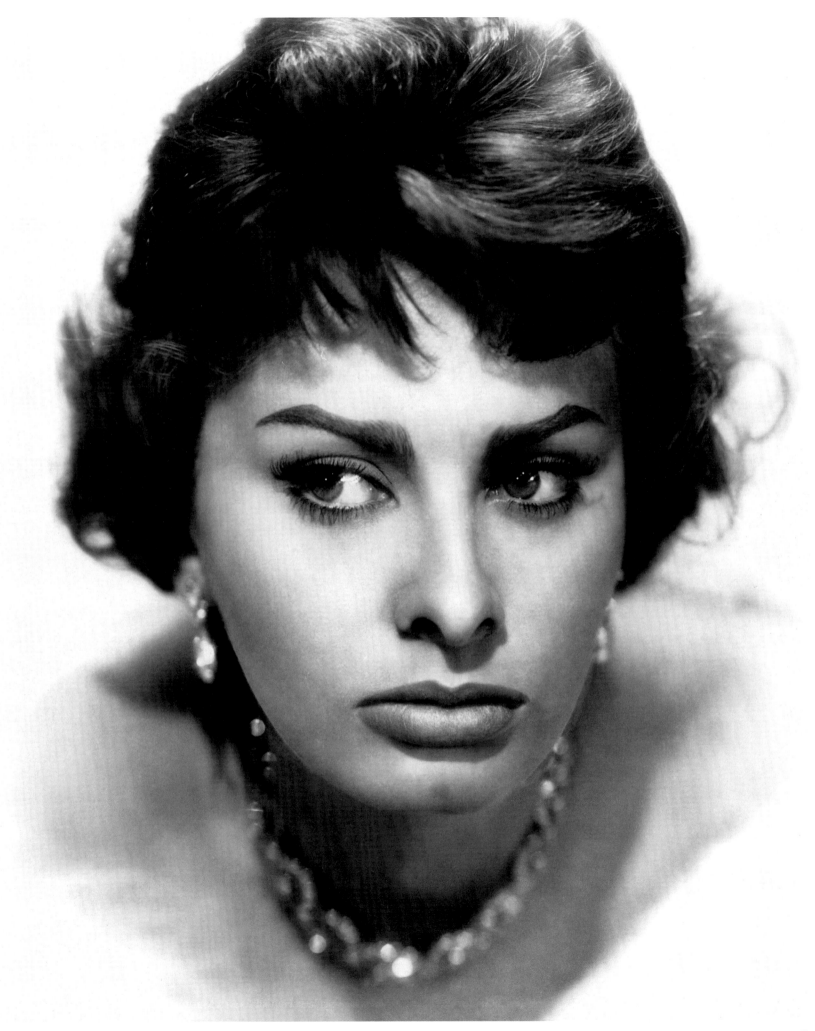

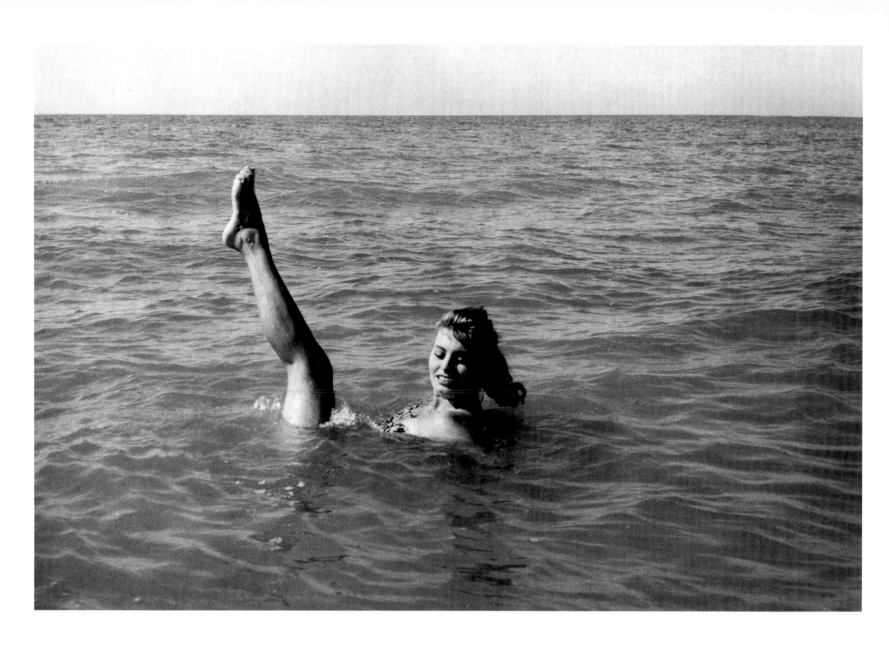

1955 / Sophia Loren had to fight to play the role of Lina Stroppiani in *Too Bad She's Bad*, as Gina Lollobrigida had initially been selected for the part. It was while making this film, directed by Alessandro Blasetti, that she met Marcello Mastroianni, who became a lifelong friend.

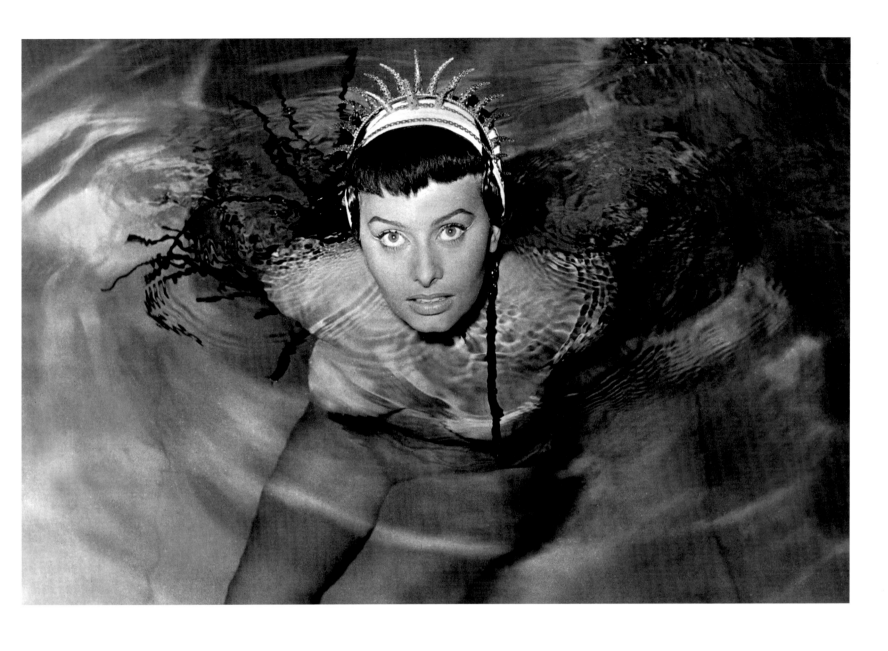

1953 / Sophia Loren in *Two Nights with Cleopatra*, directed by Mario Mattoli.

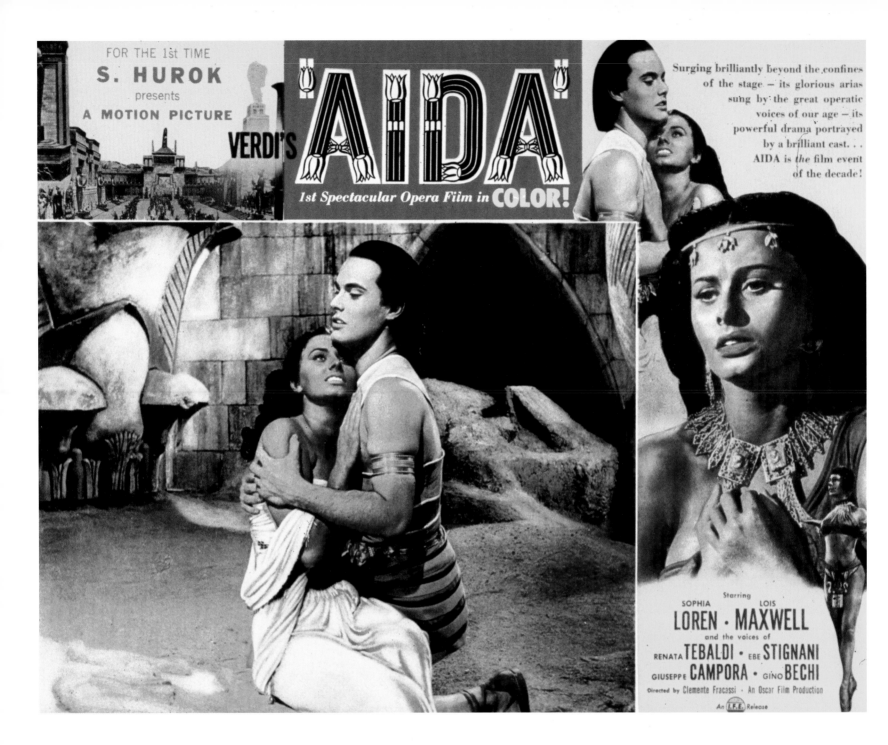

1953 / Poster for the film *Aida*, directed by Clemente Fracassi.

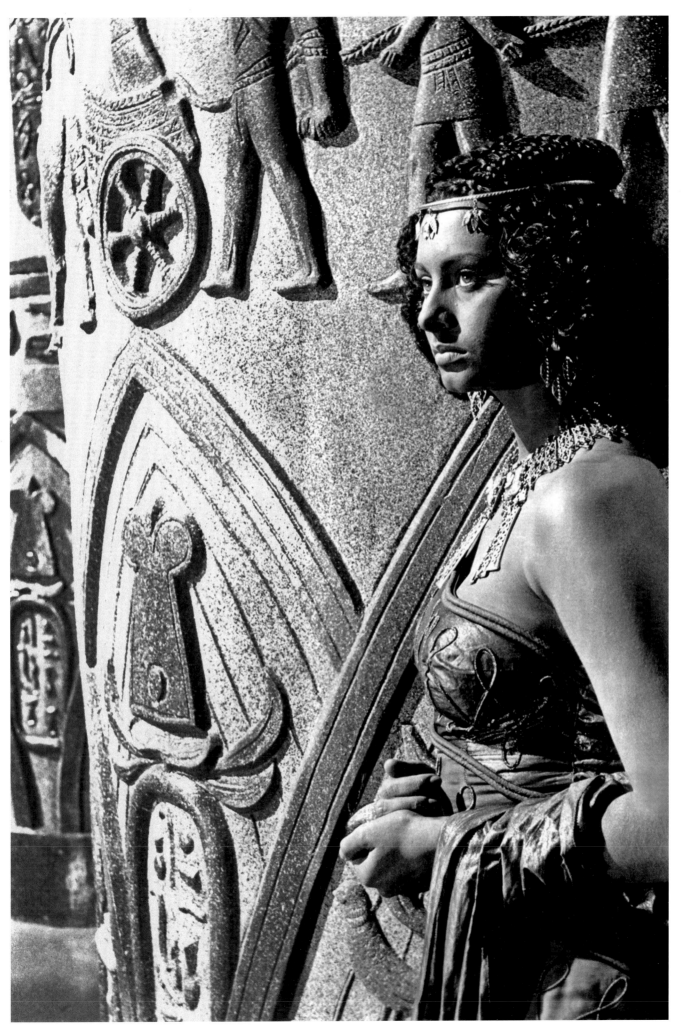

1953 / Renata Tebaldi provided the singing voice for Sophia Loren's Aida. Director Clemente Fracassi wanted to make Verdi's opera accessible to the greatest possible audience, but the hoped-for success did not materialize.

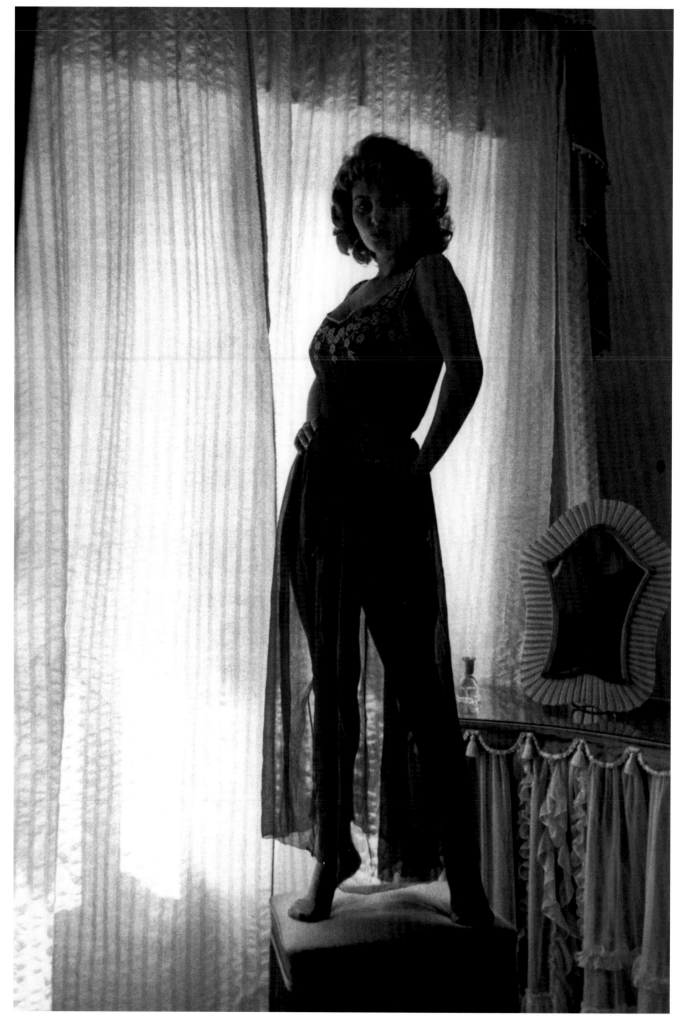

1955 / Sophia Loren at home in Rome.

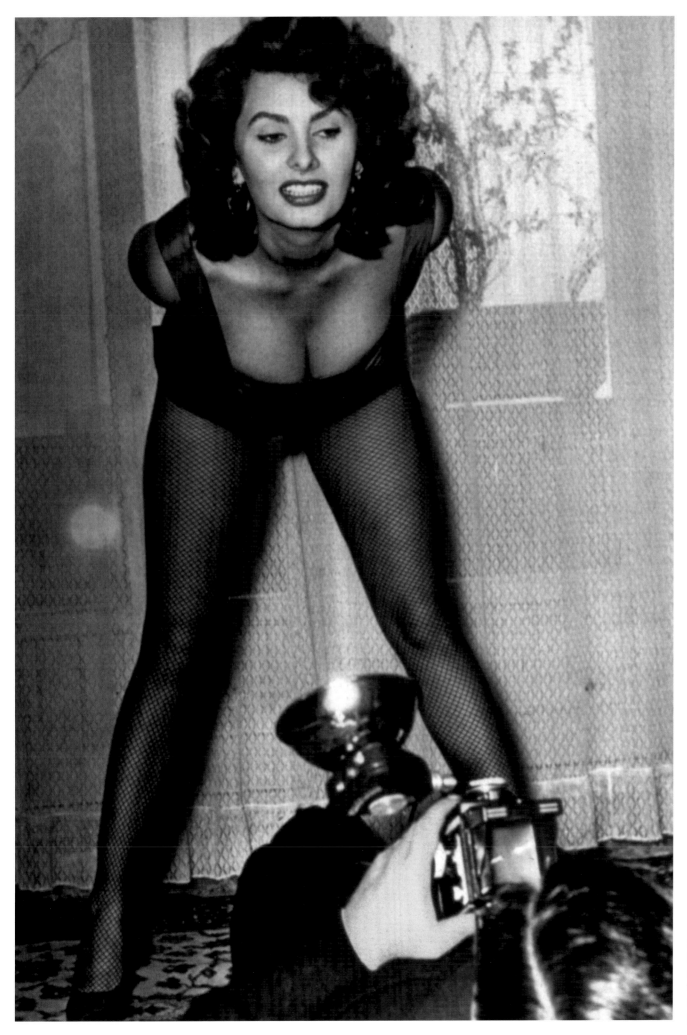

1957 / Already a star in Italy, Sophia Loren signs a four-year contract with Paramount, whose publicists arranged many photo-sessions to promote her in the USA.

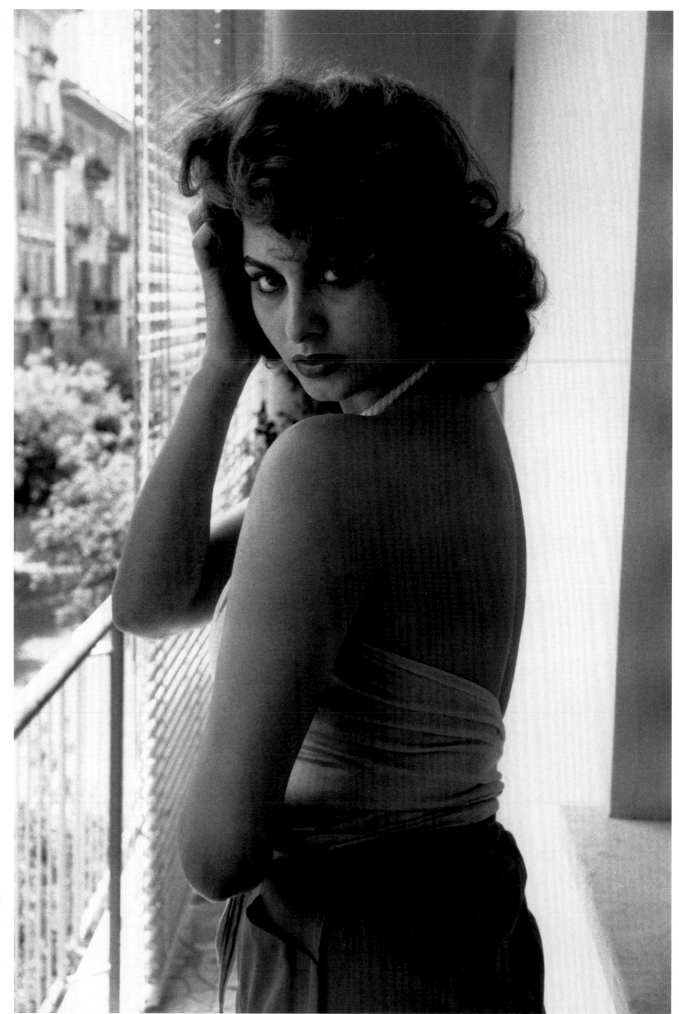

1955 / David Seymour took a series of photographs of Sophia Loren at home in Rome in 1955. It was a memorable sitting thanks to the intimate photographs that immortalized her on this Sunday morning shortly after she had got out of bed.

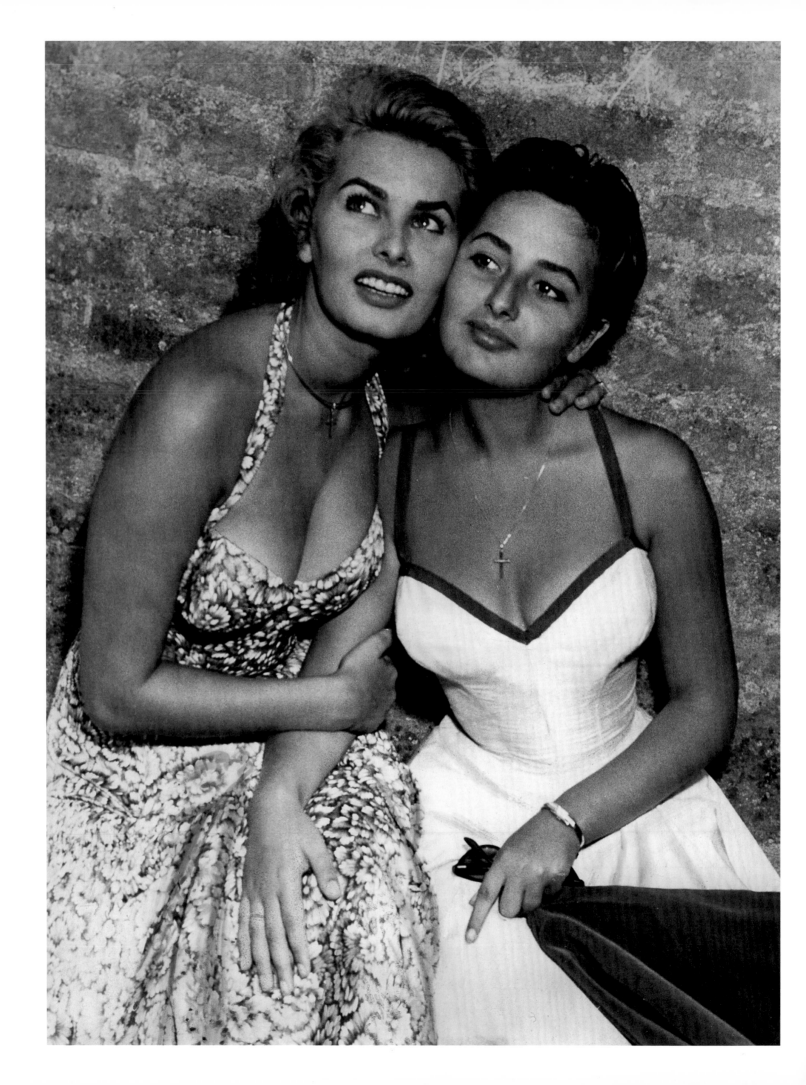

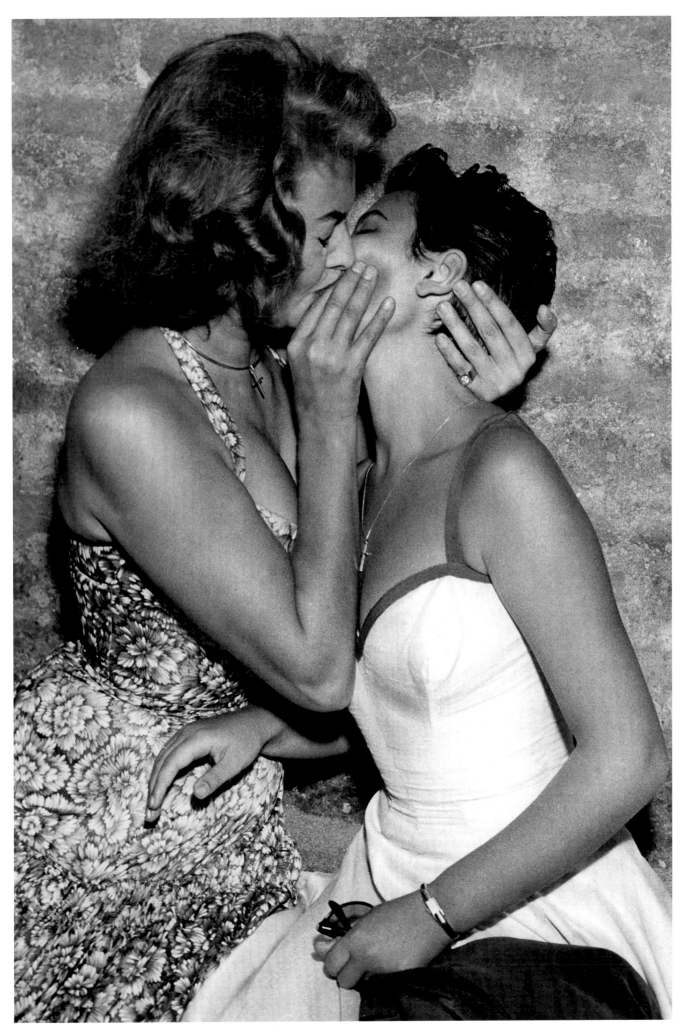

1955 / Sophia Loren and her sister, Maria Scicolone, pose for photographers and offer them a (false) cinema kiss.

25

"I like being vulnerable. It makes me feel good... sometimes even weak, but in a good way."

Sophia Loren

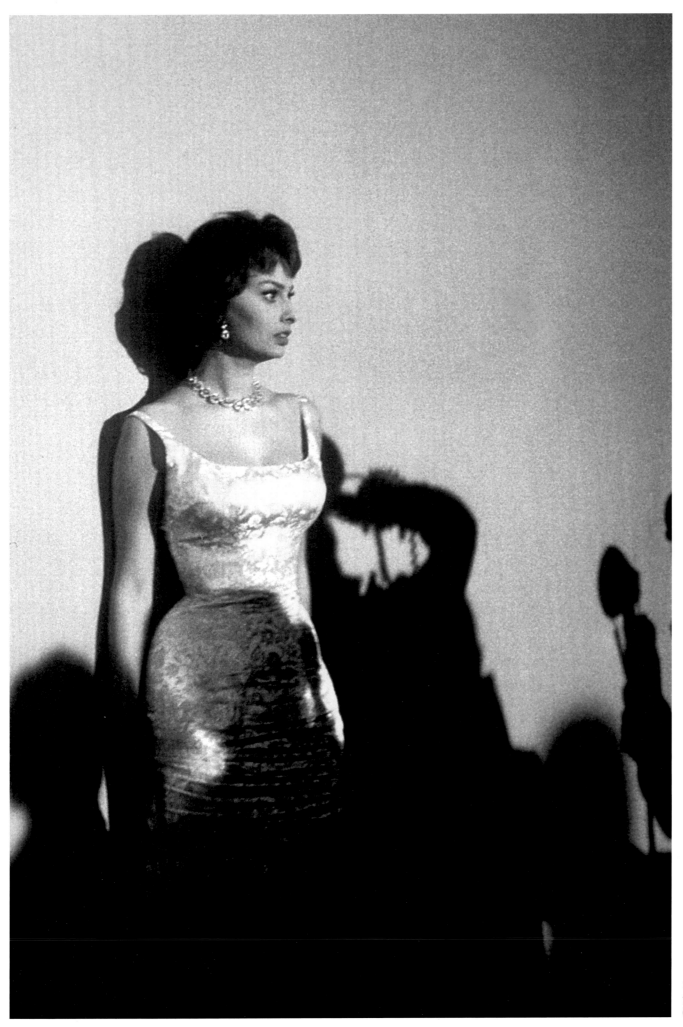

1958 / Sophia Loren attracts the cameras during the 30th Oscar ceremony.

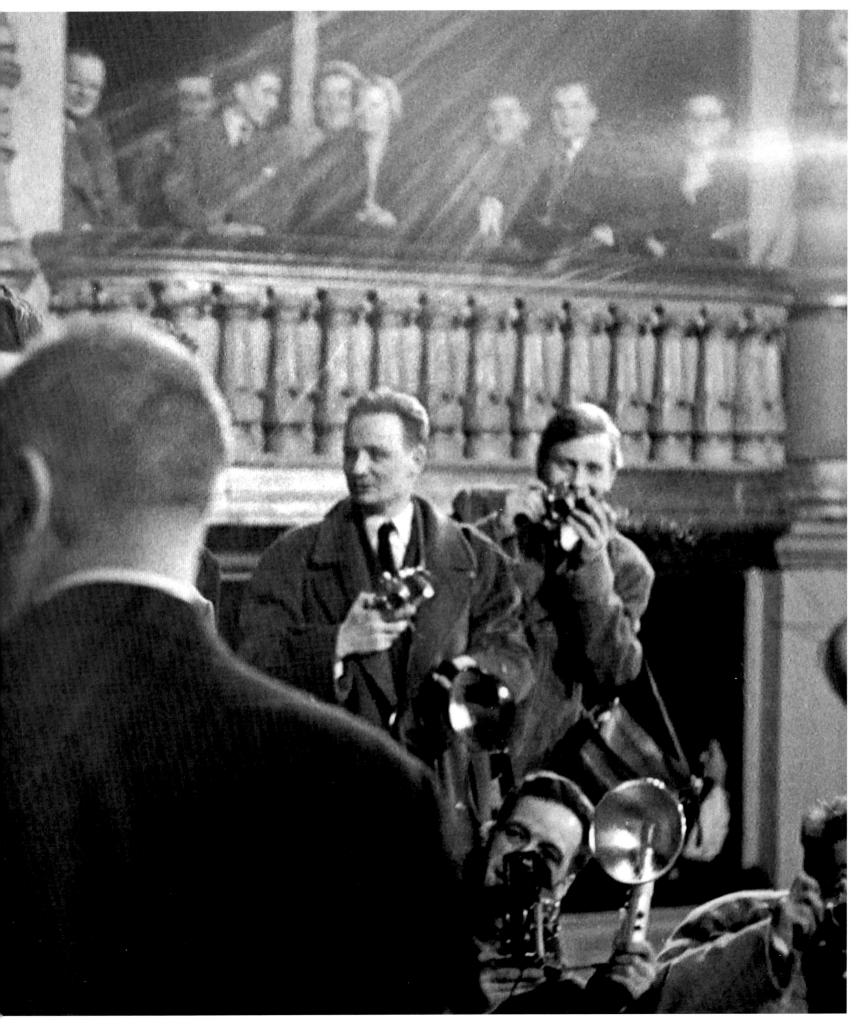

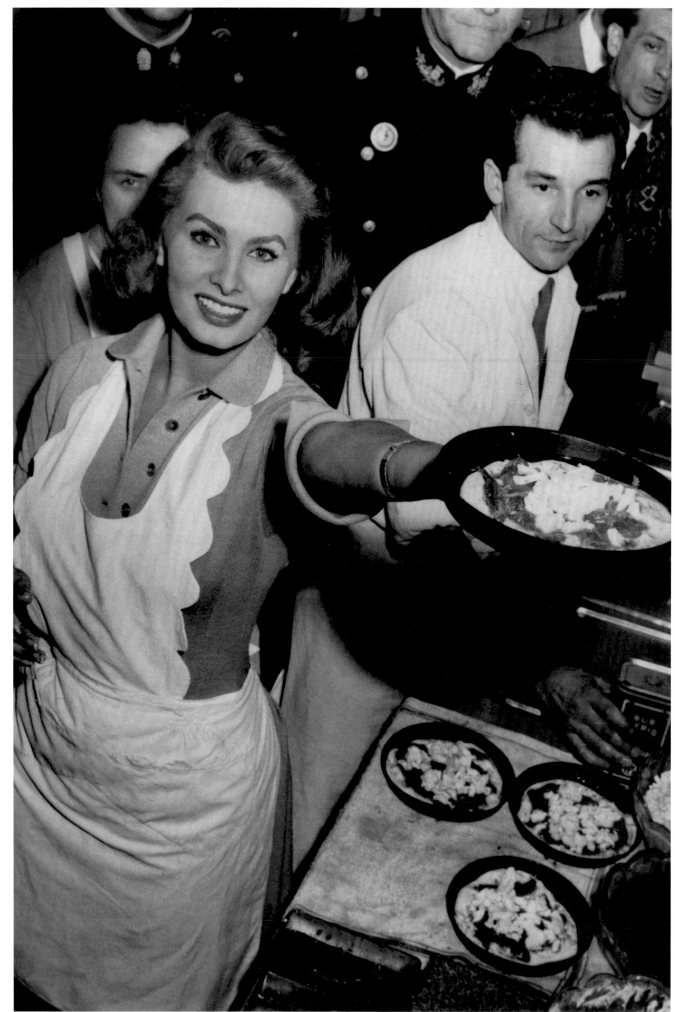

Previous pages:
1956 / Sophia Loren at a concert by the Spanish singer Gleam Mariano in a Paris theatre.

1954 / During a reception in a famous Milanese patisserie, Sophia Loren prepares some Neapolitan specialities.

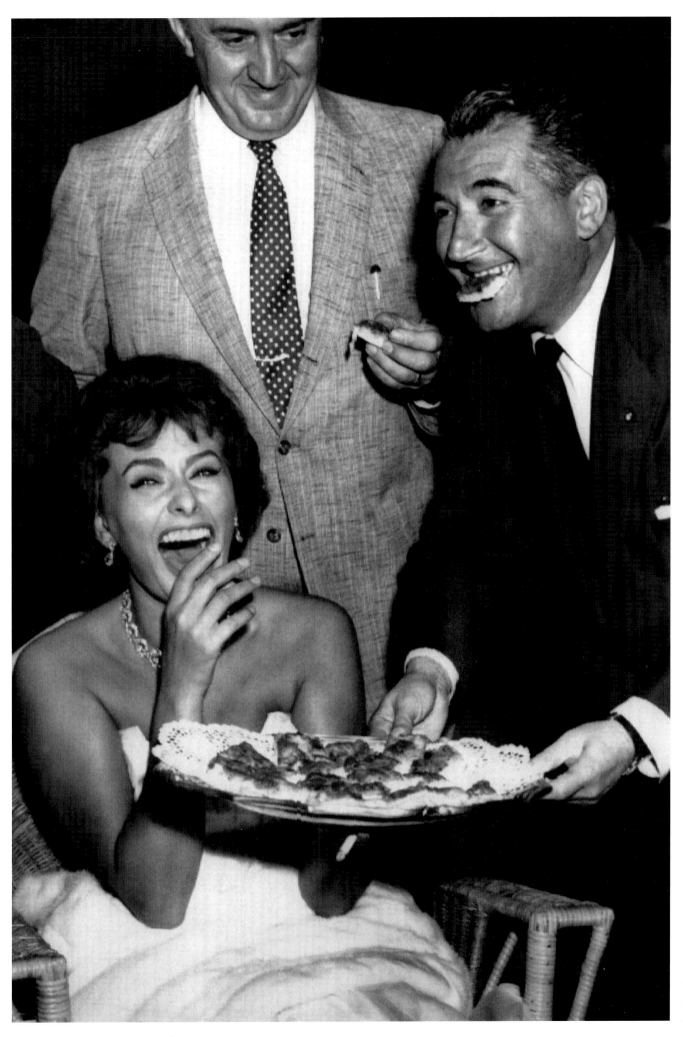

1957 / Sophia Loren, Walter Baring and Peter Rodino at a reception given by the Italian Ambassador in Washington.

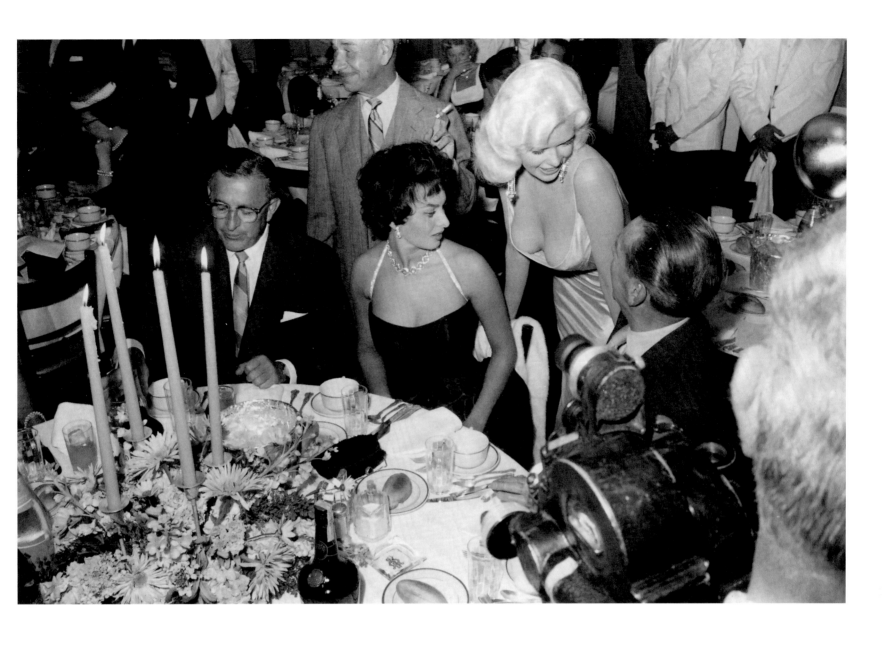

1957 / Already an Italian film icon, Sophia Loren made her first foray into the USA by signing a four-film contract with Paramount. The powerful studio organized a cocktail party to welcome her to Hollywood, where she met all the stars, including Jayne Mansfield.

"Everything you see I owe to spaghetti."

Sophia Loren

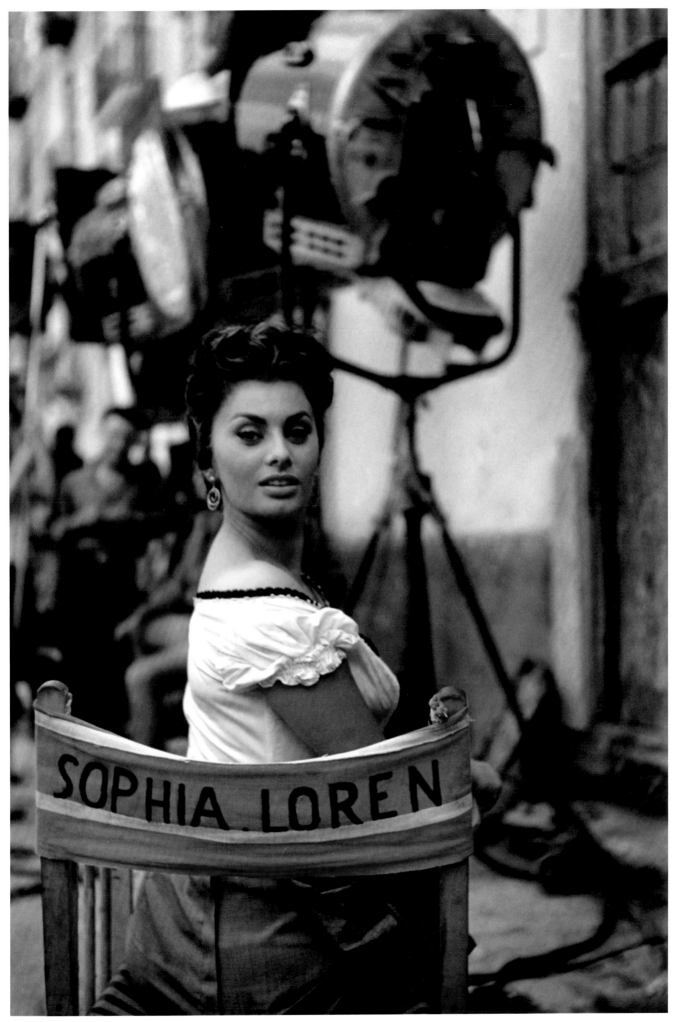

1955 / Photograph of Sophia Loren taken in Rome. She was 21 at the time.

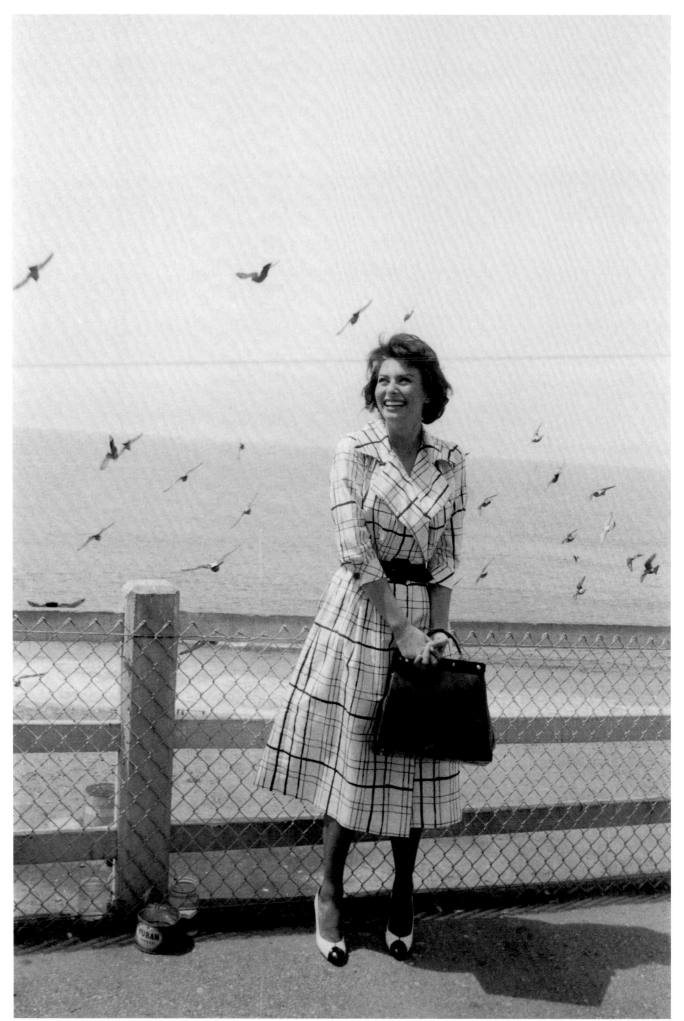

1957 / Sophia Loren takes
a few days off in California
after shooting
Desire Under the Elms.

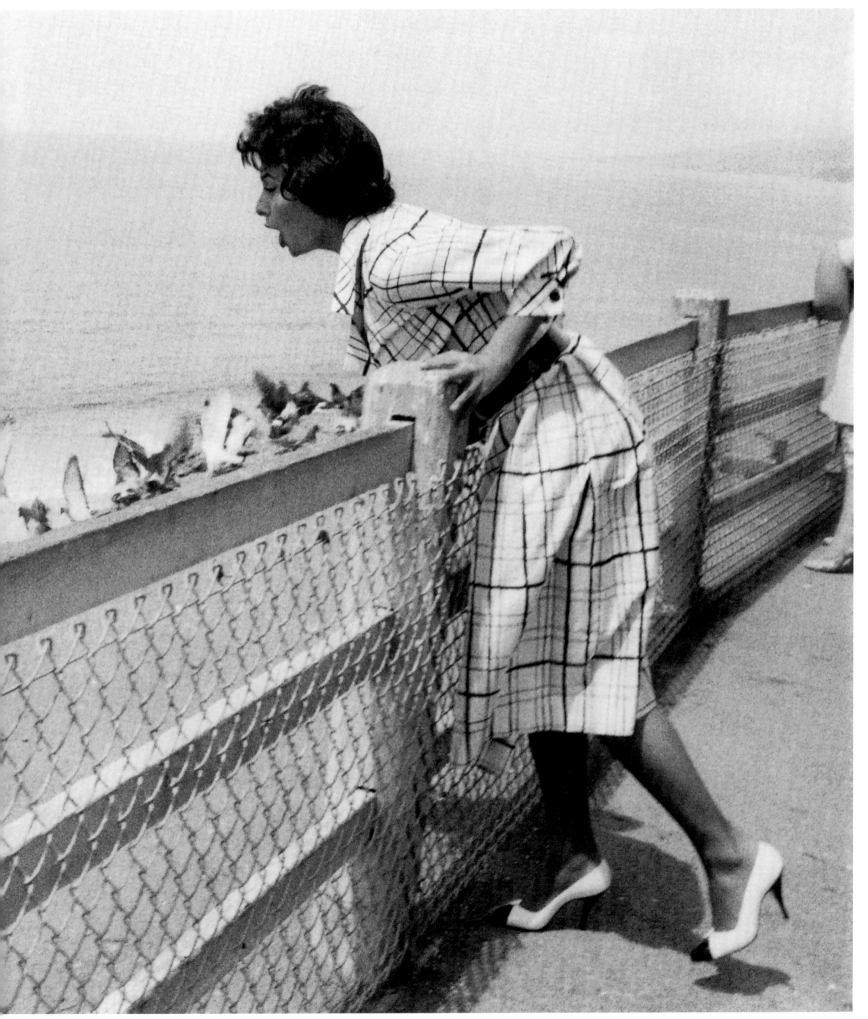

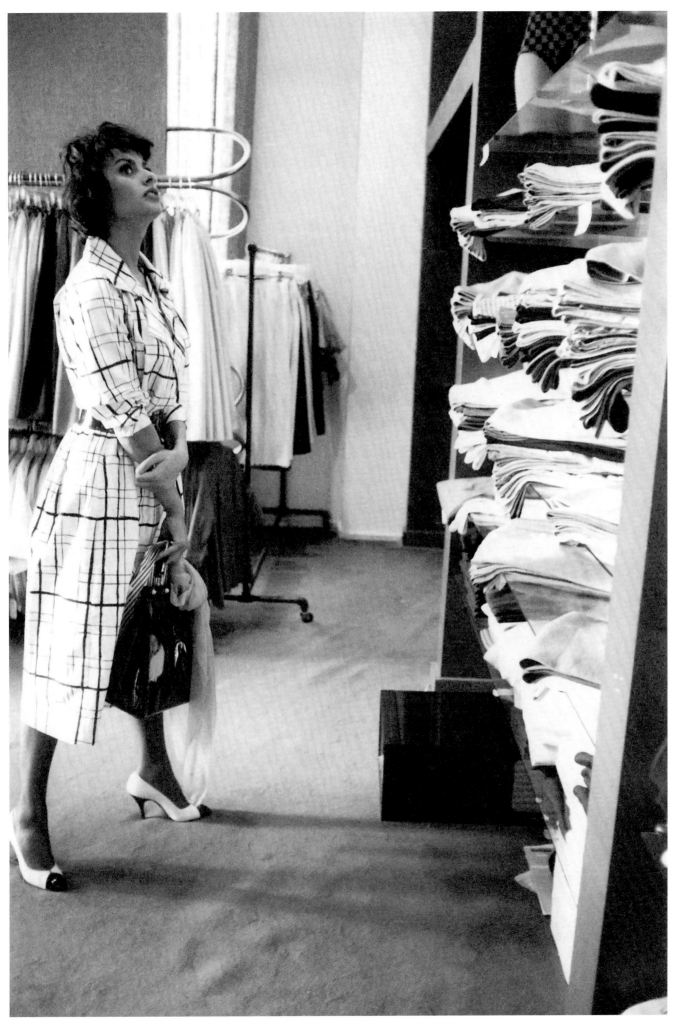

Previous pages :
1957 / Sophia Loren takes
a few days off in California.

1957 / Sophia Loren shopping
in Los Angeles.

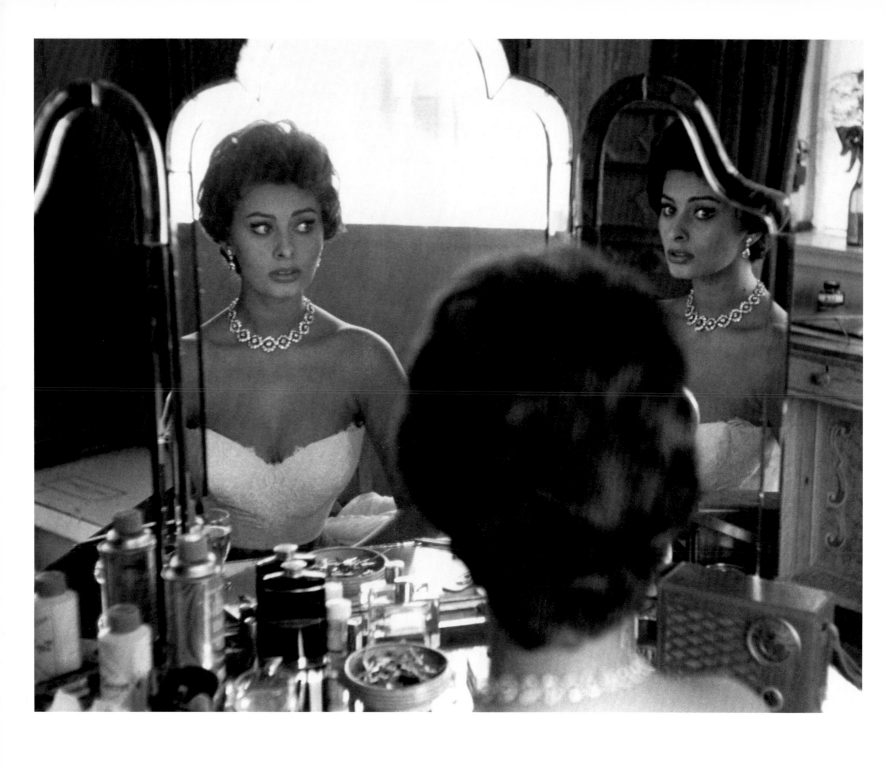

1957 / At the age of 23, Sophia Loren already had the assurance and allure of a star. She had made nearly 40 films and the following year would win international recognition at the Venice Film Festival, where she received the Best Actress Award for her role in *The Black Orchid*.

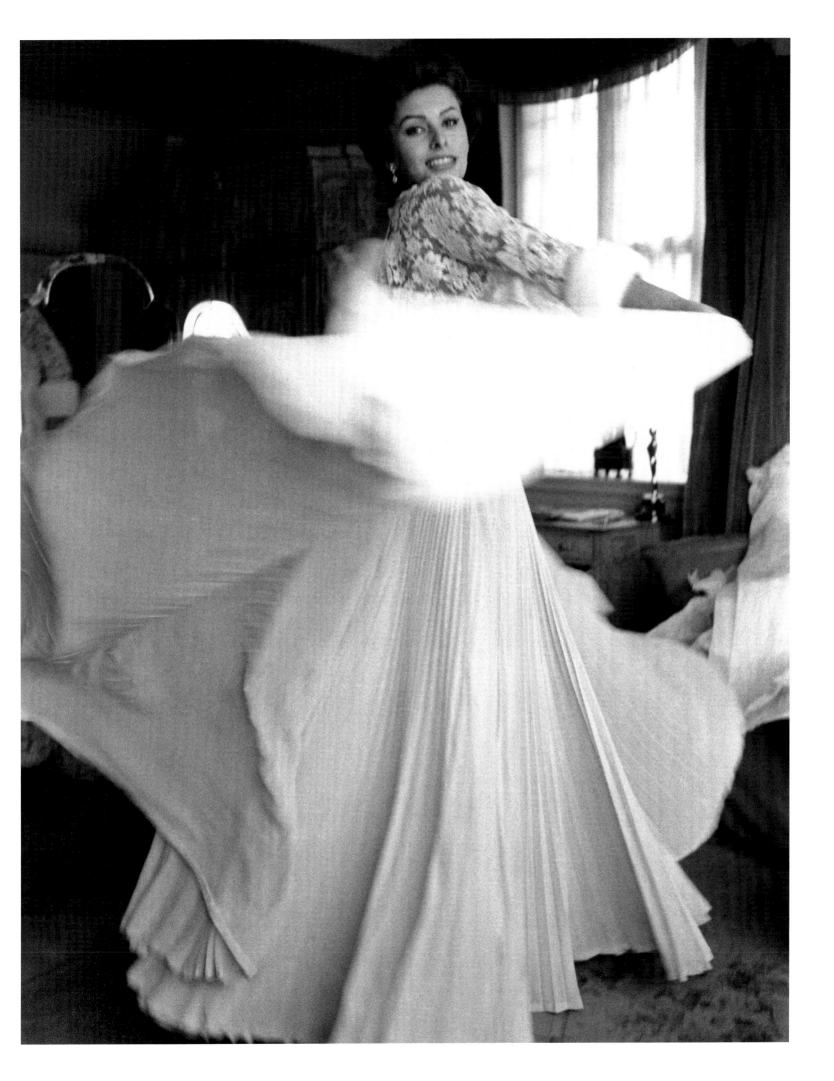

"If you haven't cried, your eyes can't be beautiful."

Sophia Loren

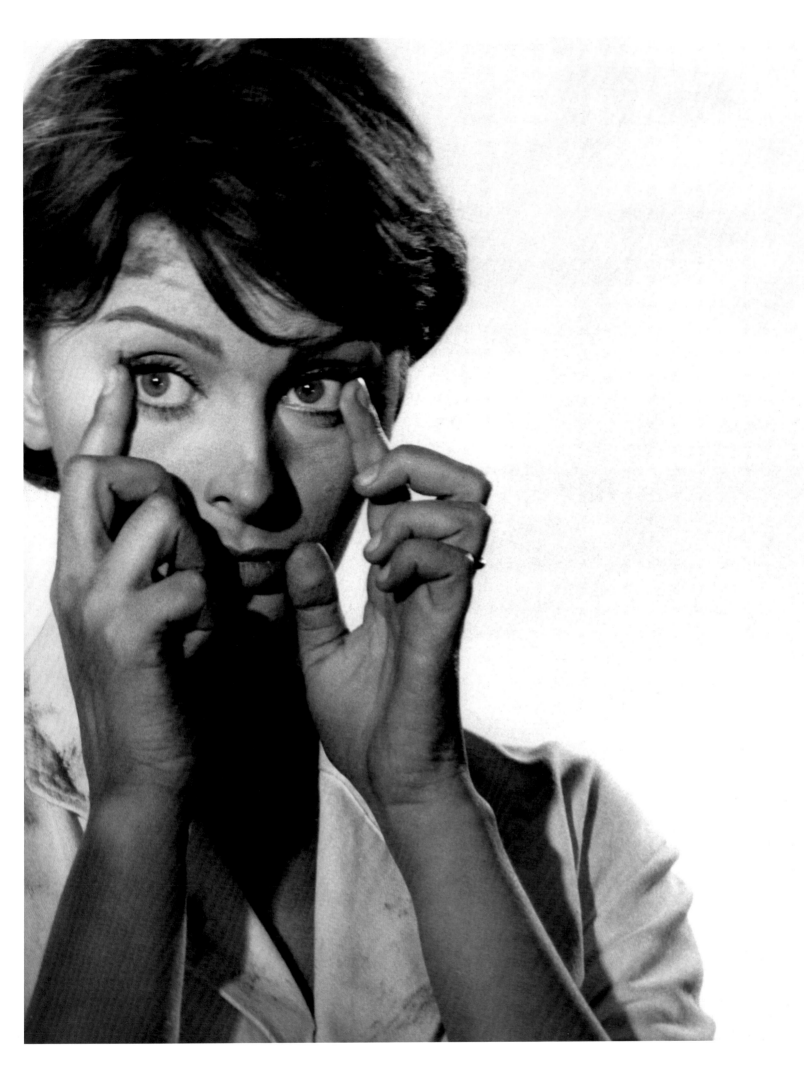

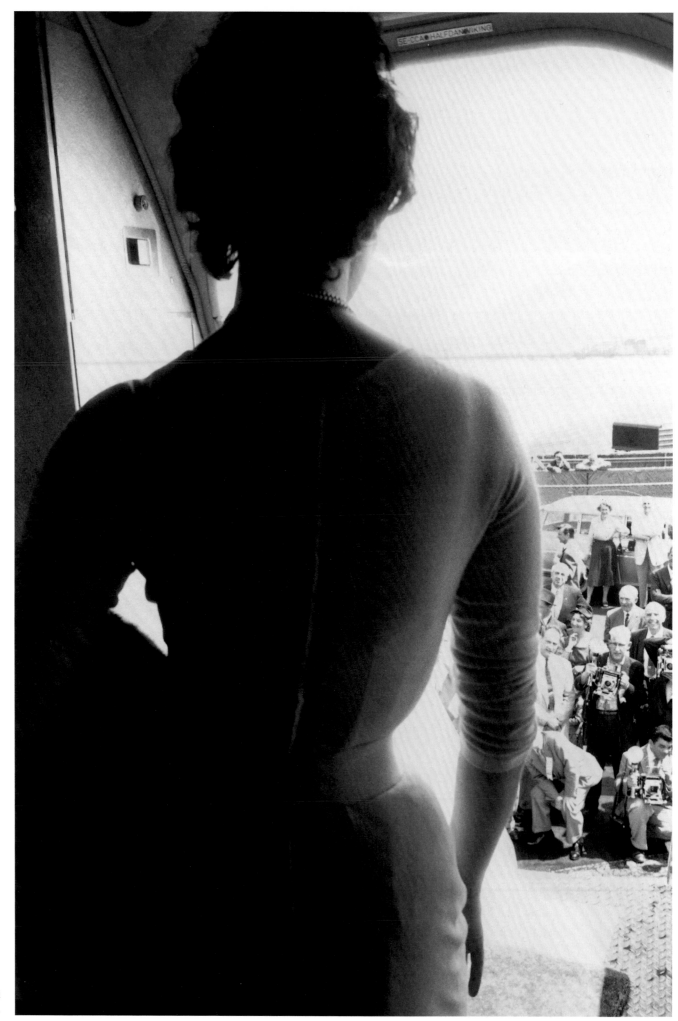

1957 / Sophia Loren arrives in
Los Angeles.

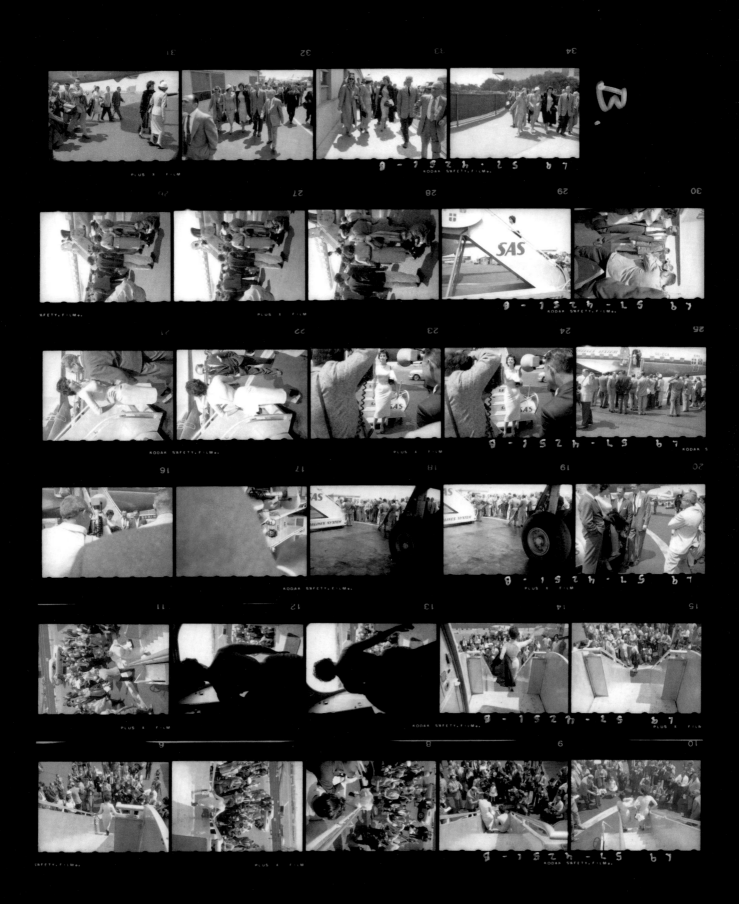

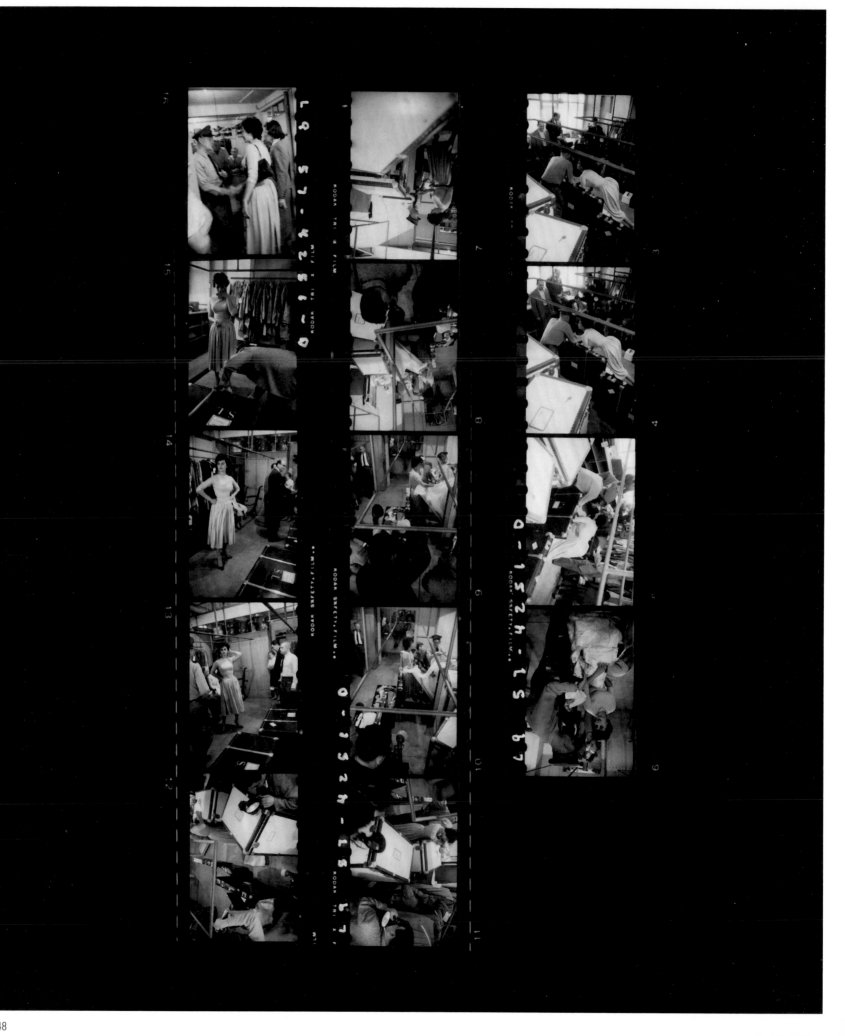

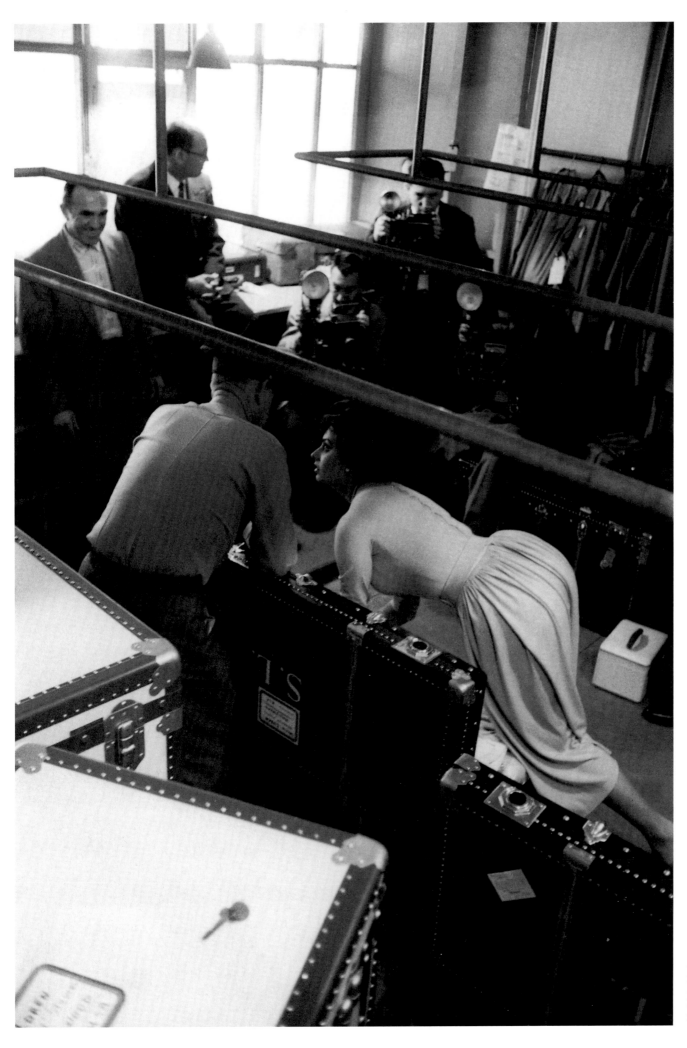

1957 / At airport customs, surrounded by her luggage, marked 'SL', Sophia Loren plays to the numerous photographers who have come to greet her.

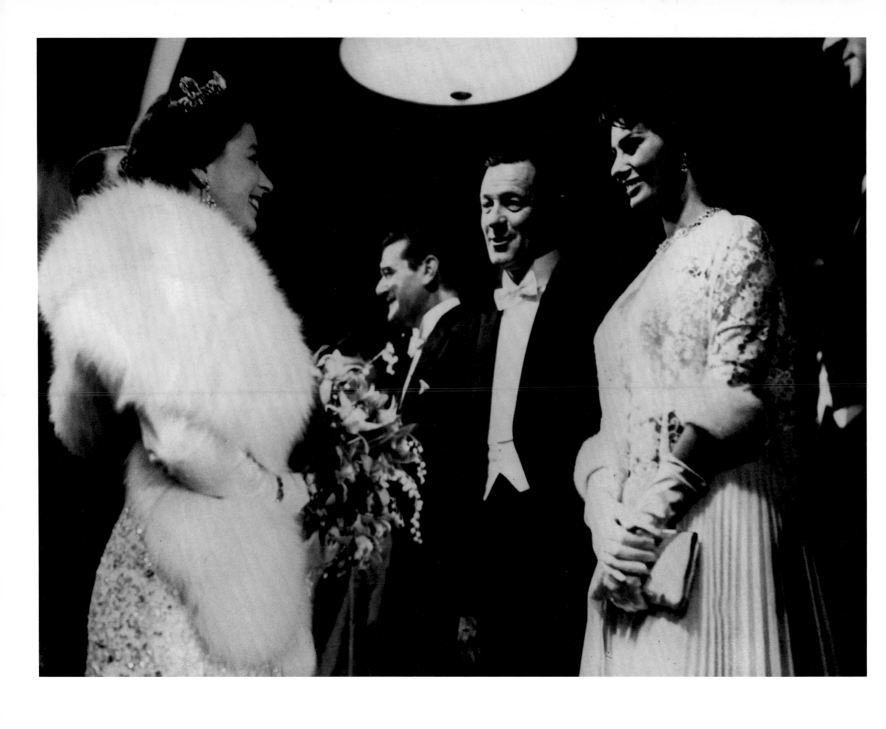

1957 / While filming *The Key* in London Sophia Loren and William Holden were received by the Queen at a reception in Buckingham Palace.

1966 / When filming *Arabesque* in England Sophia Loren took the opportunity to visit London, and to pose in front of the Queen's Guard.

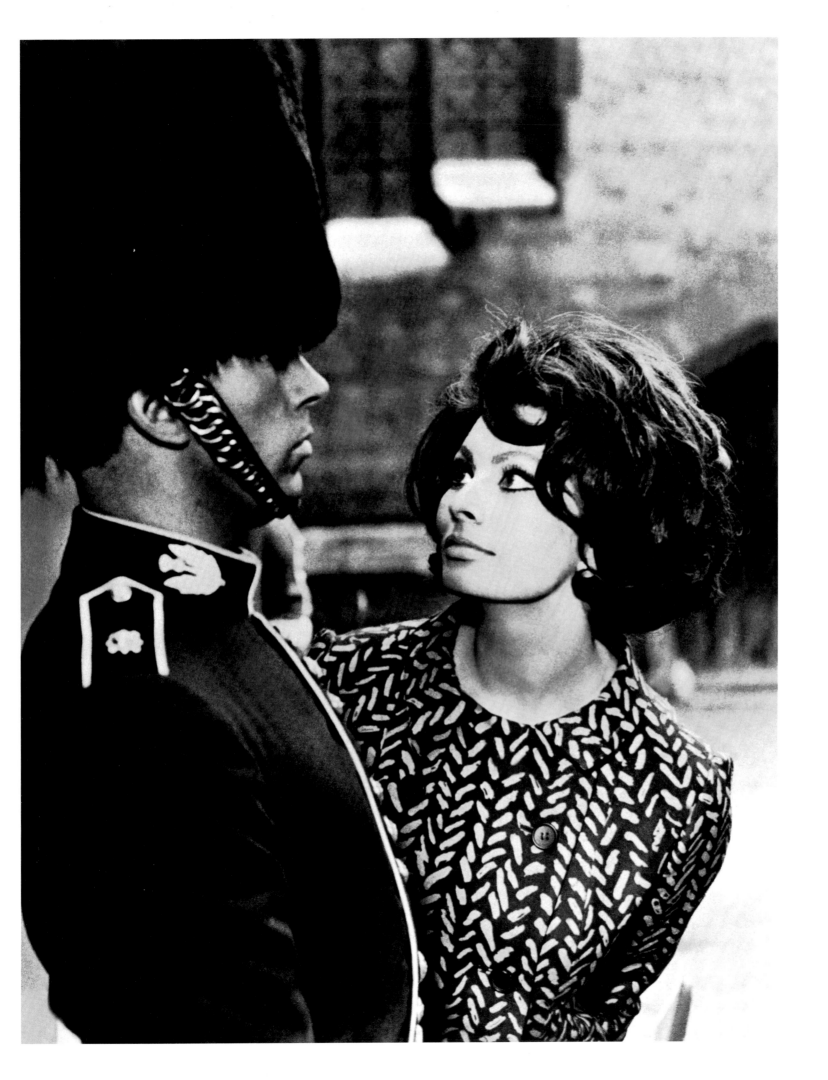

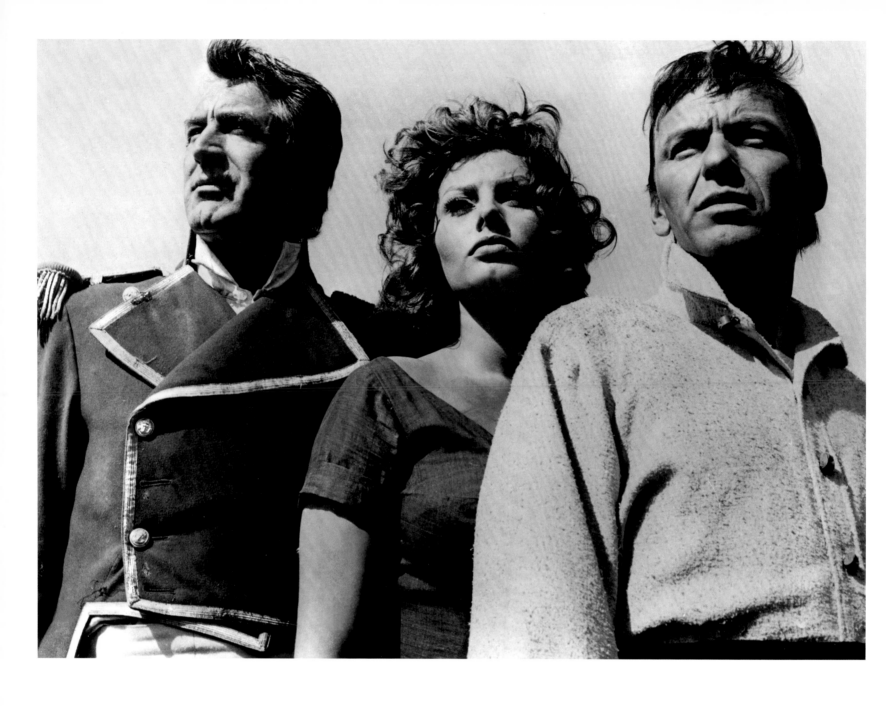

1957 / *The Pride and the Passion,* directed by Stanley Kramer, starred Cary Grant, Sophia Loren and Frank Sinatra.

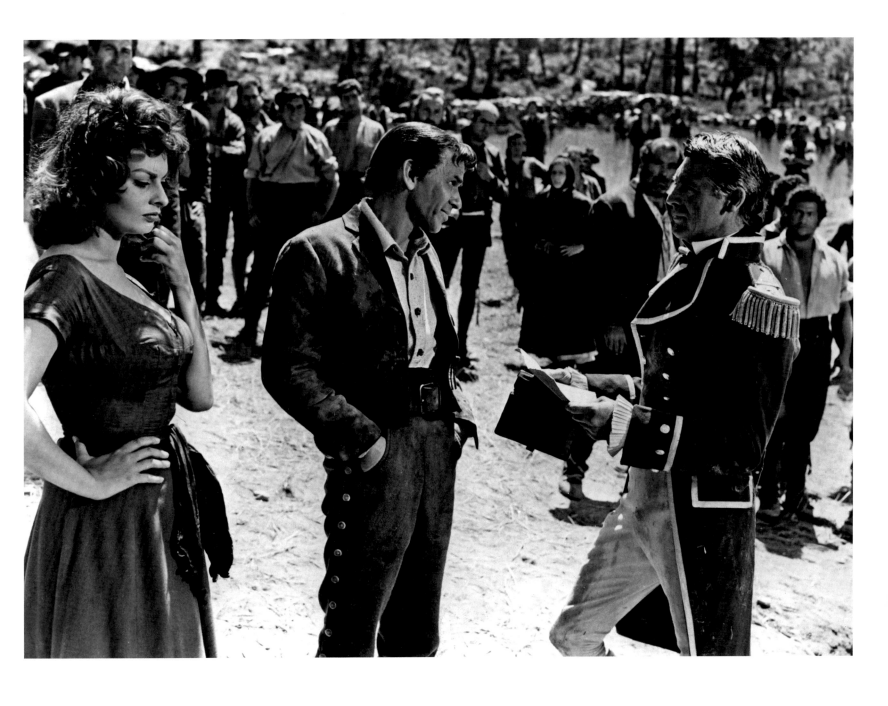

1957 / Stanley Kramer recruited no less than 10,000 extras for the battle scenes in *The Pride and the Passion*. He organized sporting contests to select the 150 supporting actors surrounding the star trio.

"A woman's dress should be like a barbed-wire fence: serving its purpose without obstructing the view."

Sophia Loren

Previous pages :
1957 / Cary Grant and Sophia Loren give a press conference to launch Stanley Kramer's *The Pride and the Passion*.

1957 / Taken on the set of Henry Hathaway's *Legend of the Lost*.

56

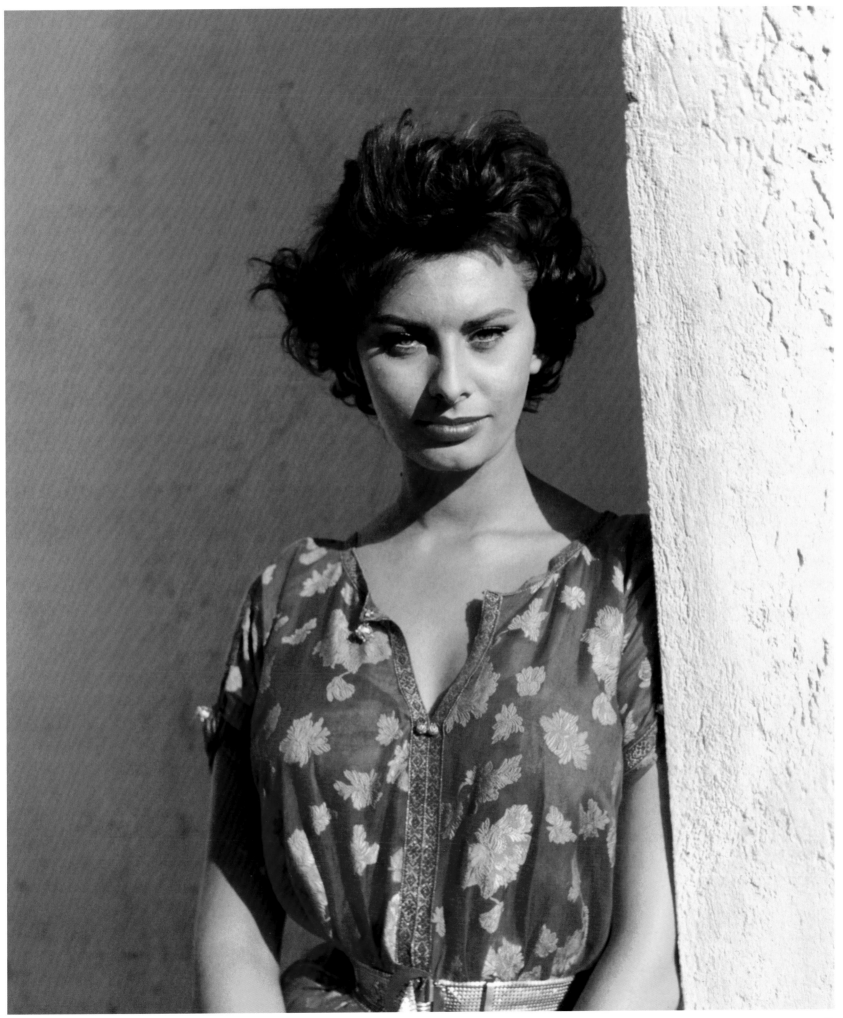

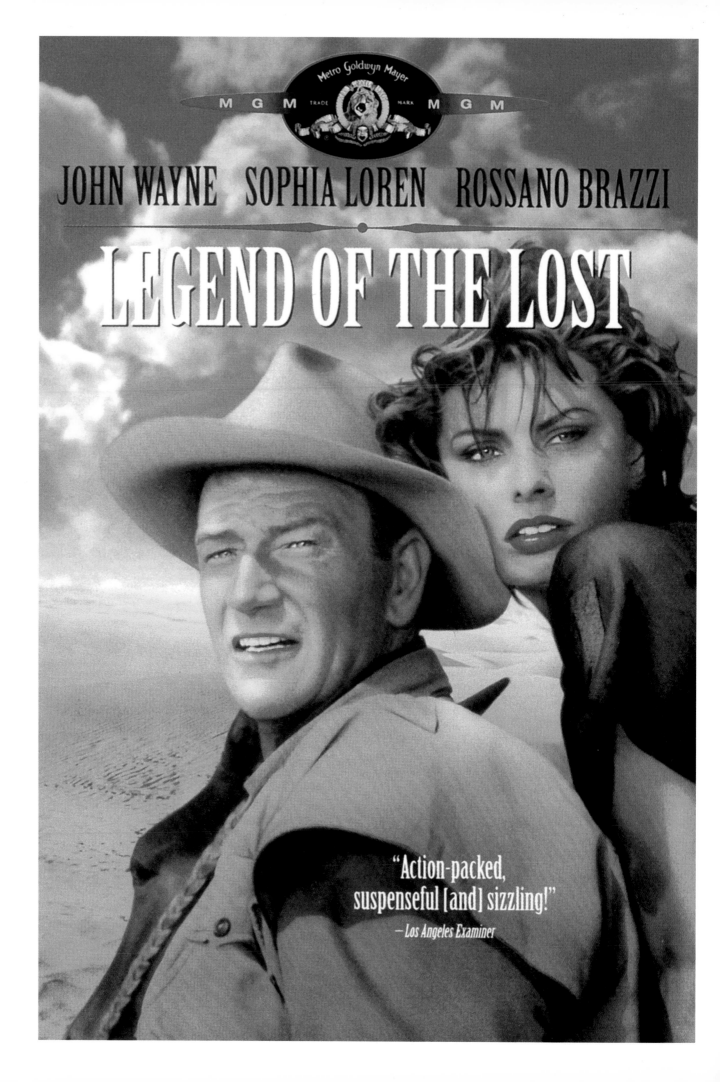

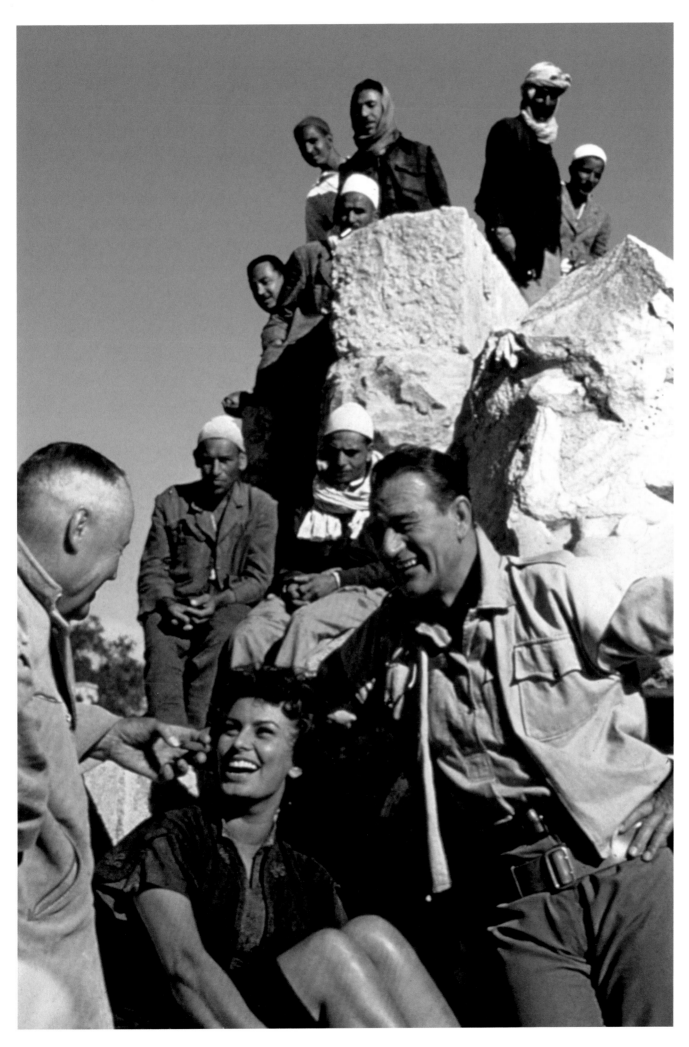

1957 / Sophia Loren and John Wayne co-star in *Legend of the Lost* by Henry Hathaway.

1957 / Most of *Legend of the Lost* was filmed at Ghadames, in the Libyan desert. The few interior scenes were shot at Cinecittà.

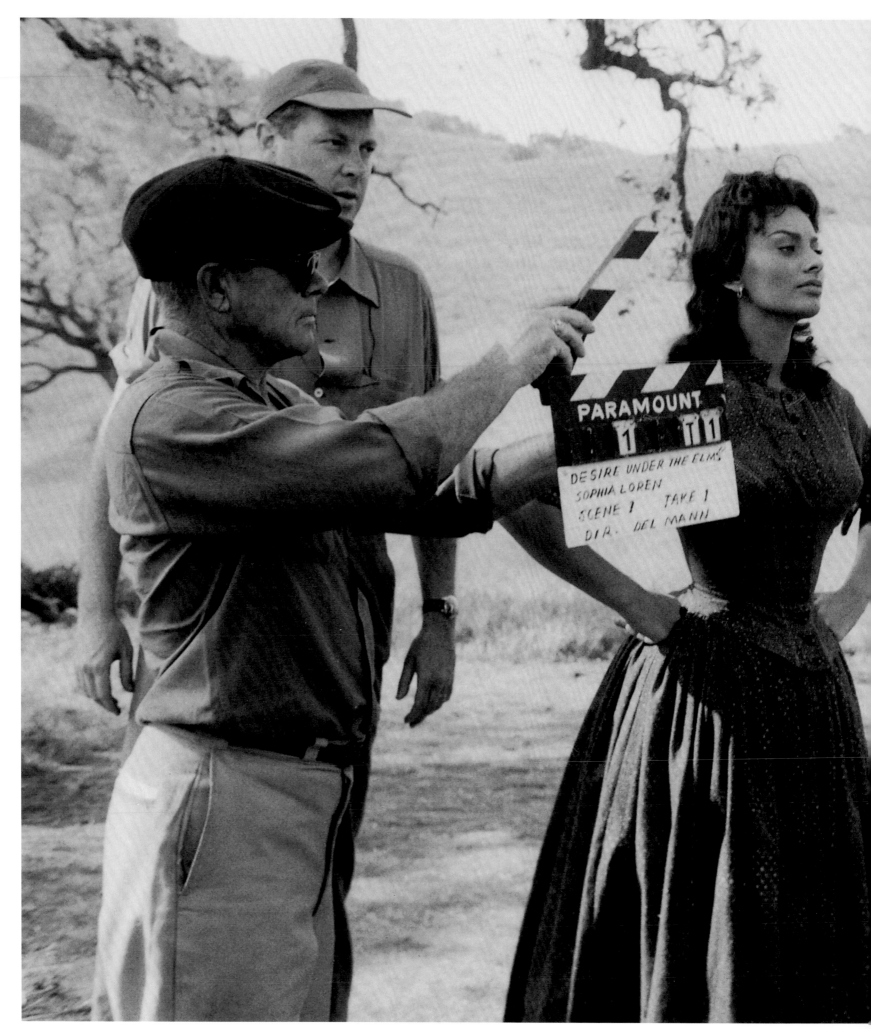

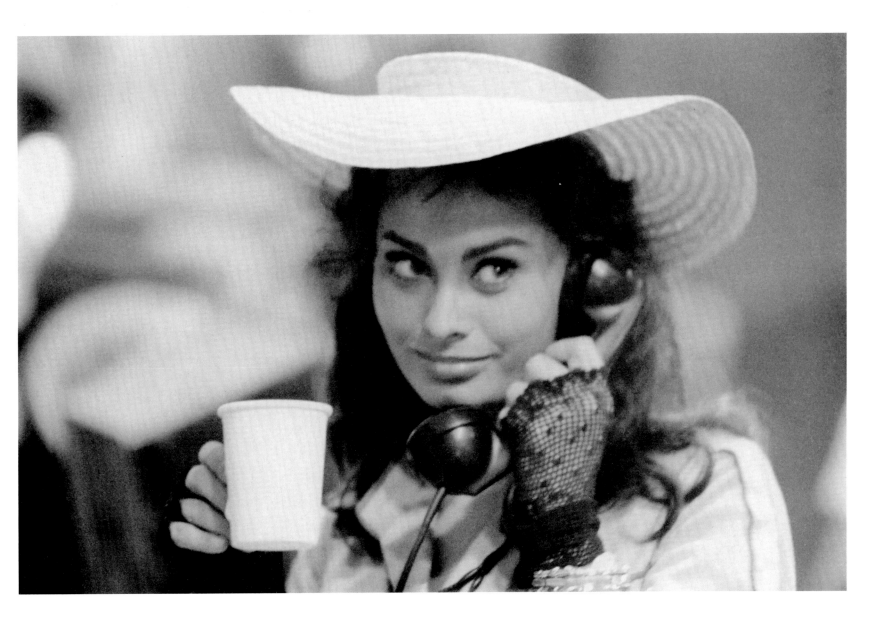

Previous pages :
1957 / Shooting *Desire Under the Elms*, directed by Delbert Mann.

1957 / Adapted from the book of the same name by Nobel Prize winner, Eugene O'Neill, *Desire Under the Elms* provided Sophia Loren with her first important dramatic role.

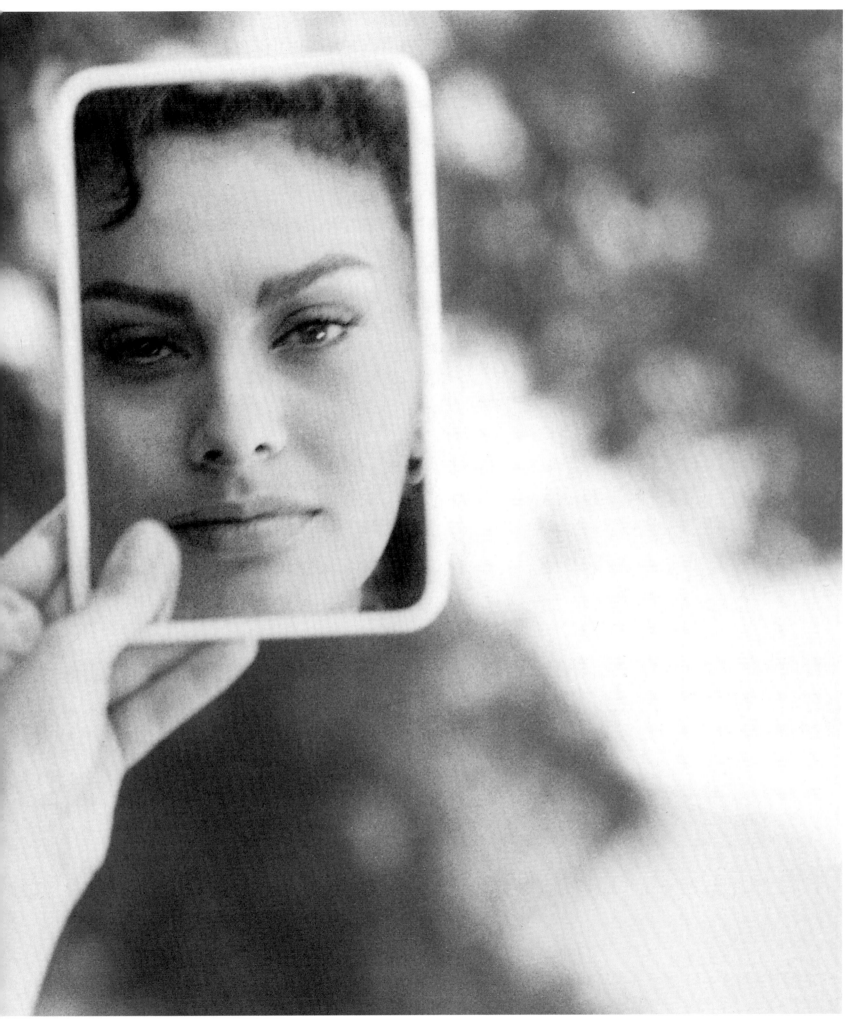

"A gentleman is someone who is able to describe Sophia Loren without using his hands."

Michel Audiard, Director

Previous pages :
1957 / Sophia Loren on the set of *Desire Under the Elms*.

1957 / Sophia Loren aged 23.

66

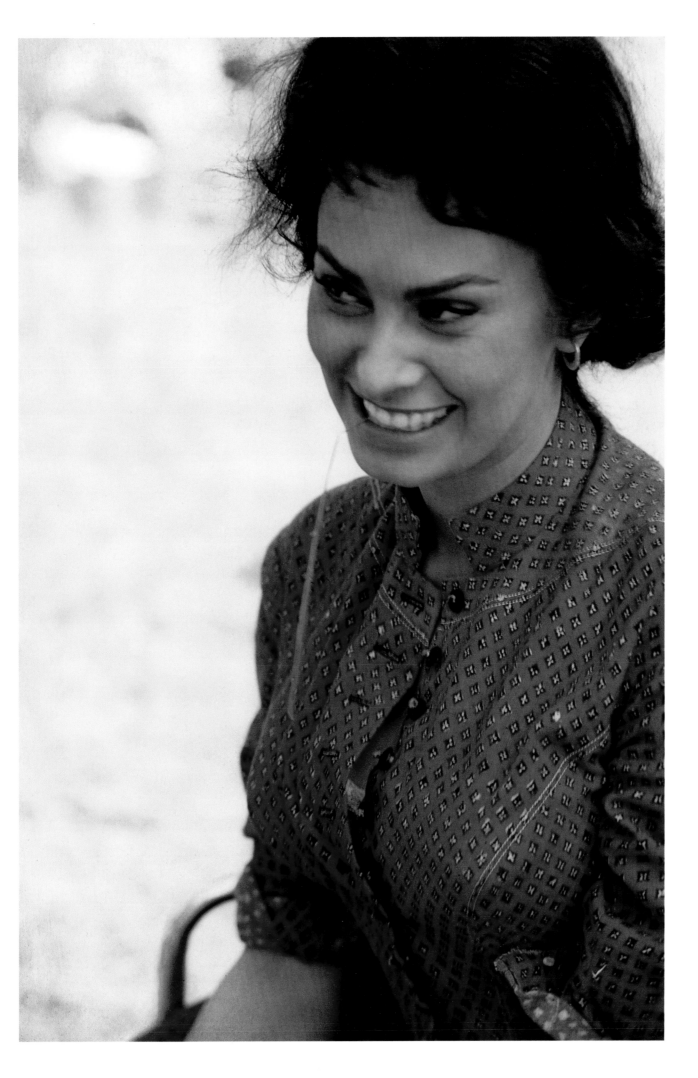

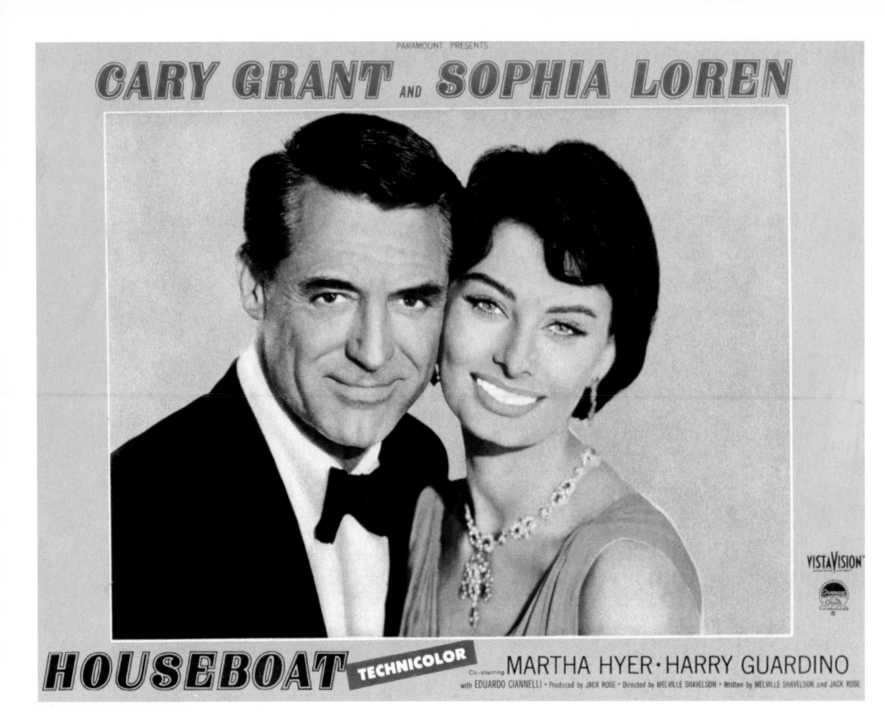

1958 / Poster for Melville Shavelson's *Houseboat*. Sophia Loren teamed up with Cary Grant again, a year after *The Pride and the Passion*.

1958 / While filming *Houseboat*, Cary Grant again proposed to Sophia Loren. Although she was attracted to him, the actress refused to become the fourth Mrs Grant. Carlo Ponti had finally divorced his wife and she was now able to marry him.

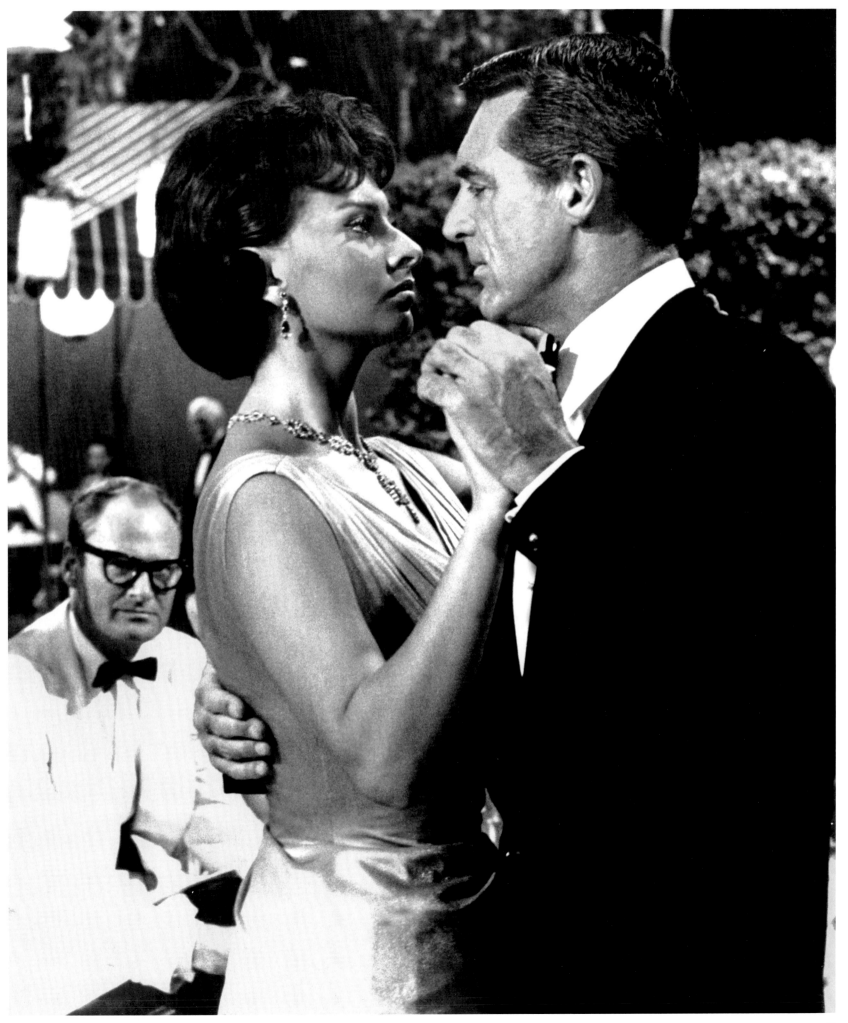

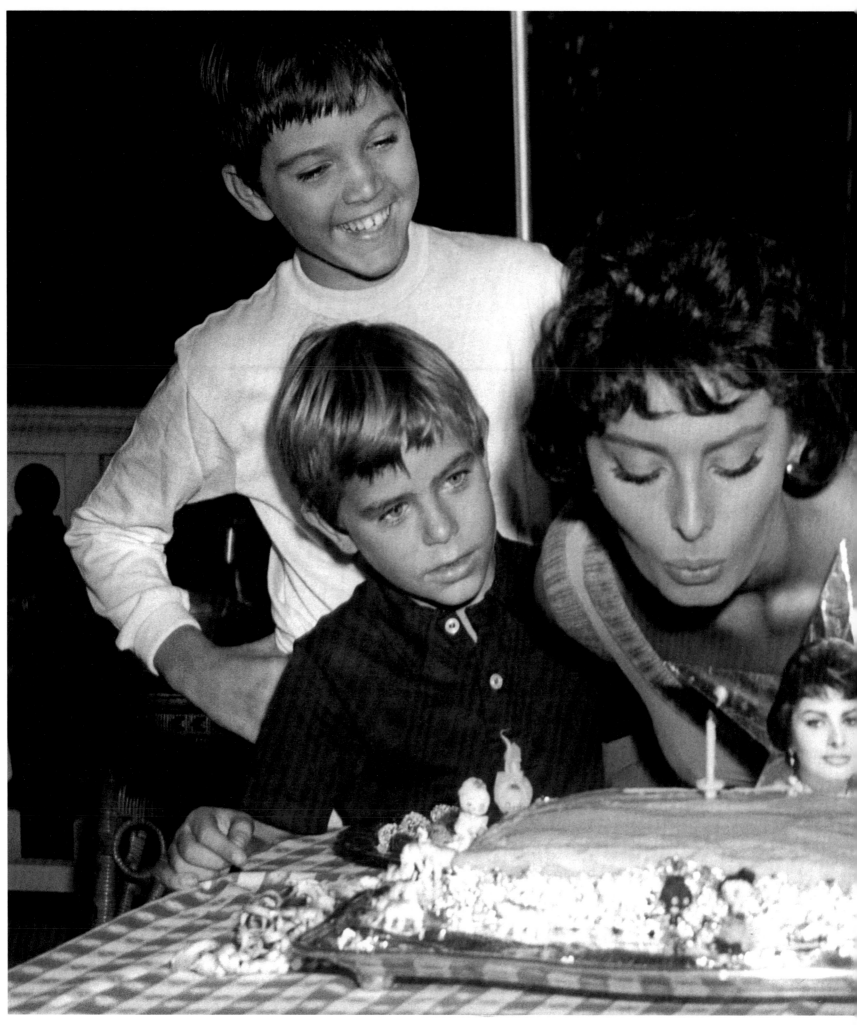

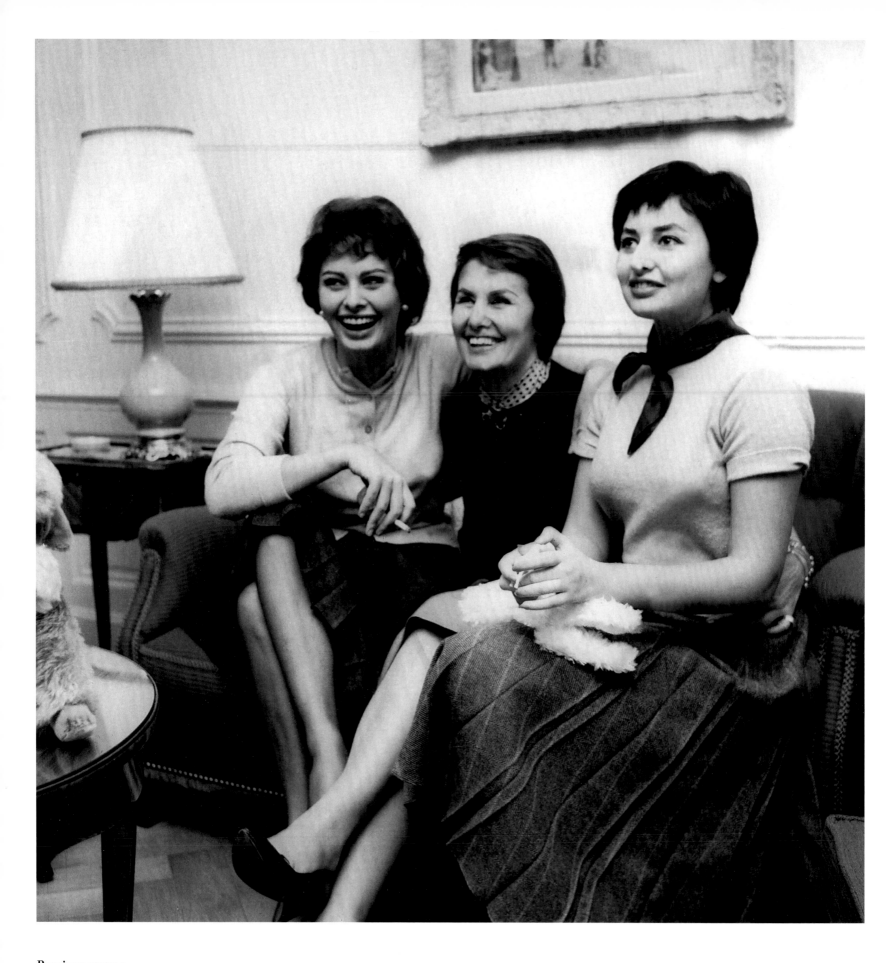

Previous pages :
1958 / On the set of *Houseboat*, Sophia Loren celebrates her birthday surrounded by Paul Petersen, Charles Herbert and Mimi Gibson.

1958 / Sophia Loren with her mother Romilda and her sister Maria, four years her junior.

1963 / Sophia Loren with her sister Maria and her niece, Alessandra Mussolini, daughter of Maria and Romano Mussolini.

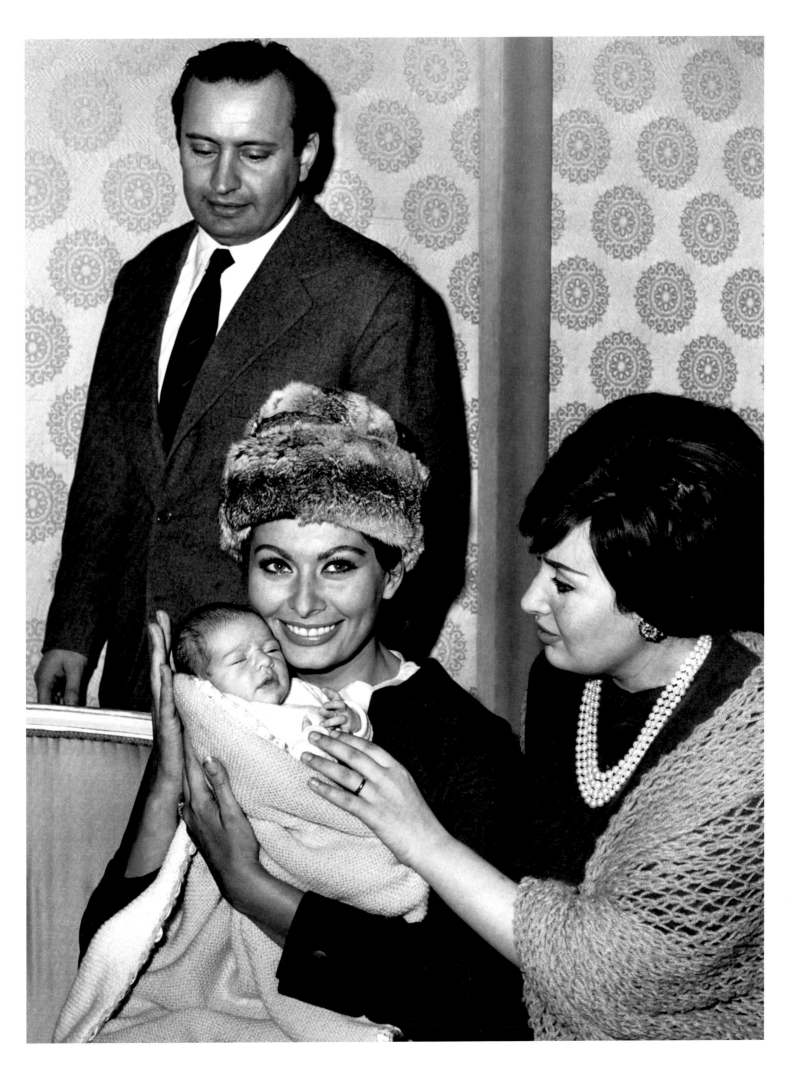

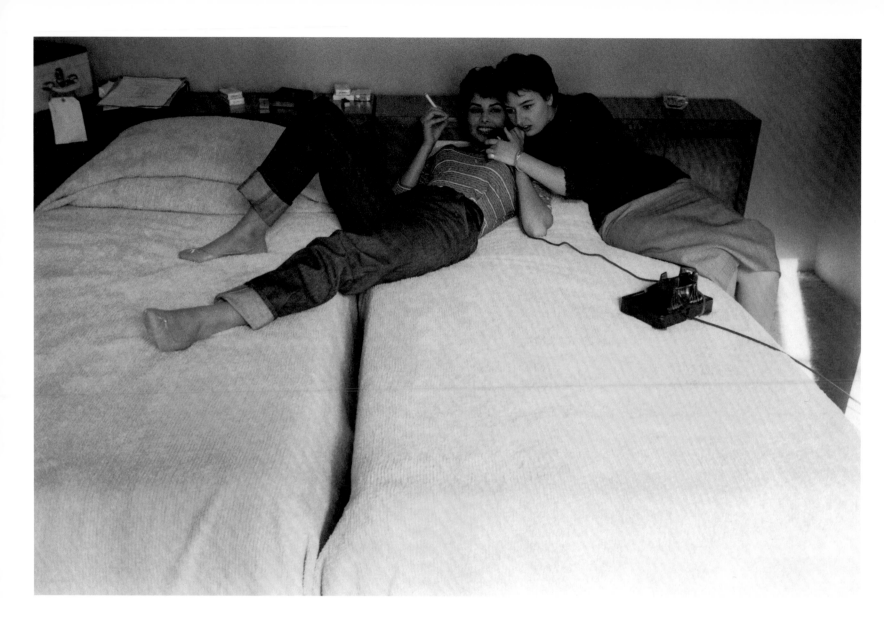

1957 / Sophia Loren and her sister, Maria, enjoying a weekend between two film shoots.

1957 / Sophia Loren relaxes at home.

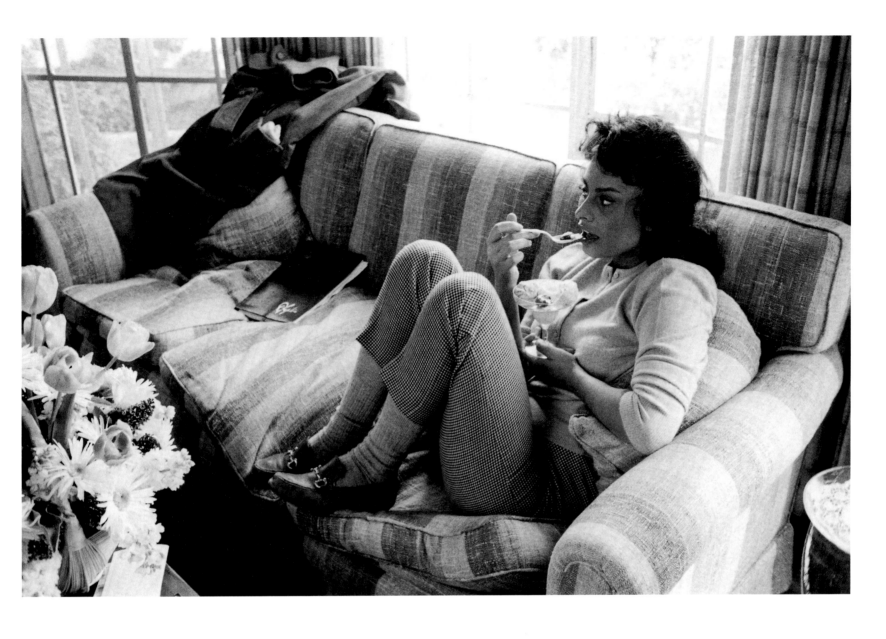

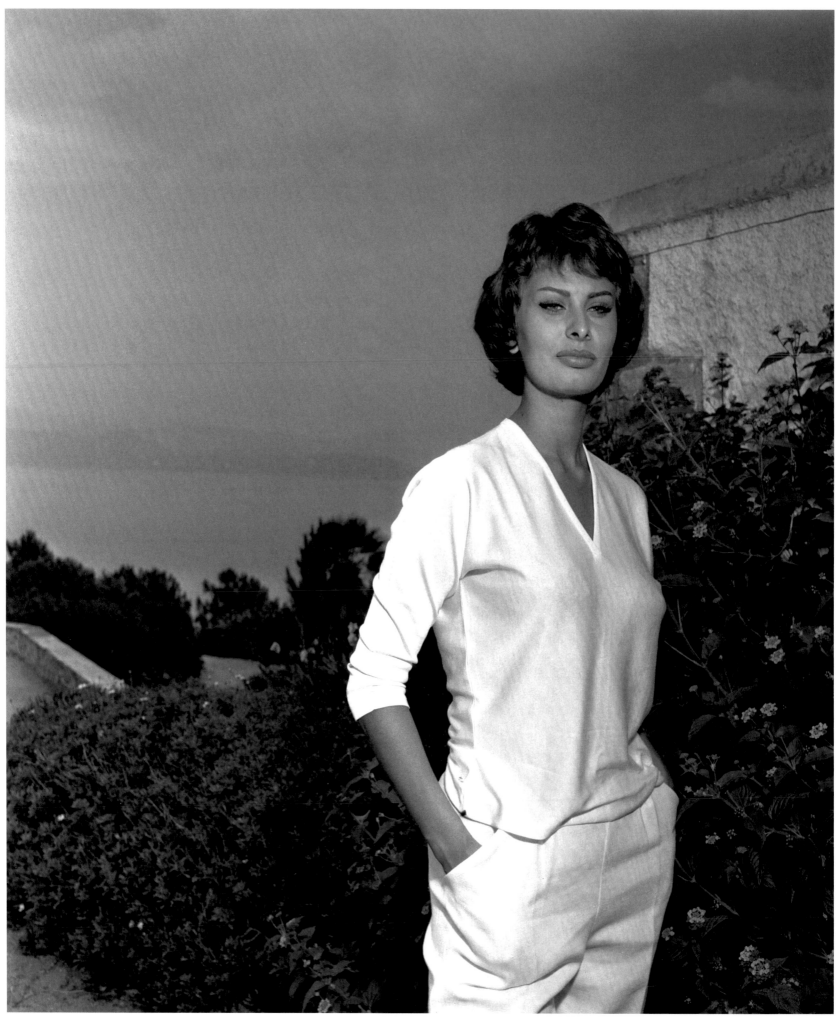

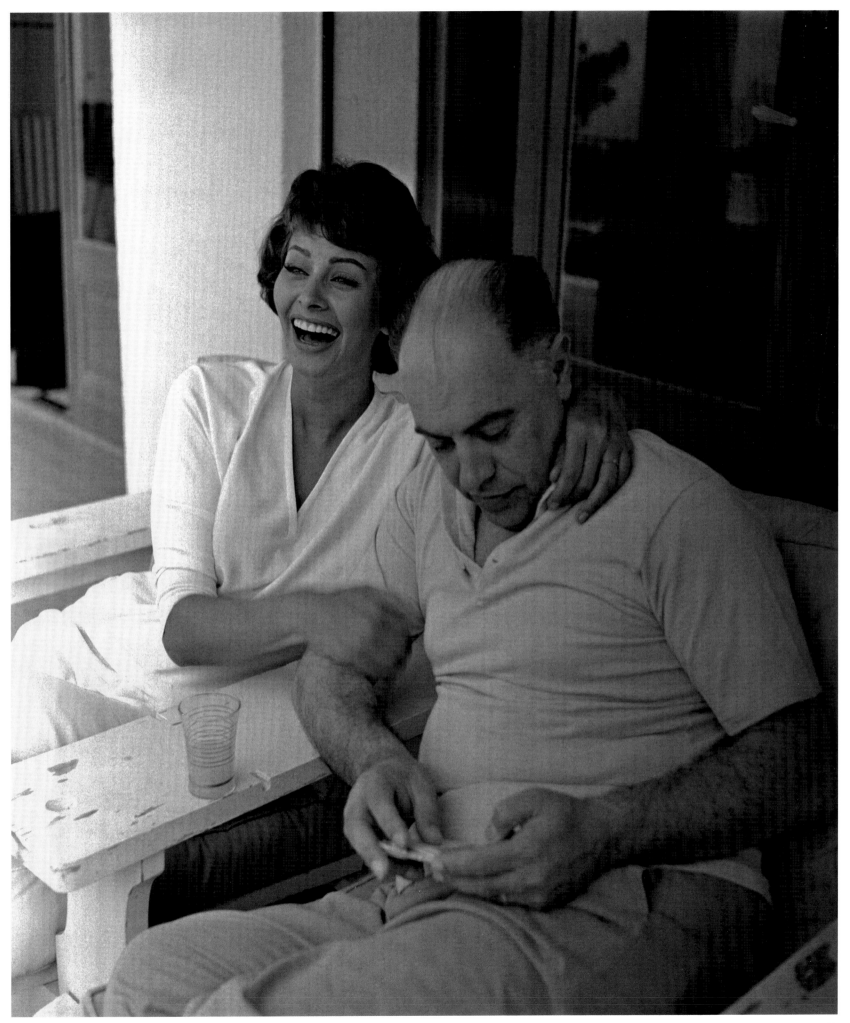

"What mattered to me about the business of acting was not what it brought to me but what it helped me to bring out of myself."

Sophia Loren

Previous pages :
1959 / Sophia Loren and her husband Carlo Ponti spent their holidays at Saint Tropez.

1957 / After moving to Los Angeles, Sophia Loren poses in the pool of her new home.

78

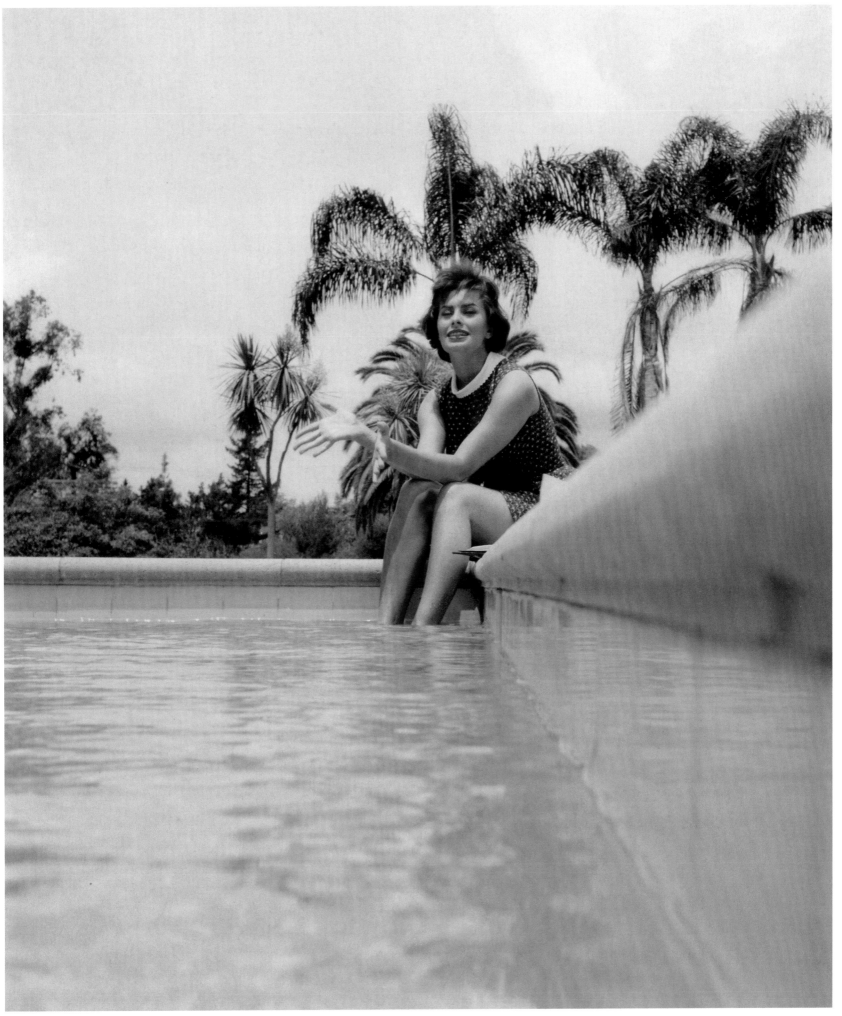

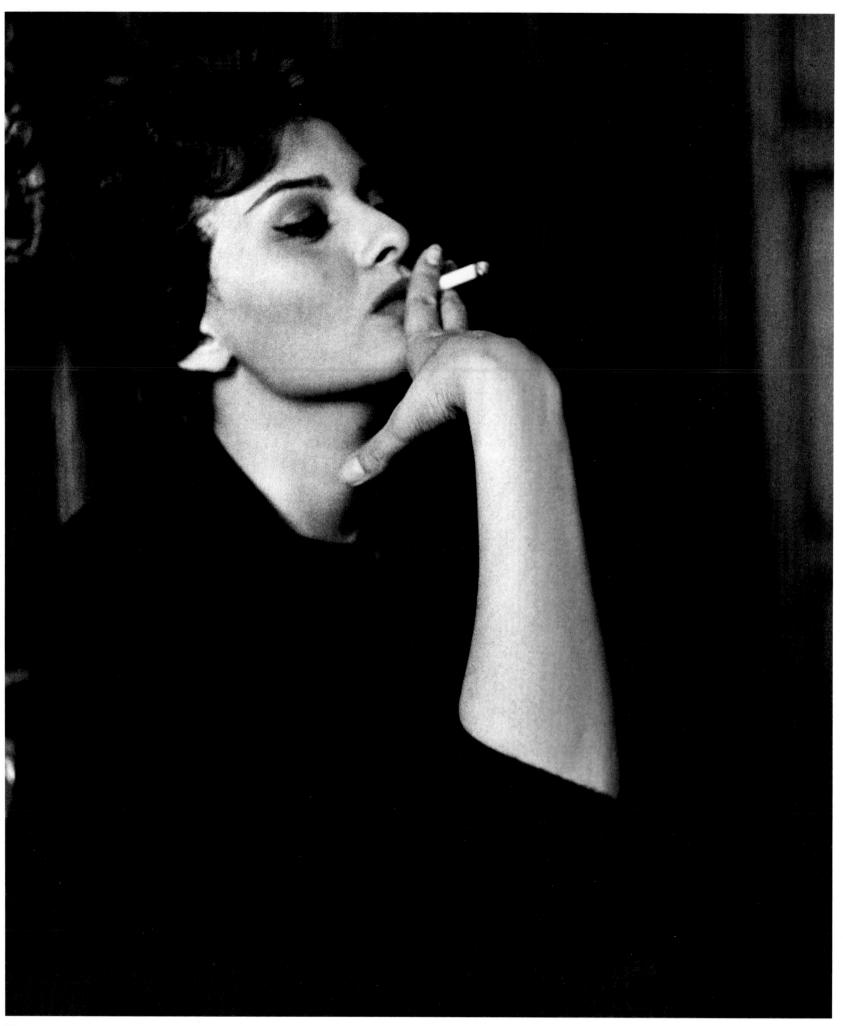

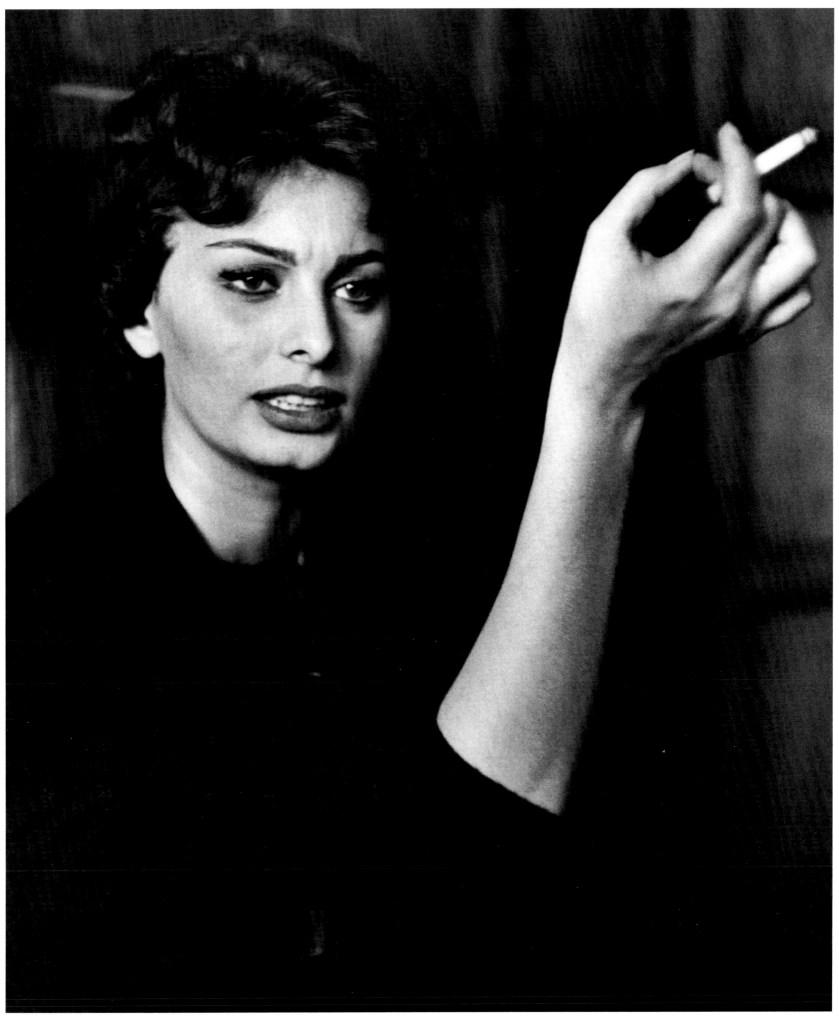

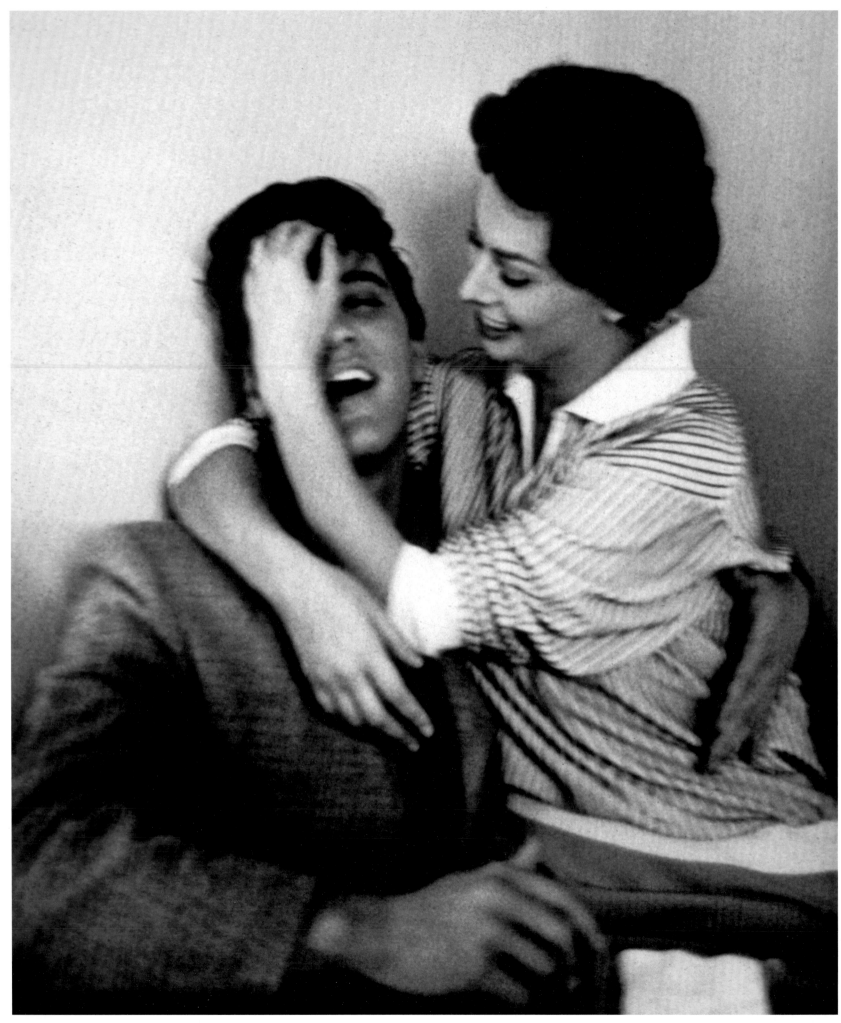

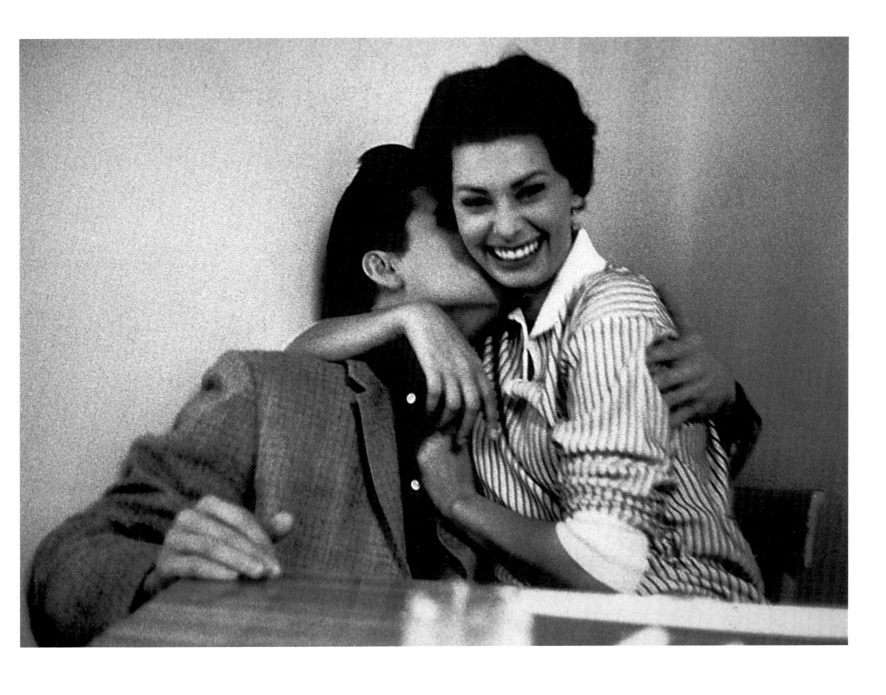

1958 / Elvis Presley and Sophia Loren share a relaxed moment at Paramount Studios.

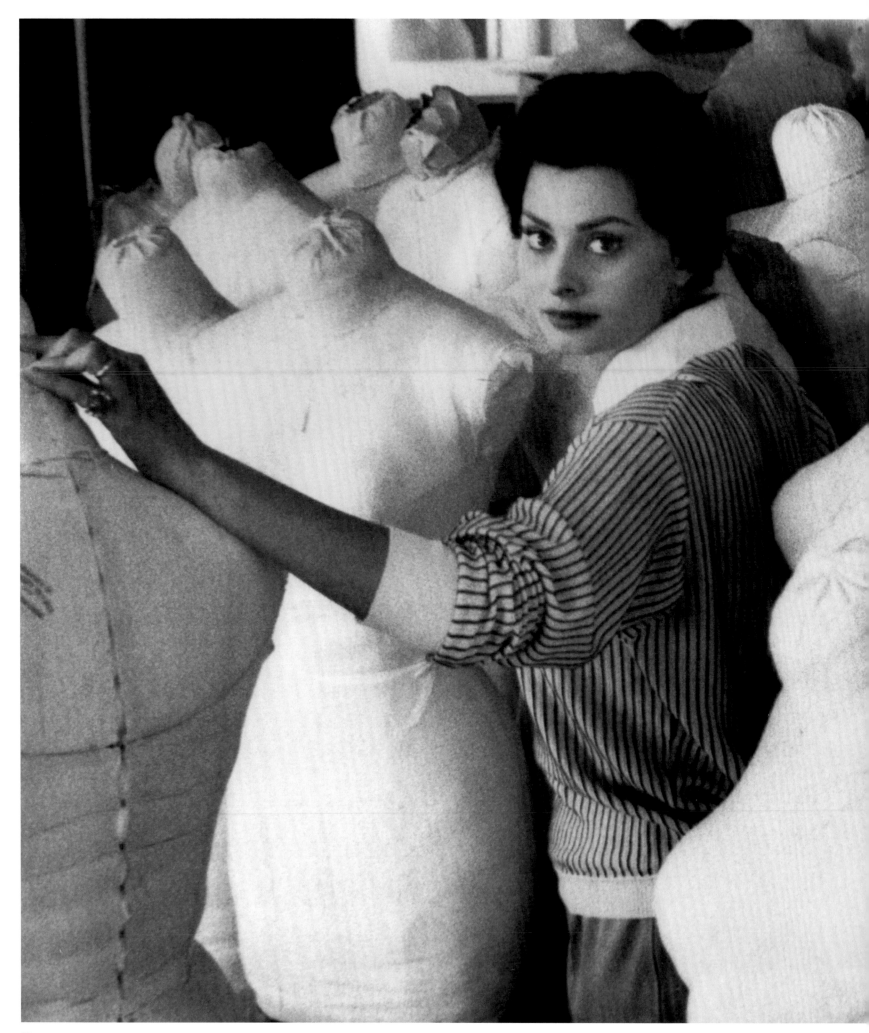

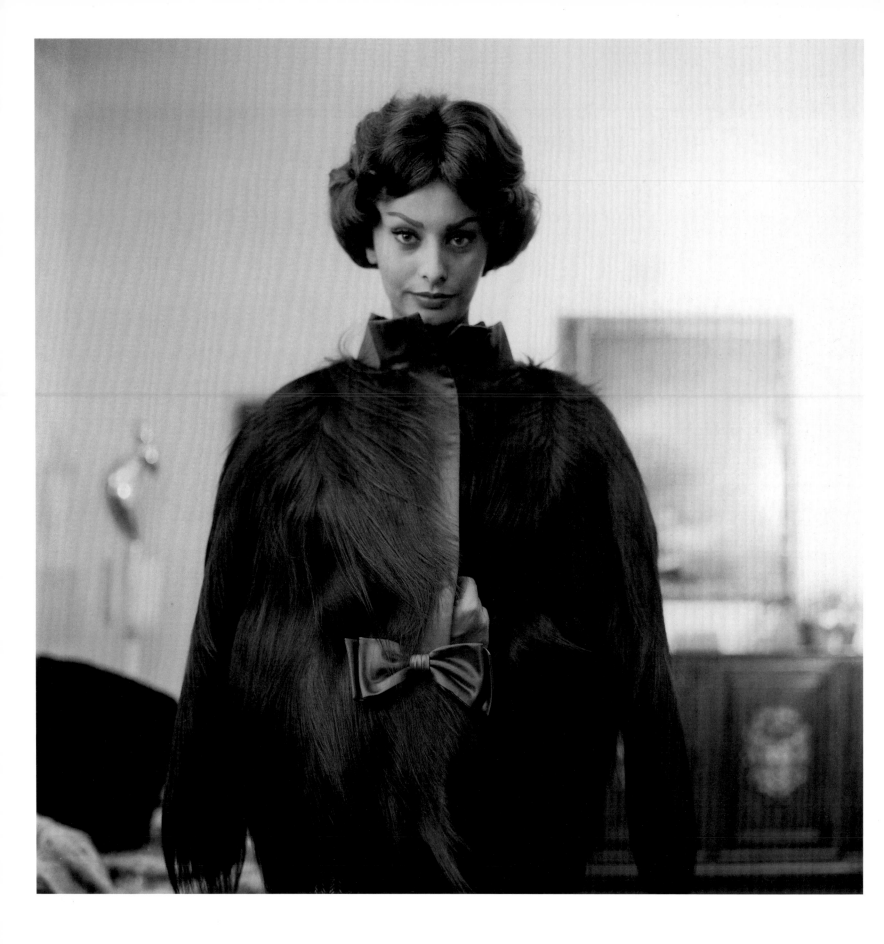

Previous pages :
1958 / Sophia Loren visits the costume department at Paramount.

1958 / Sophia Loren poses for a new fur collection by Scaasi for Ben Khan.

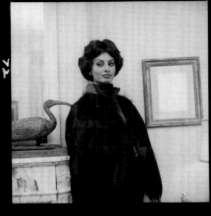
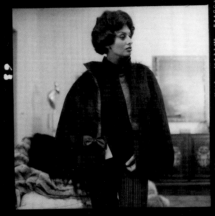
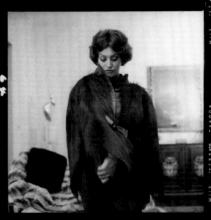
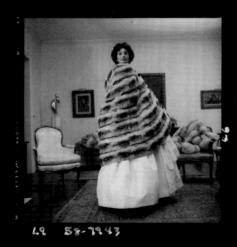
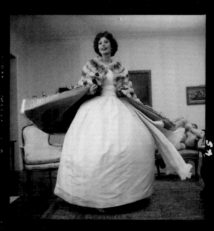
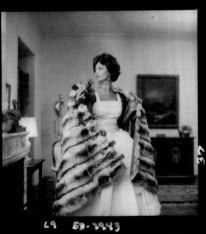
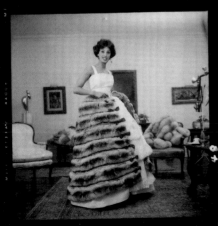
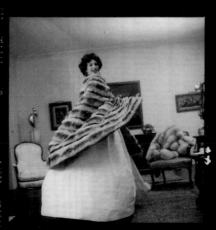
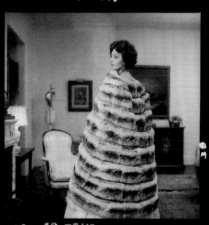

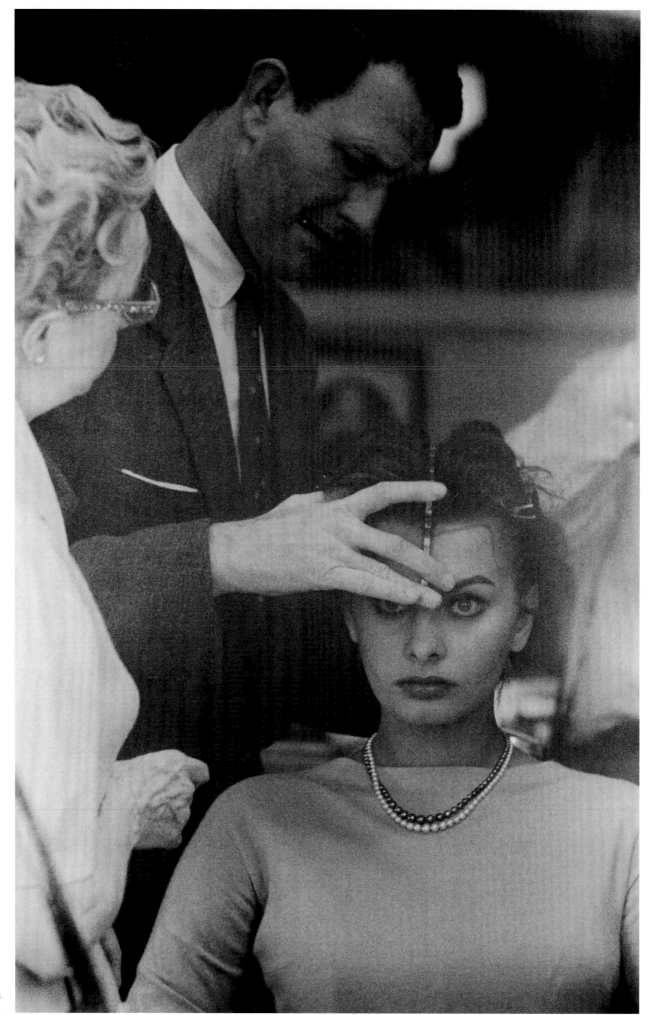

1957 / Sophia Loren is measured for a wig for a forthcoming film shoot.

"When I hear the word 'action' I become natural, my inhibitions disappear, I forget everything."

Sophia Loren

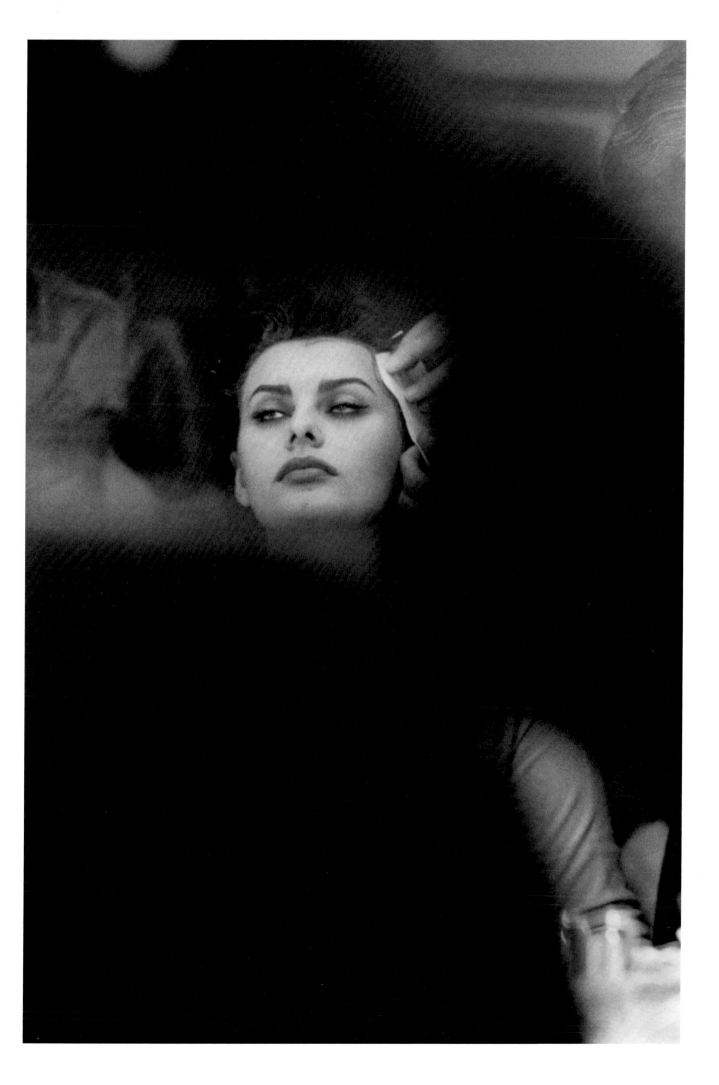

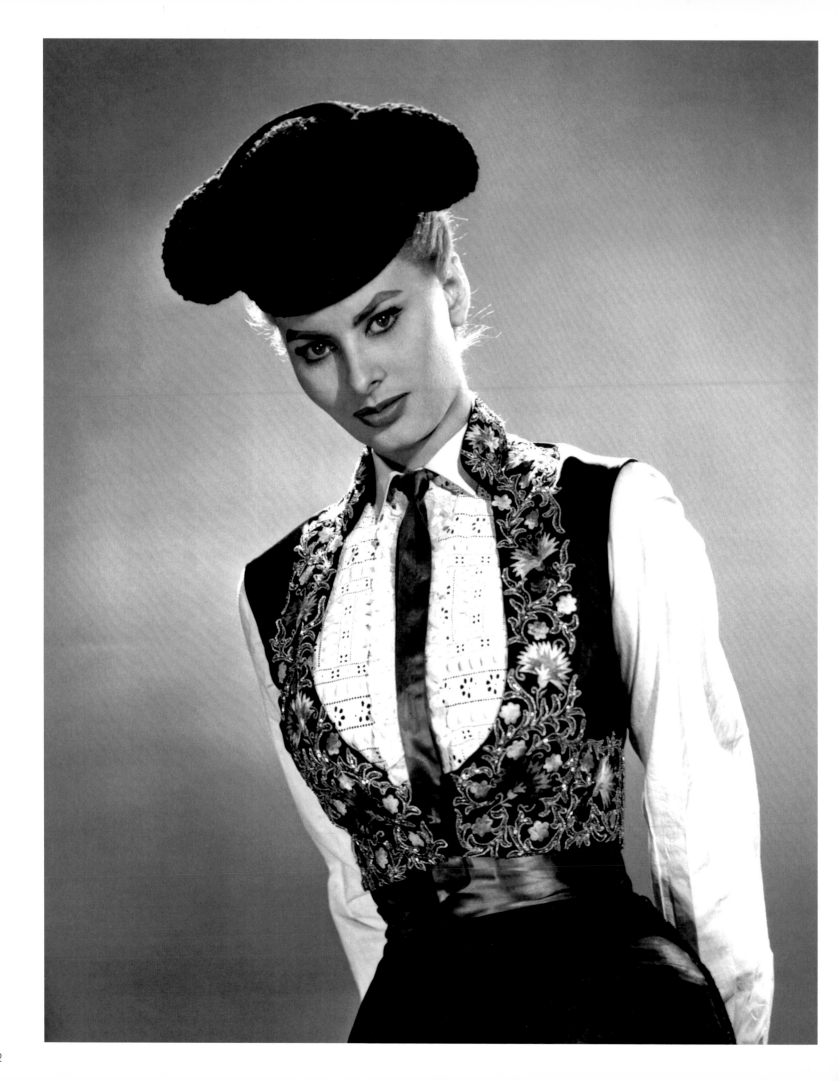

1957 / Sophia Loren aged 23.

1956 / The famous bullfighter, Miguel Dominguin, initiates Sophia Loren into the basics of bull-fighting.

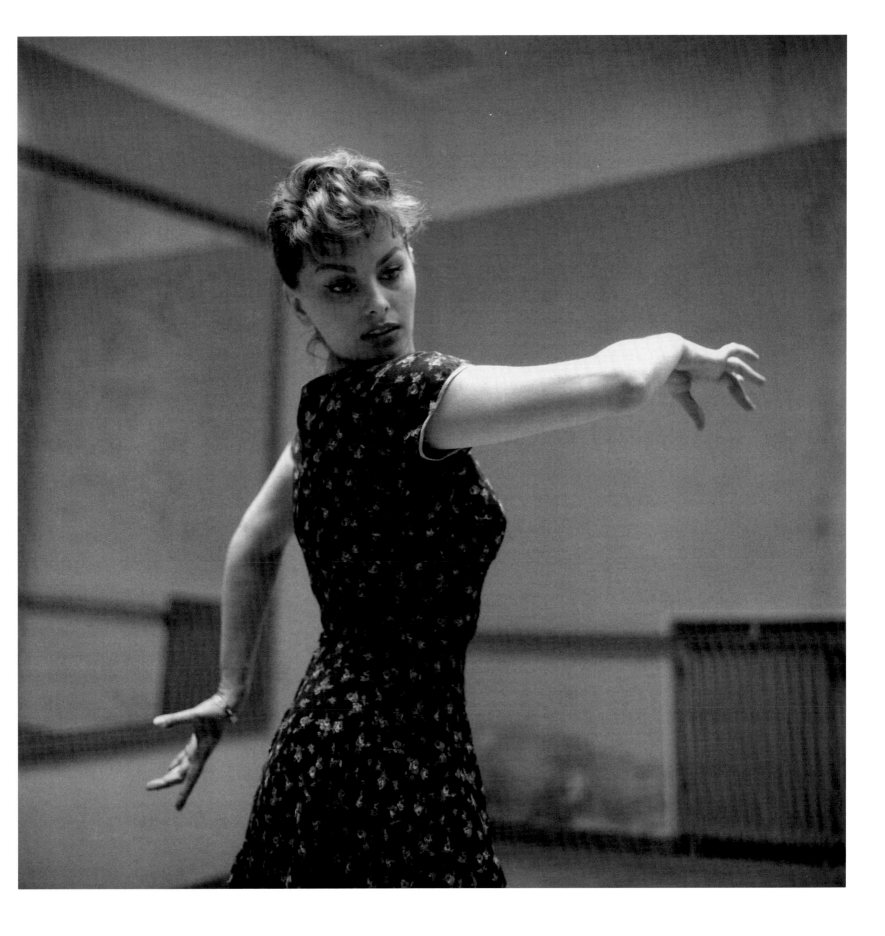

Previous and these pages:
1961 / While in Spain filming Anthony Mann's *El Cid*, Sophia Loren took flamenco lessons.

"Sex appeal is fifty per cent what you've got and fifty per cent what people think you've got."

Sophia Loren

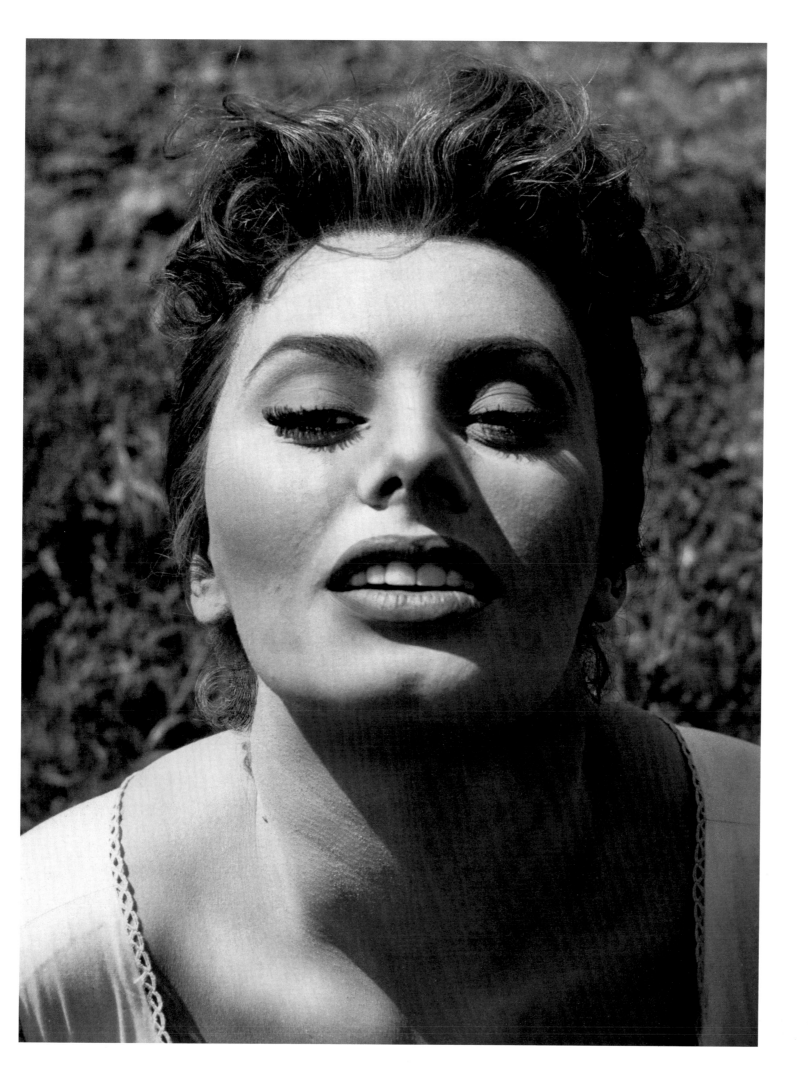

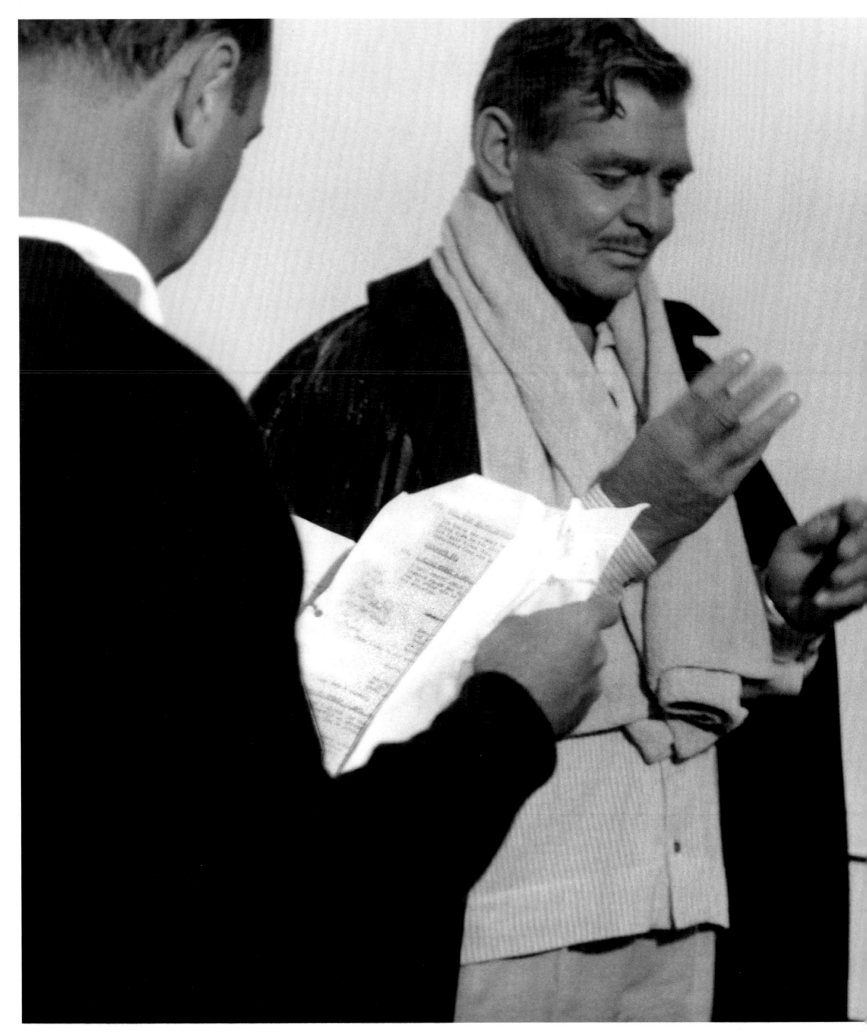

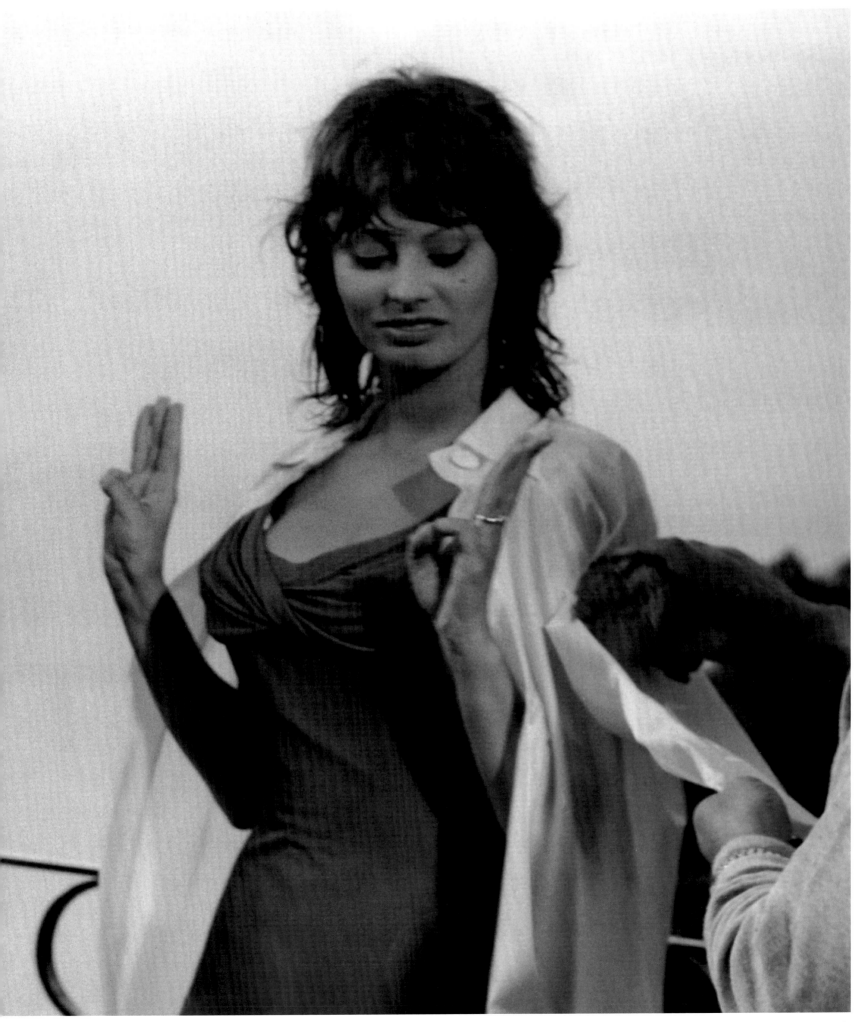

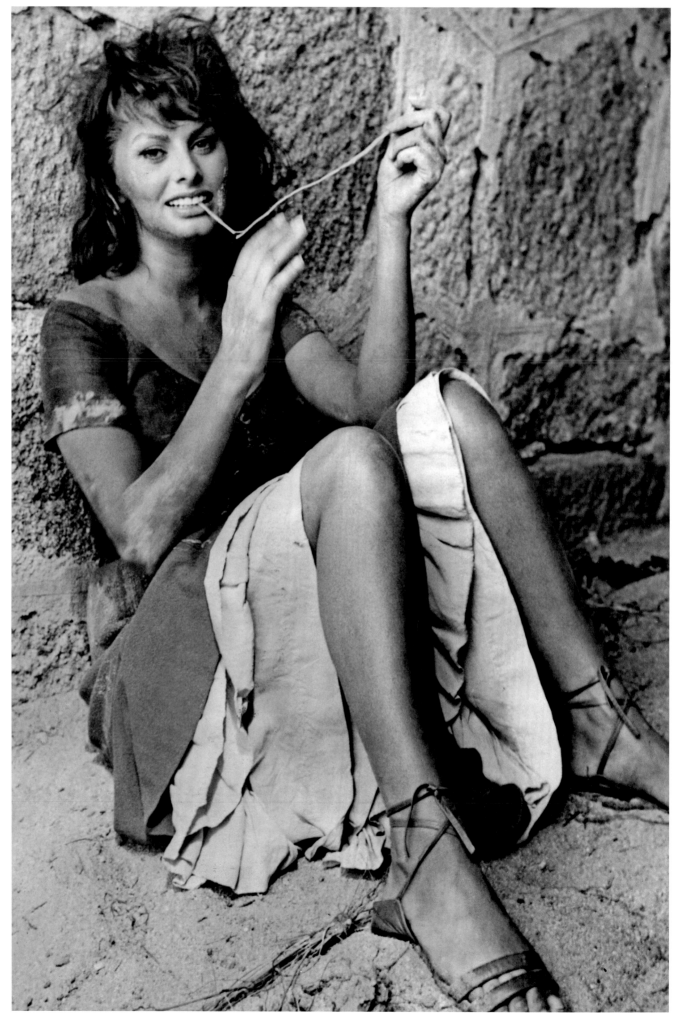

Previous pages :
1960 / Sophia Loren and
Clark Gable on the set of
It Started in Naples, directed
by Melville Shavelson. It was
Gable's penultimate film
before his death the following
year after shooting
The Misfits.

1957 / Sophia Loren on the
set of *The Pride and the
Passion*.

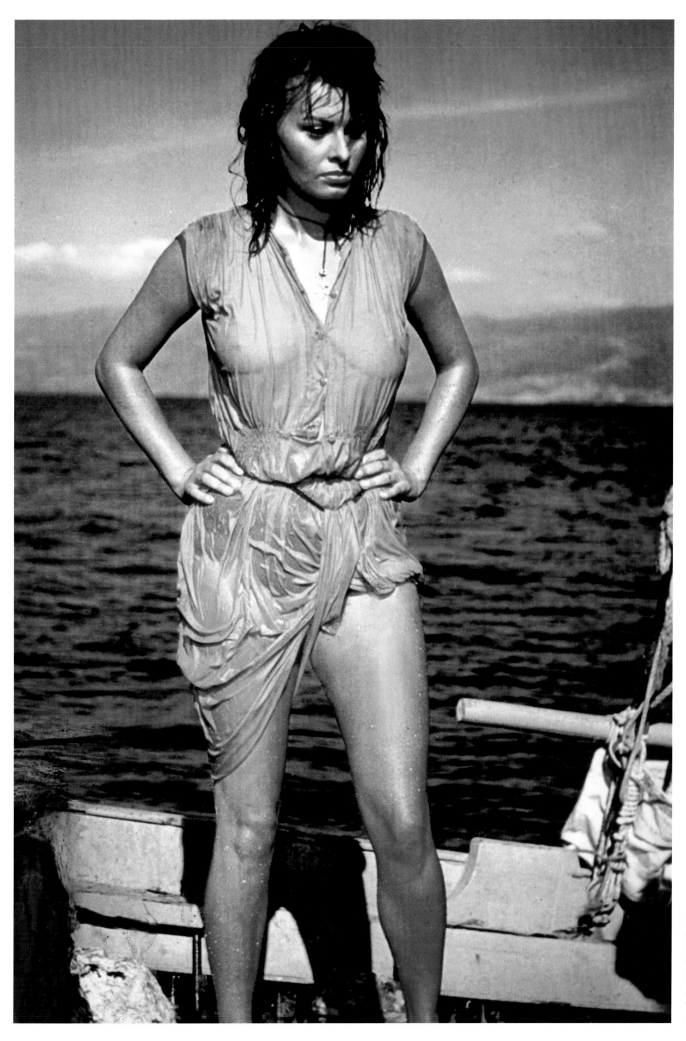

1957 / Jean Negulesco's *Boy on a Dolphin* was filmed in Greece. Because Sophia Loren did not swim well enough, a body double was often used for her role of a sponge-diver who discovers a 2,000-year-old statue.

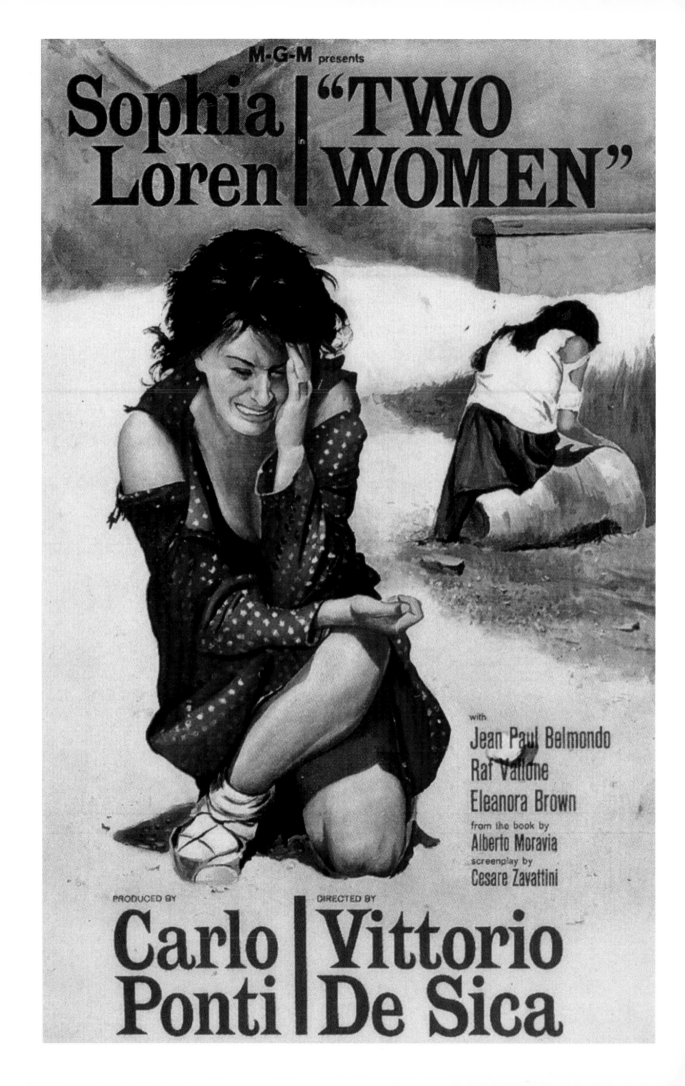

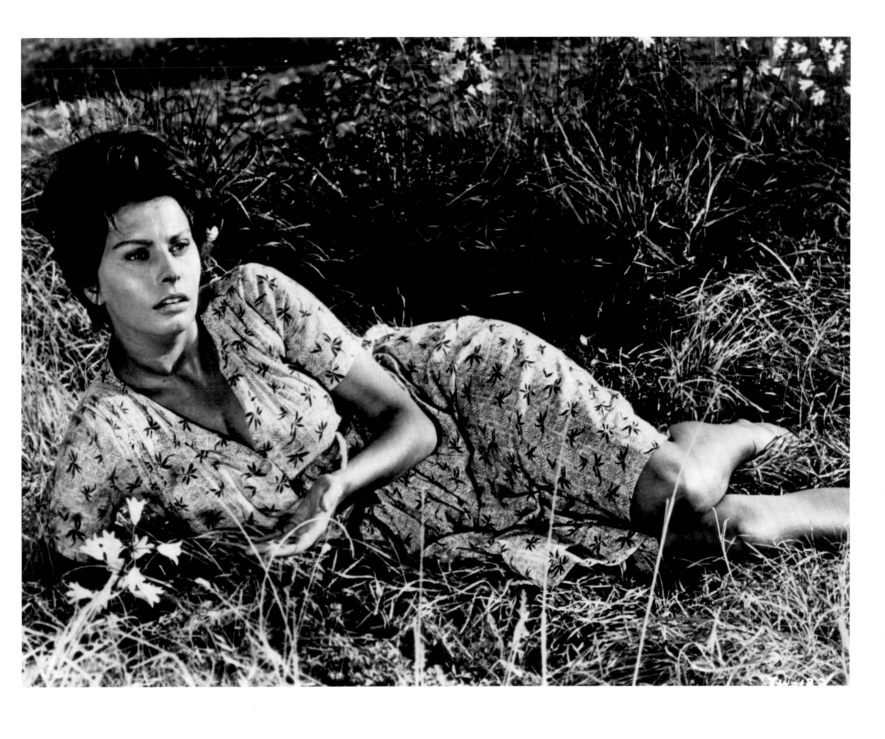

1960 / American poster for *Two Women*. The film was shot a few kilometres from Pozzuoli, where Sophia Loren grew up.

1960 / Director Vittorio De Sica gave Sophia Loren her finest role in *Two Women*. Her performance earned her the 1962 Best Actress Oscar. It was the first time the award was given to a foreign actress playing in a language other than English.

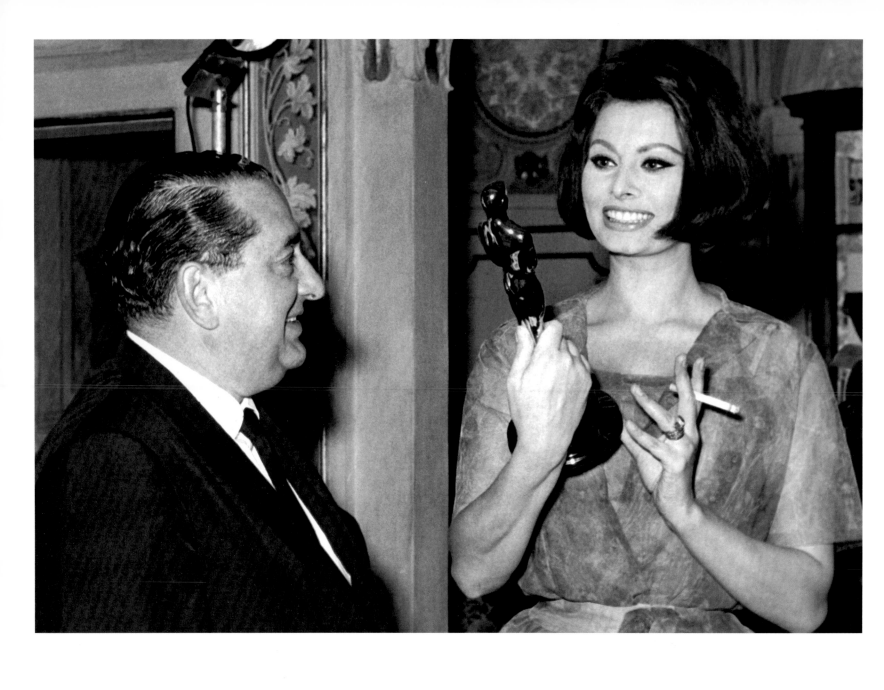

1961 / In her Rome apartment, Sophia Loren shows Joseph Levine the Oscar that she won for her interpretation of Cesira in *Two Women*.

1961 / At the Cannes film festival, Sophia Loren poses in front of a poster for *La Ciociara (Two Women)* in which she stars. A few days later, she won the Palme d'Or for Best Actress.

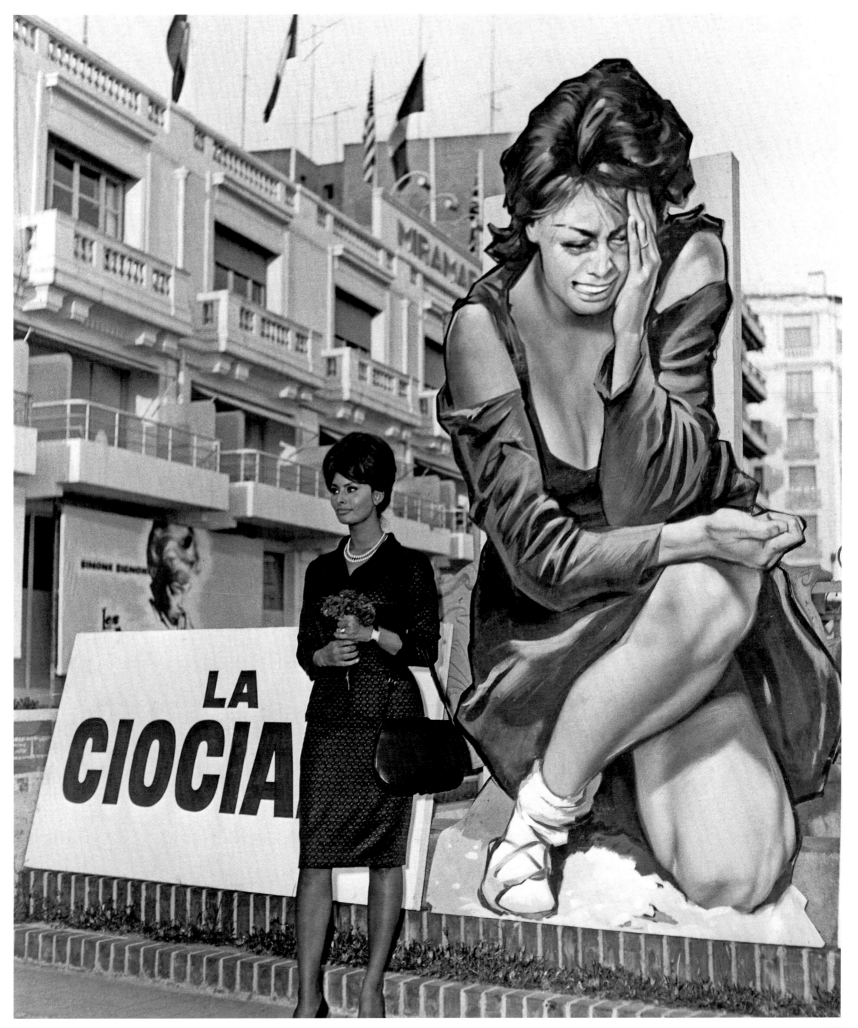

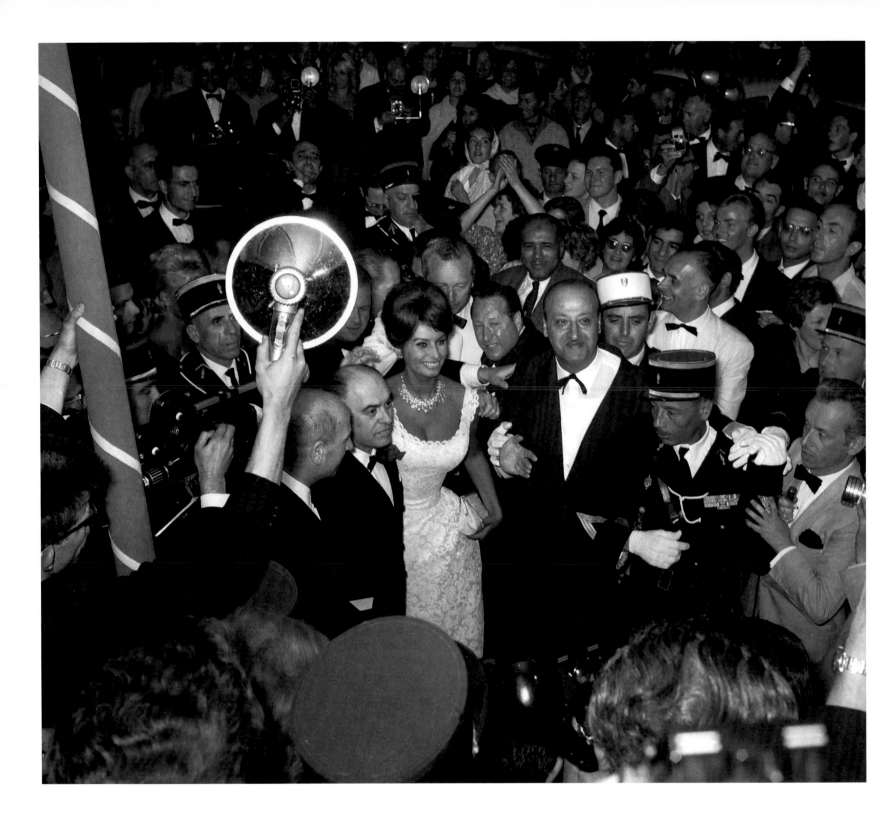

1961 / Sophia Loren ascends the staircase of the Cannes Film Festival on the arm of her husband, Carlo Ponti.

1959 / Sophia Loren poses on the balcony of the Carlton Hotel's room 431 overlooking the Croisette, during the Cannes Film Festival.

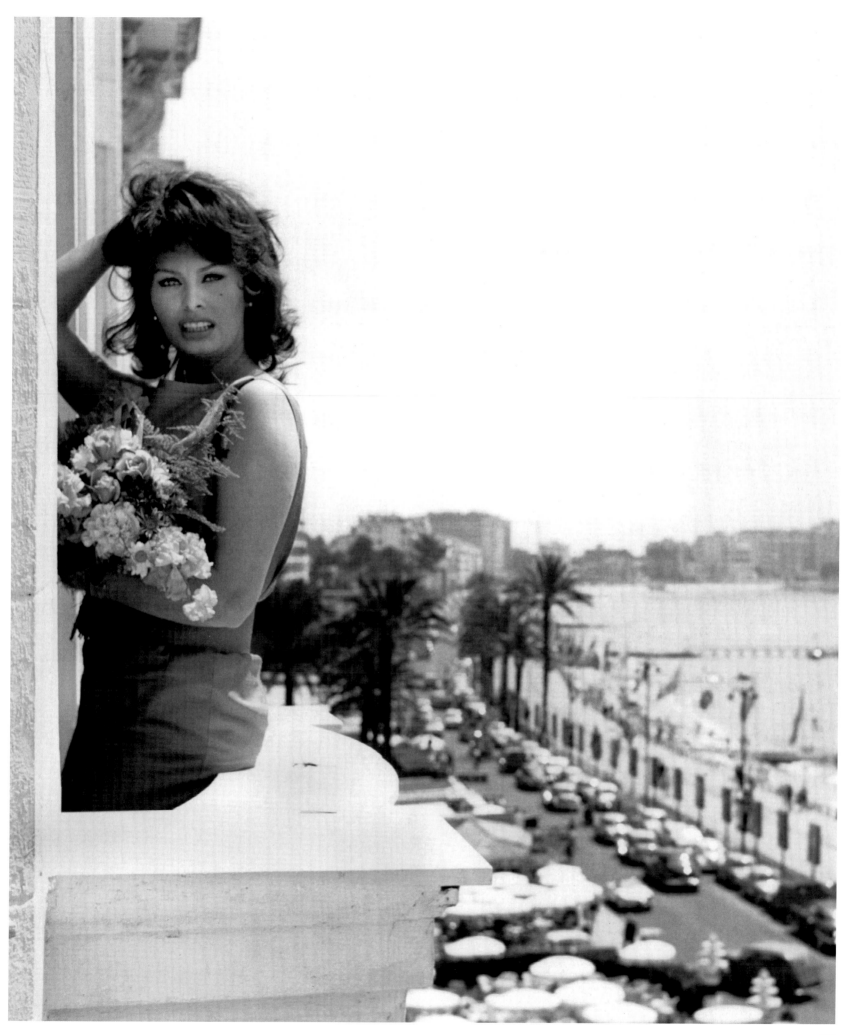

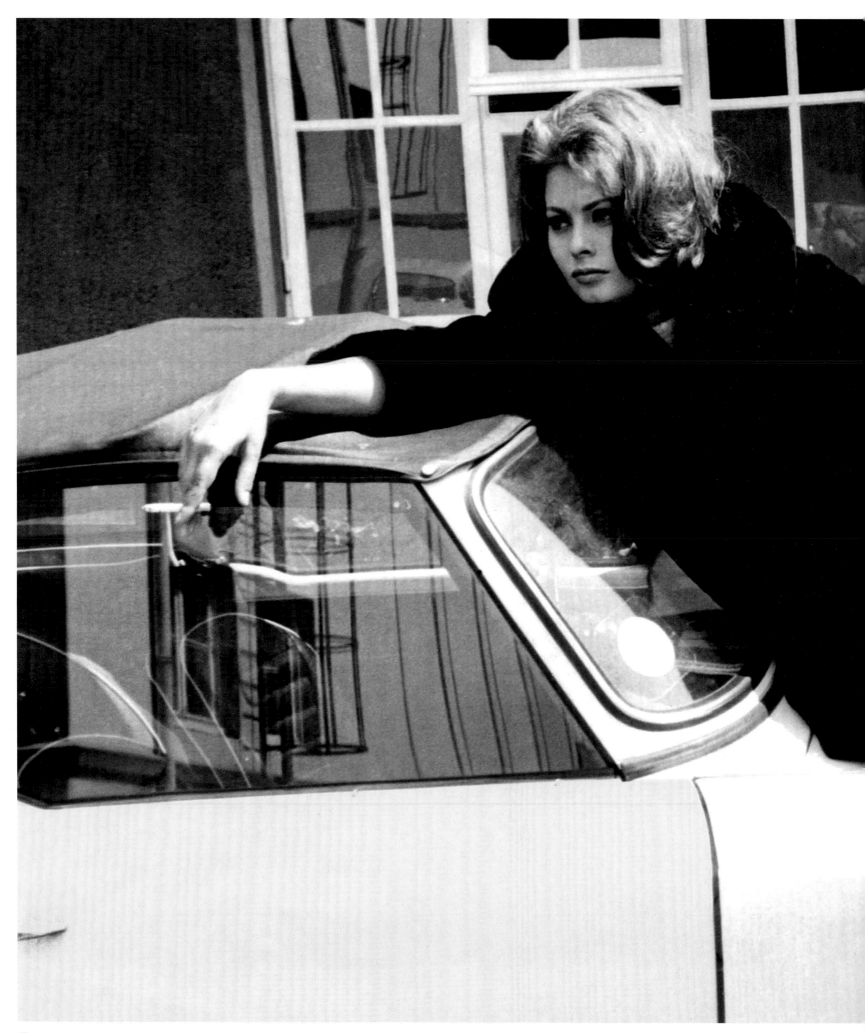

"Nothing makes a woman more beautiful than the belief that she is beautiful."

Sophia Loren

Previous pages :
1962 / Sophia Loren poses with a sports car in Tirrenia, Italy.

112

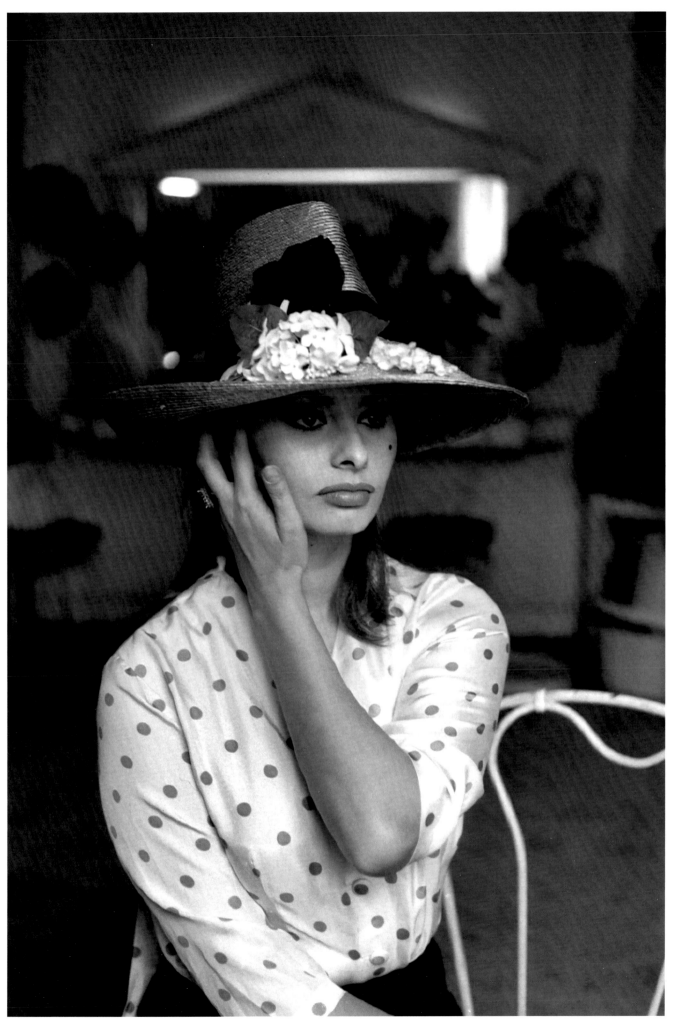

1960 / A portrait of Sophia Loren aged 25.

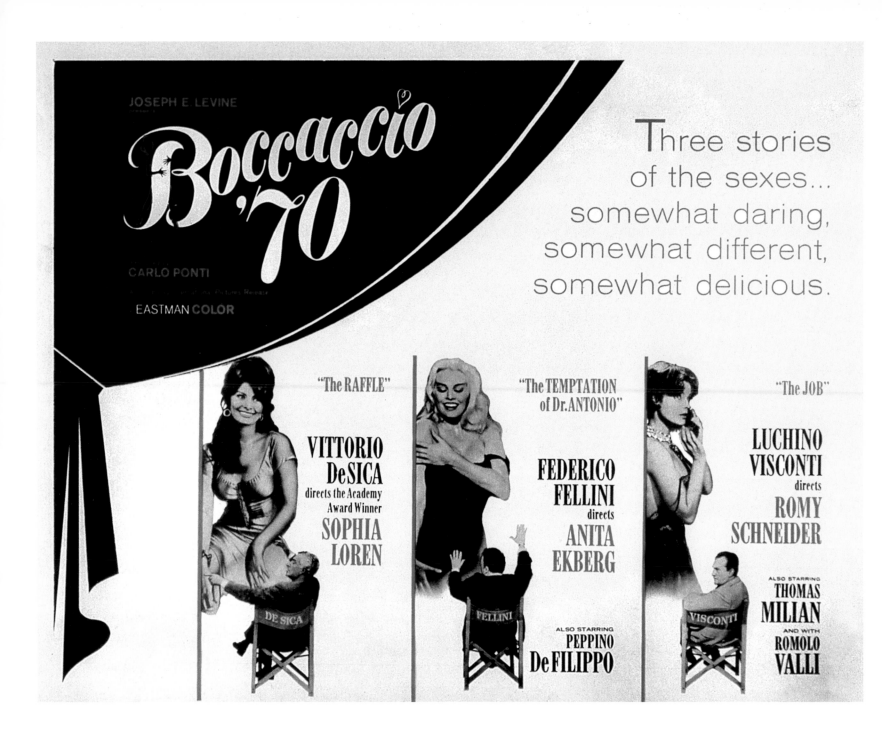

1961 / A poster for the multi-episode film *Boccaccio '70*, starring Sophia Loren, Anita Ekberg and Romy Schneider. The film caused a row at the 1962 Cannes Film Festival because the fourth episode, directed by Mario Monicelli, was dropped to shorten the running time.

1963 / Sophia Loren, aged 29.

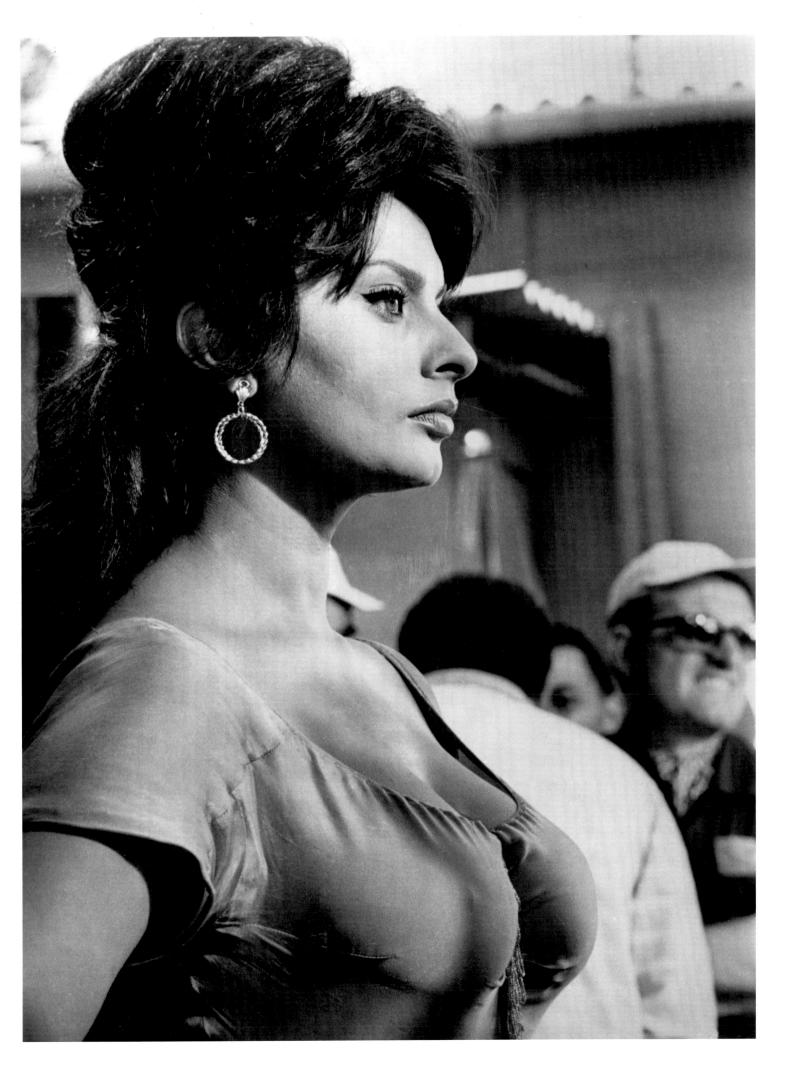

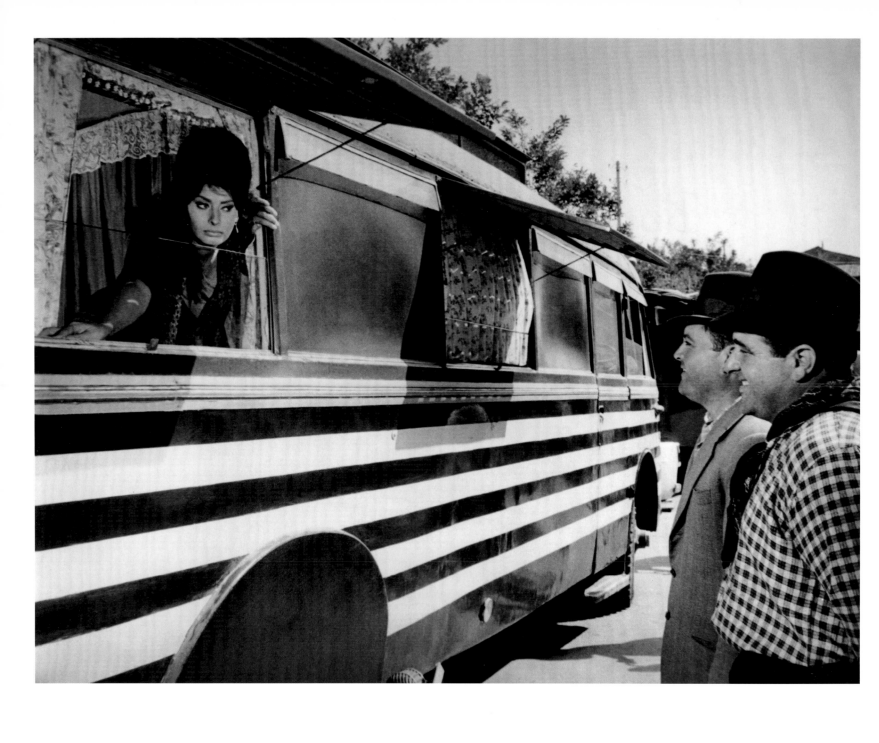

1961 / In *Boccaccio '70*, Sophia Loren was again directed by Vittorio De Sica. Between 1954 and 1974 she made eight films with the director.

1966 / Sophia Loren and Gregory Peck at Gatwick Airport, near London, while shooting *Arabesque*.

"You have to be born a sex symbol, you don't just become one."

Sophia Loren

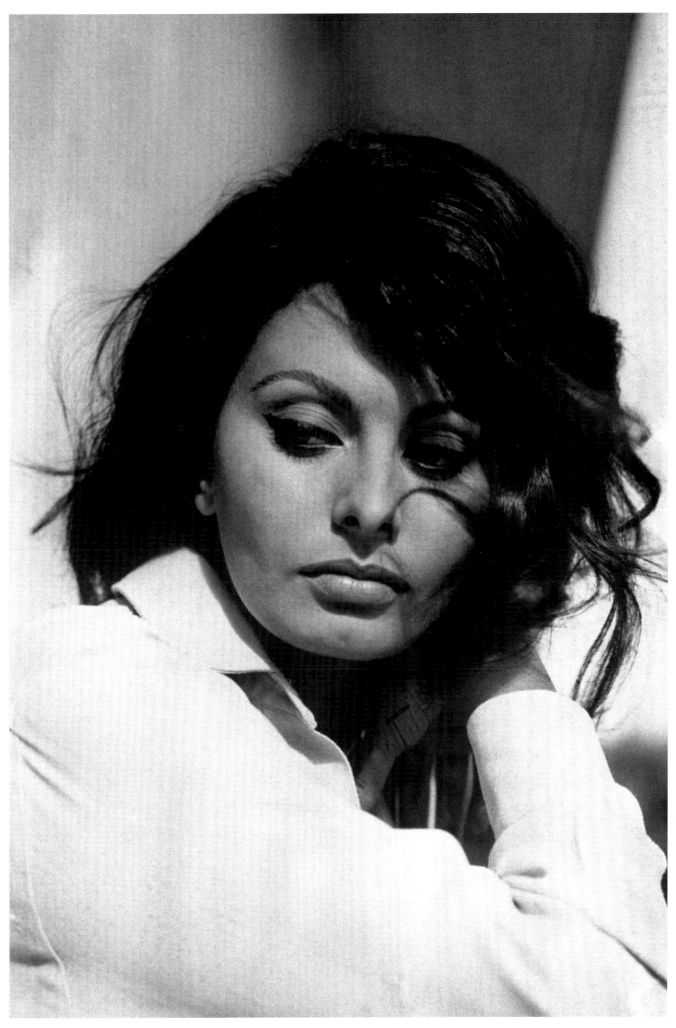

1966 / Sophia Loren at 32.

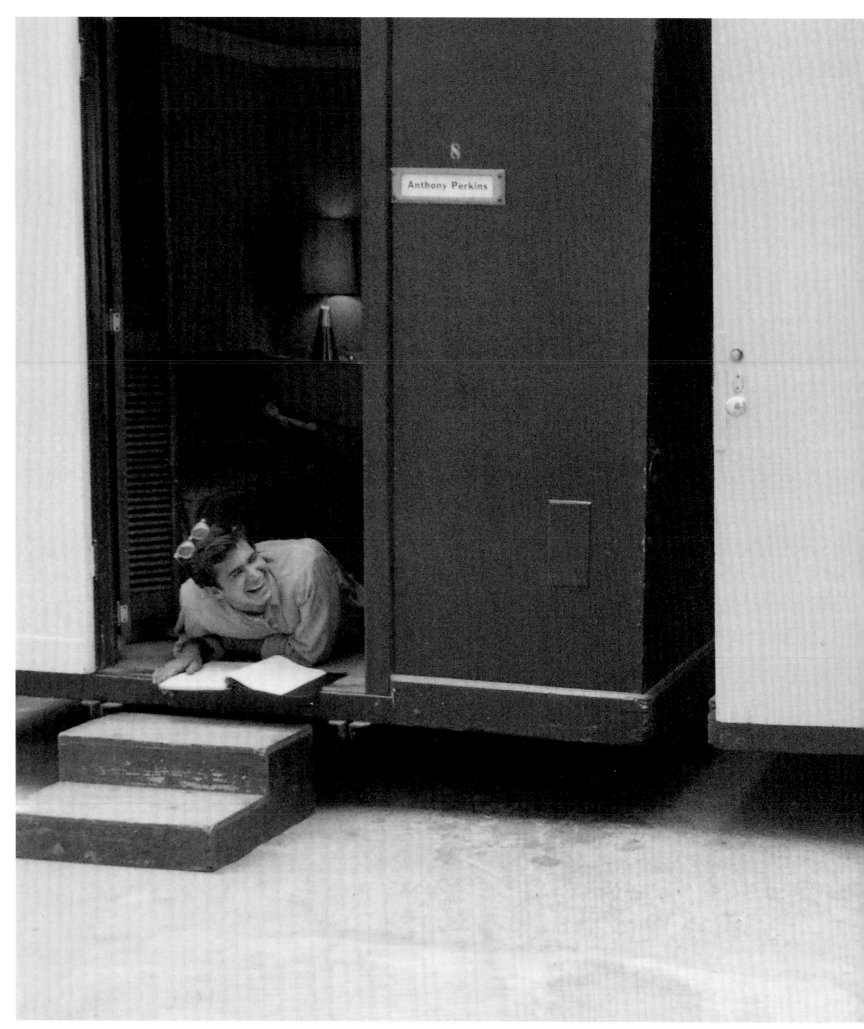

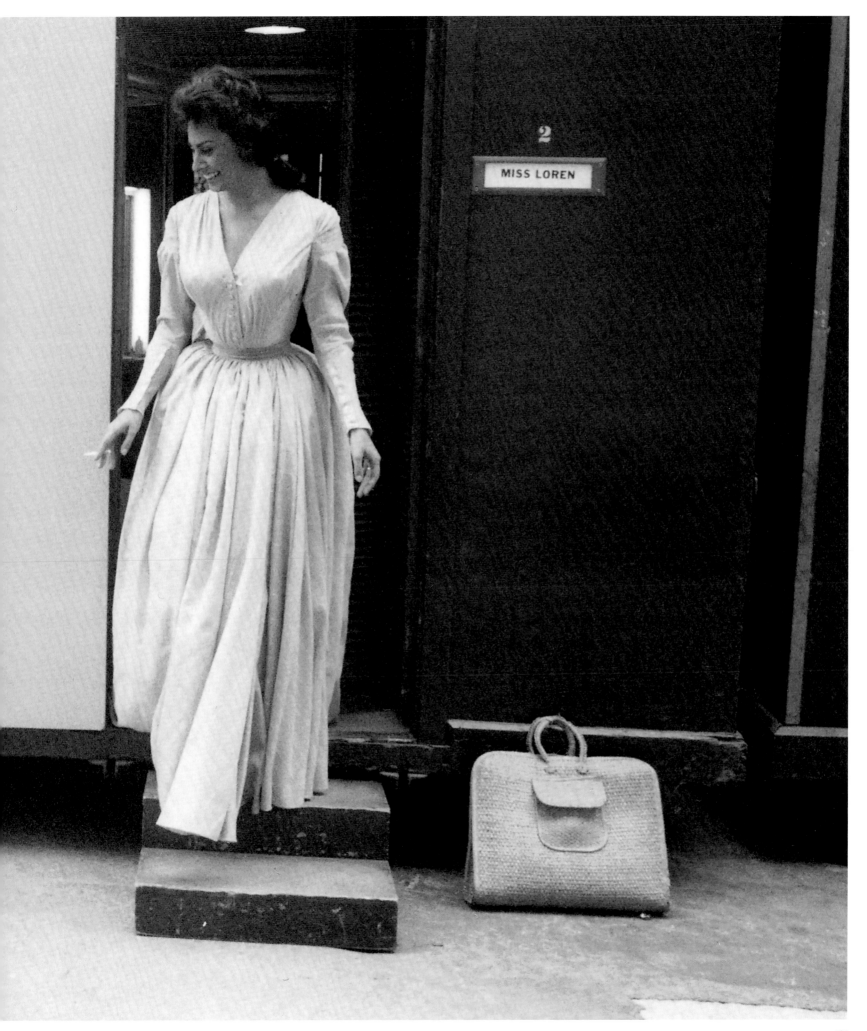

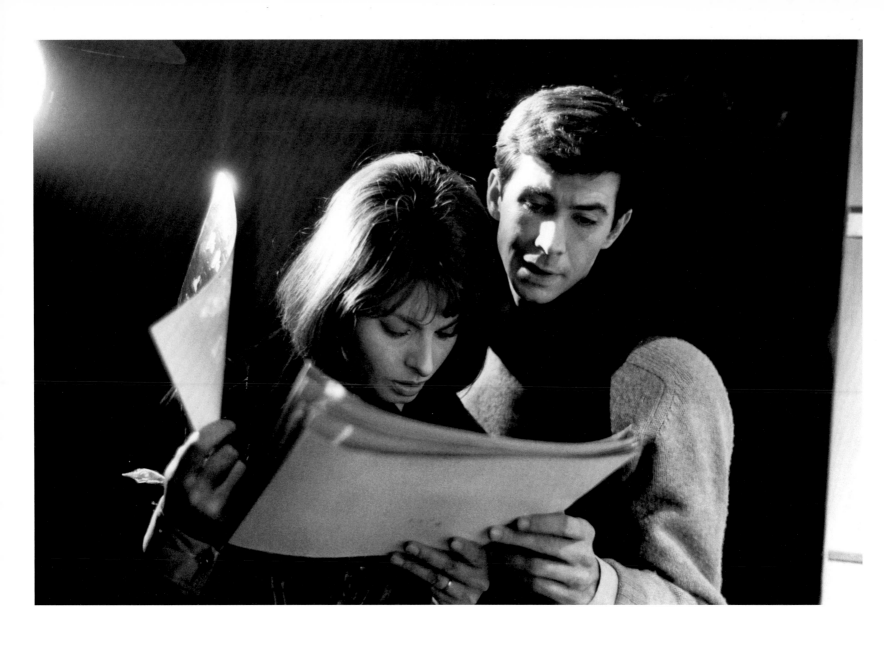

Previous pages :
1958 / Anthony Perkins and Sophia Loren on the set of *Desire under the Elms*, directed by Delbert Mann.

1962 / Sophia Loren reads the script during filming of *Five Miles to Midnight*, directed by Anatole Litvak.

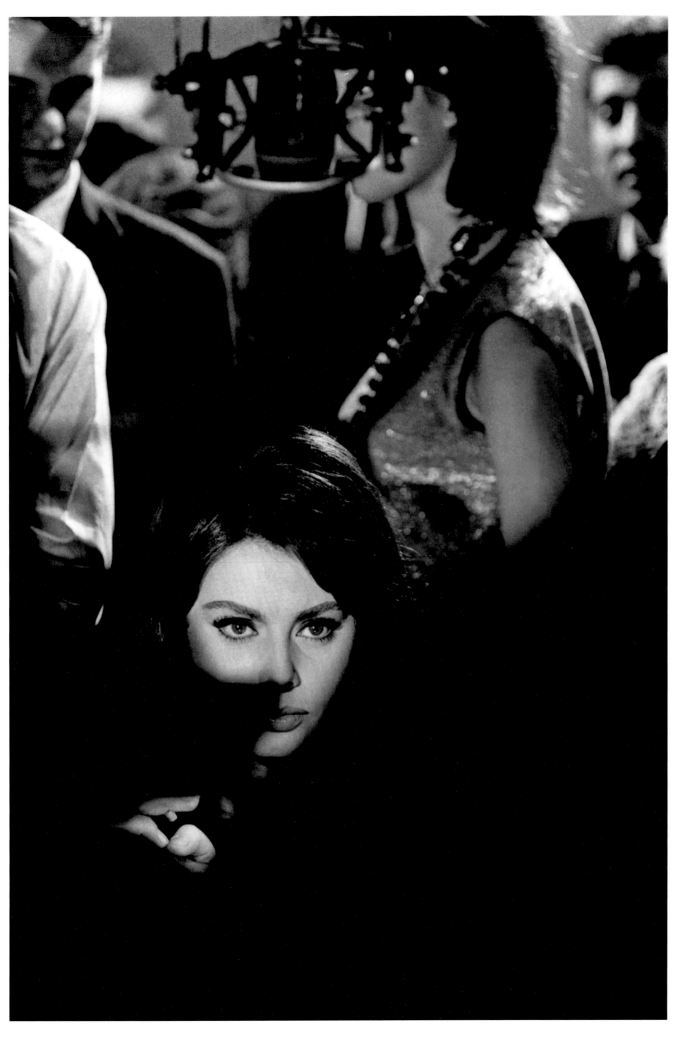

1962 / A portrait of Sophia Loren on the set of Five Miles to Midnight, filmed in Paris.

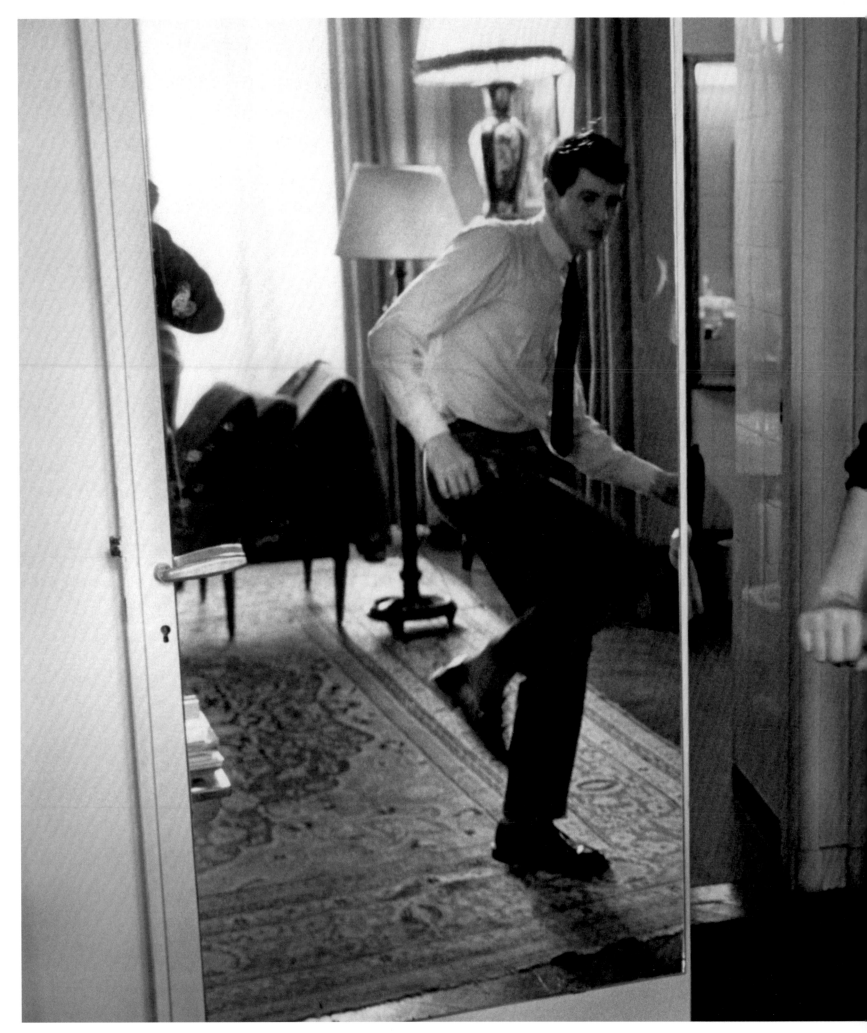

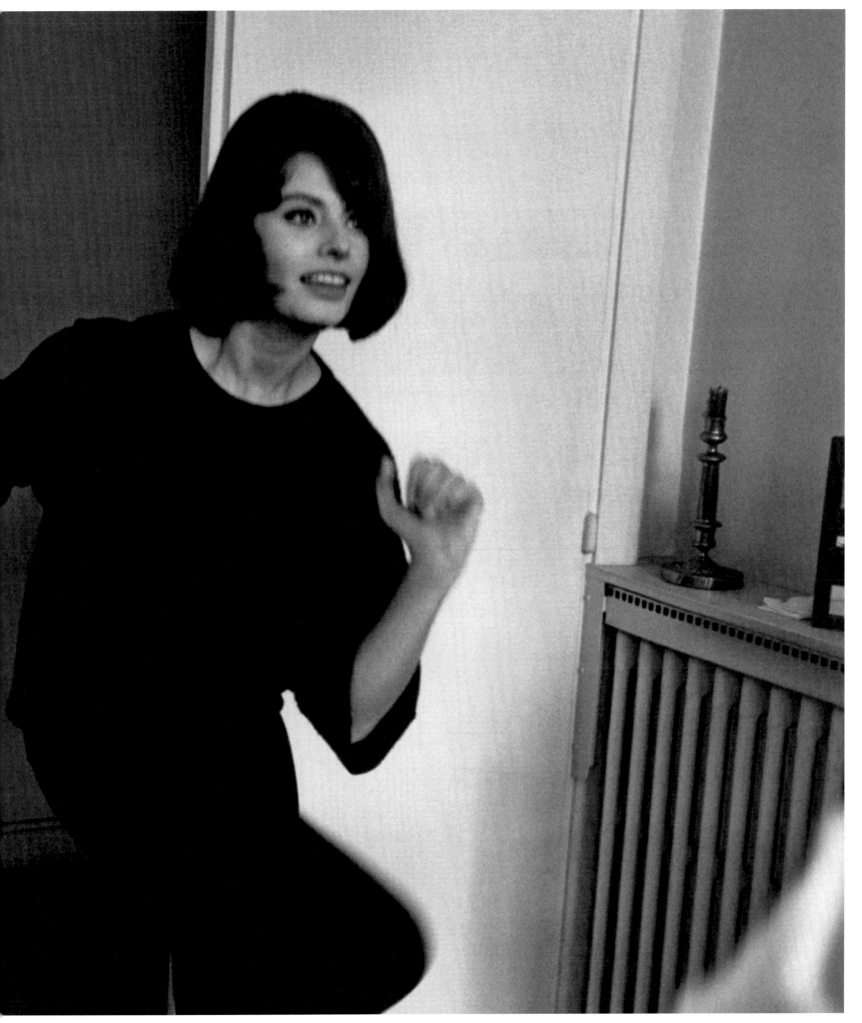

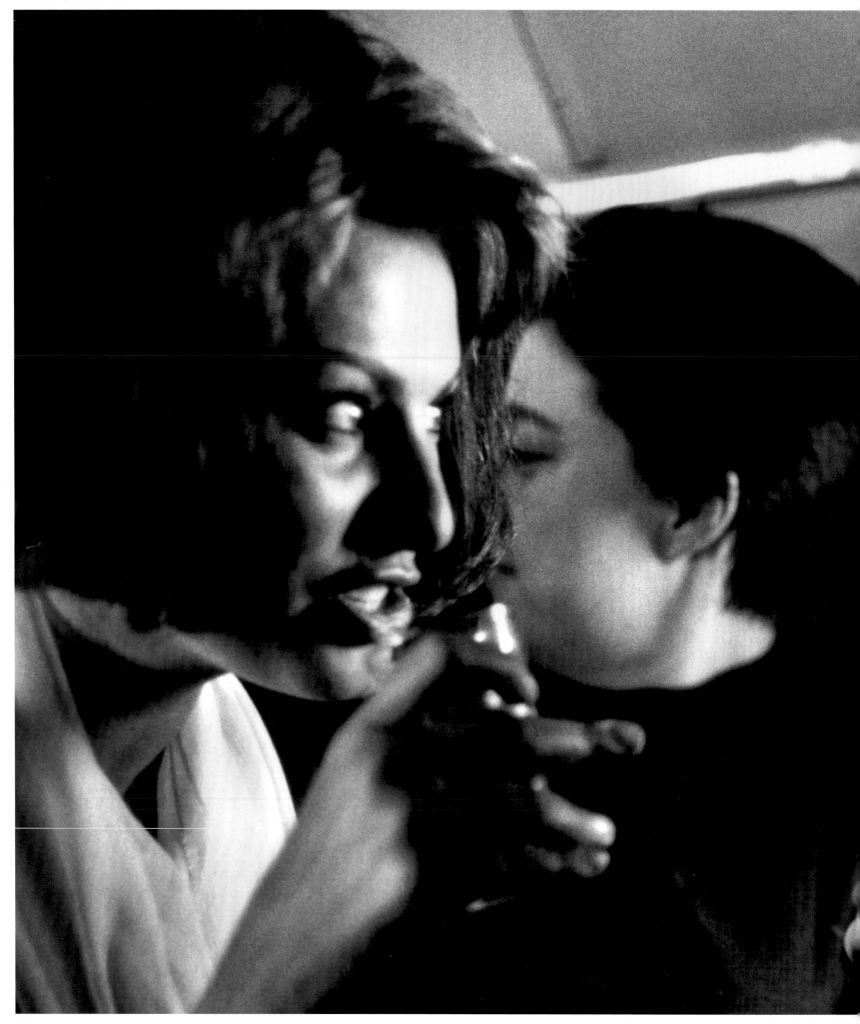

"I feel so timid and vulnerable when the camera is not filming."

Sophia Loren

Previous pages, 126–127:
1962 / Anthony Perkins and Sophia Loren on the set of *Le Couteau Dans La Plaie*.

pages 128–129:
1962 / Sophia Loren and Maximilian Schell during the shooting of *Les Sequestres d'Altona* by Vittorio De Sica.

128

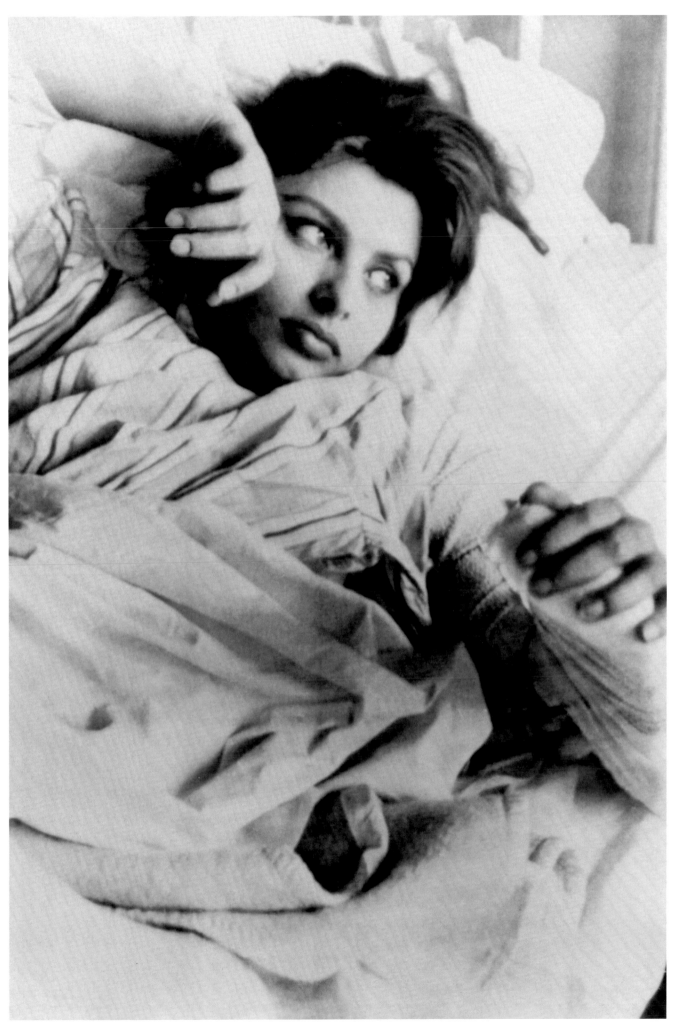

1961 / After filming Anthony Mann's *El Cid*, Sophia Loren spent some days in a Madrid hospital following a fall in her apartment: she had fractured her shoulder.

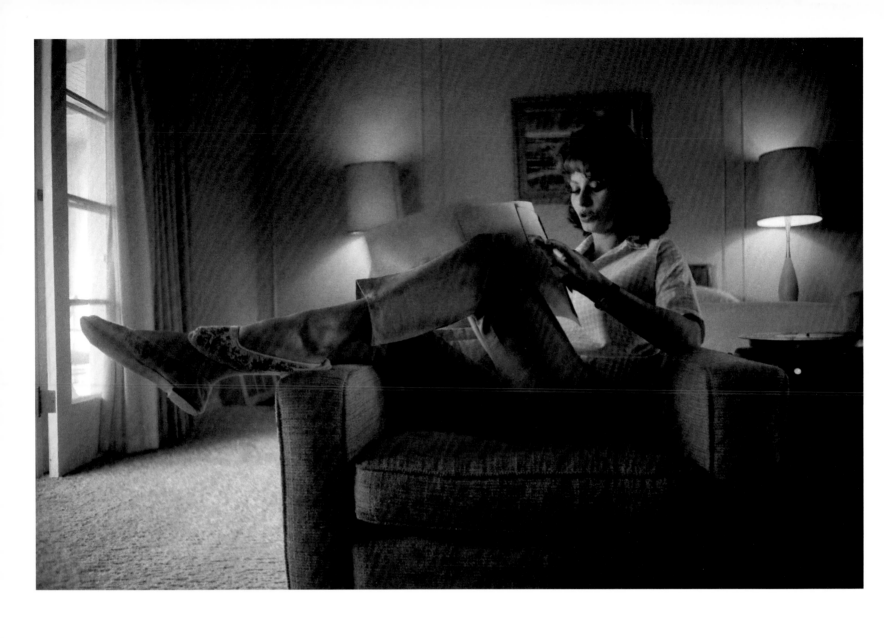

1963 / Sophia Loren, at home in Los Angeles.

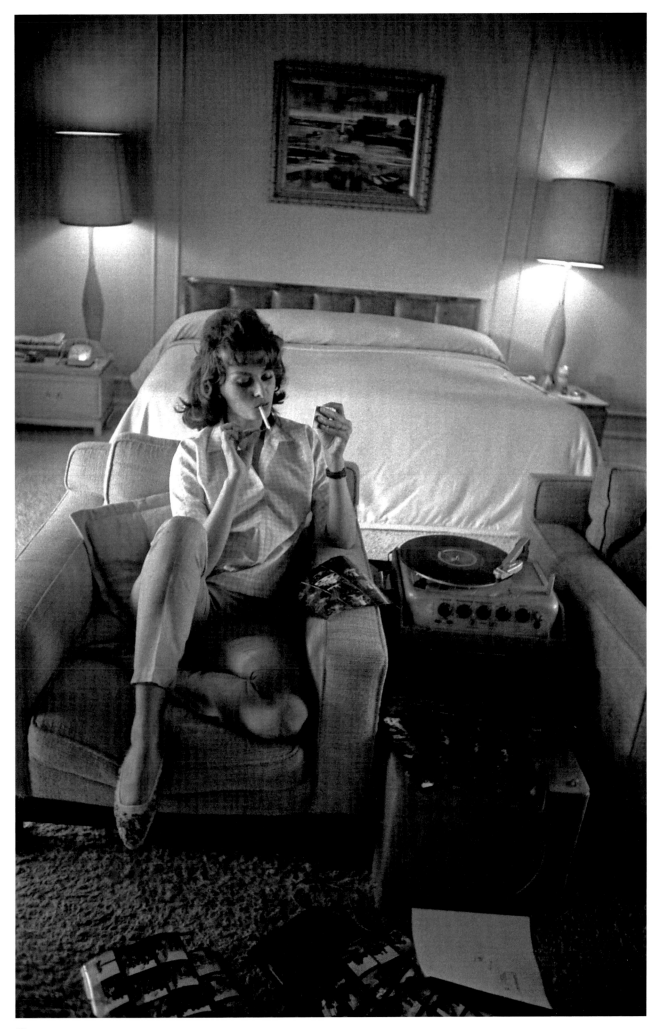

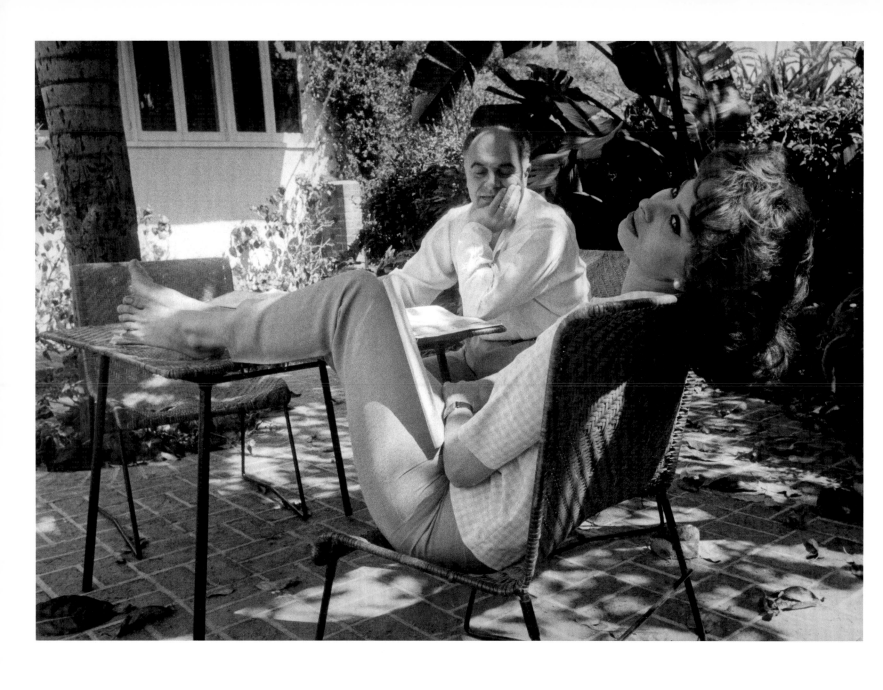

1963 / Sophia Loren and Carlo Ponti enjoying a weekend in their Los Angeles house.

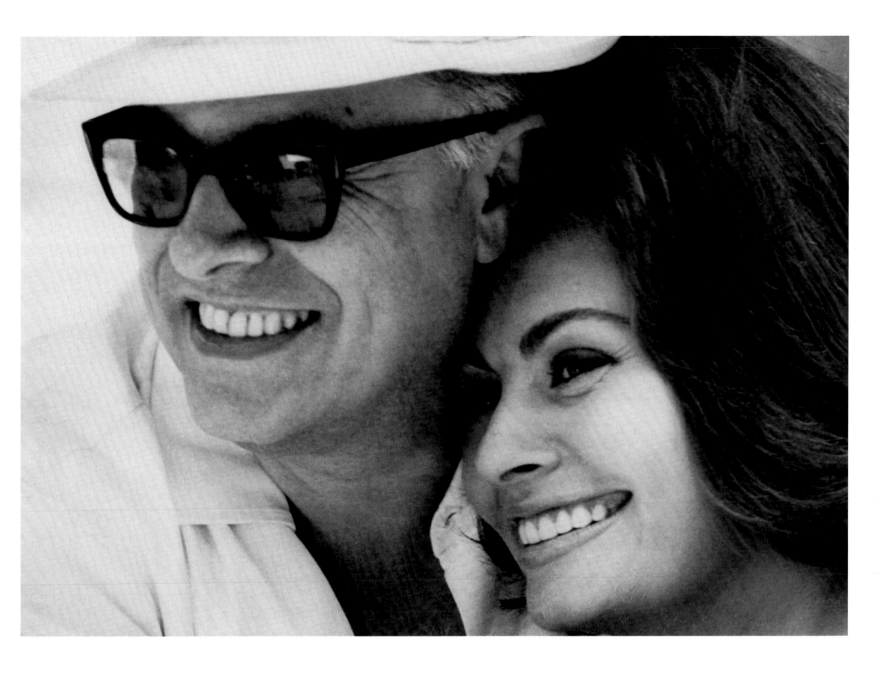

1962 / Sophia Loren and her husband Carlo Ponti.

"Being beautiful can never hurt, but you have to have more. You have to sparkle, you have to be fun, you have to use your brain, if you have one."

Sophia Loren

1961 / In her Rome apartment, Sophia Loren prepares to blow out the candles for her 27th birthday.

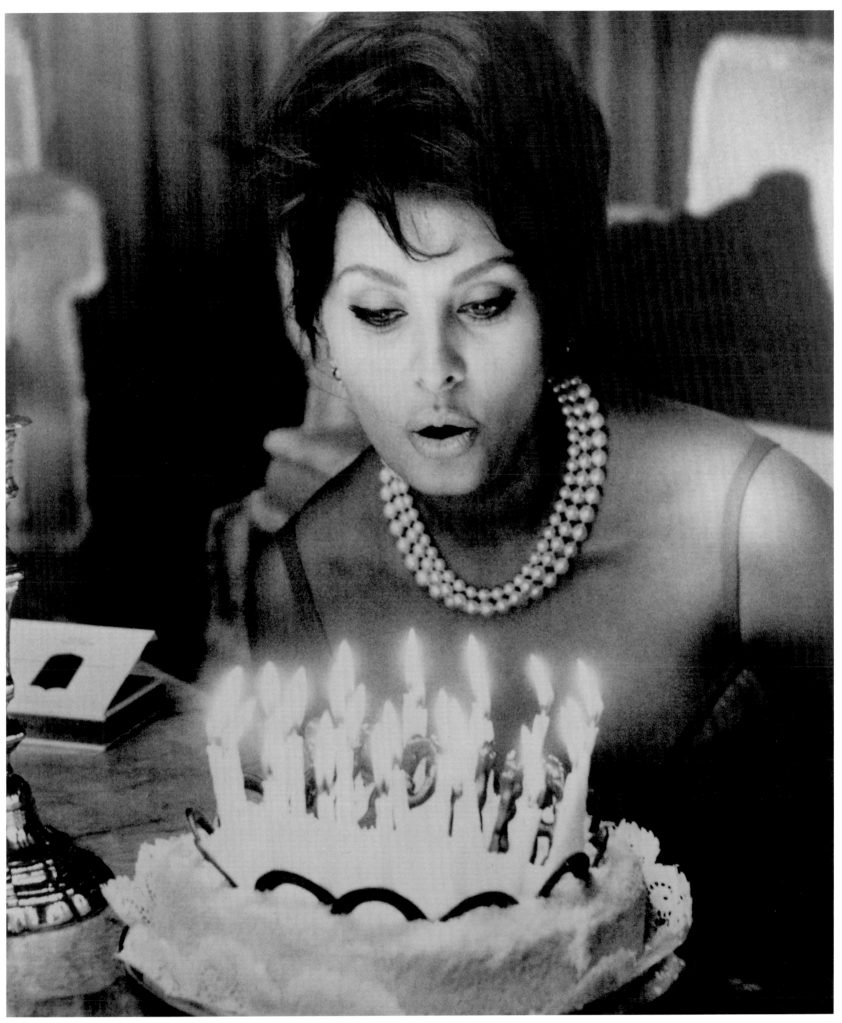

1963 / A hair and make-up session before filming *Yesterday, Today and Tomorrow.*

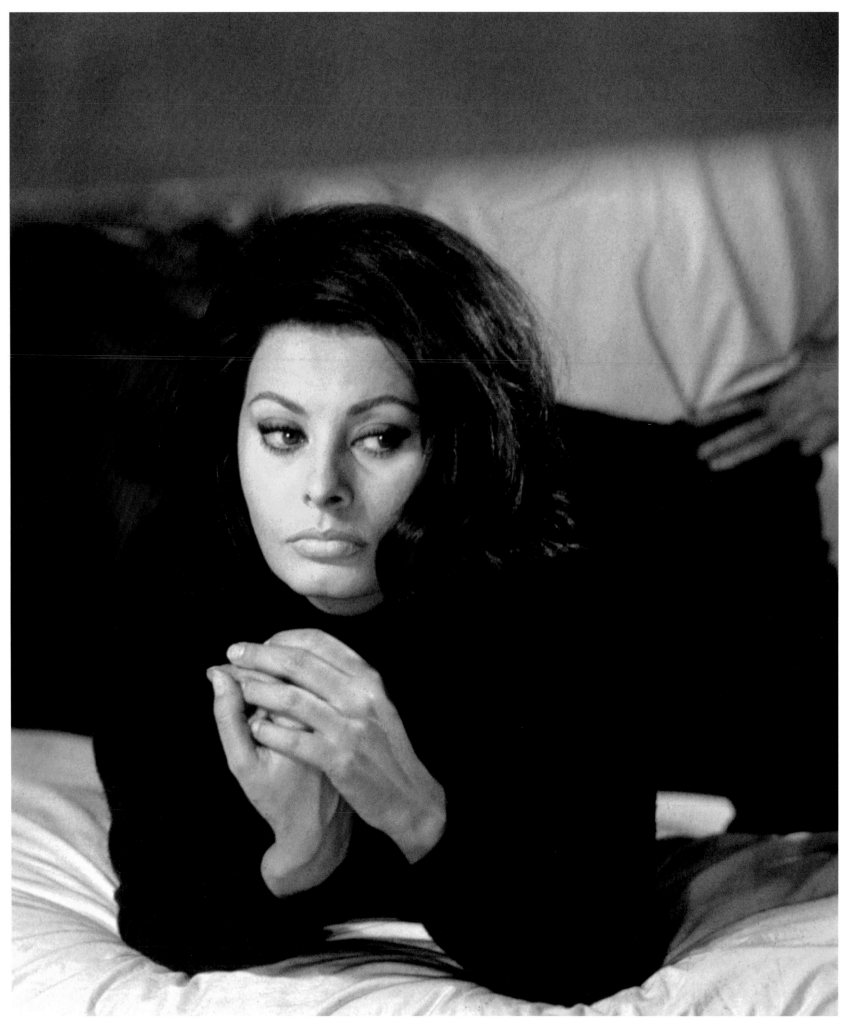

1964 / Sophia Loren on the set of *Marriage, Italian Style*, for which she was nominated for a Best Actress Oscar.

1963 / Sophia Loren and Marcello Mastroianni during filming of *Yesterday, Today and Tomorrow*. It was the fourth time the two friends co-starred together and the second time they were directed by Vittorio De Sica.

1963 / Vittorio De Sica's Yesterday, *Today and Tomorrow* created a rumpus when it opened in Italy, thanks to Sophia Loren's strip-tease scene. Italian Deputy, Agostino Greggi, demanded that it be seized for gross immorality, but his complaint was rejected. The film became a huge popular success and won the Best Foreign Film Oscar.

"Mistakes are part of the price to be paid for a full life."

Sophia Loren

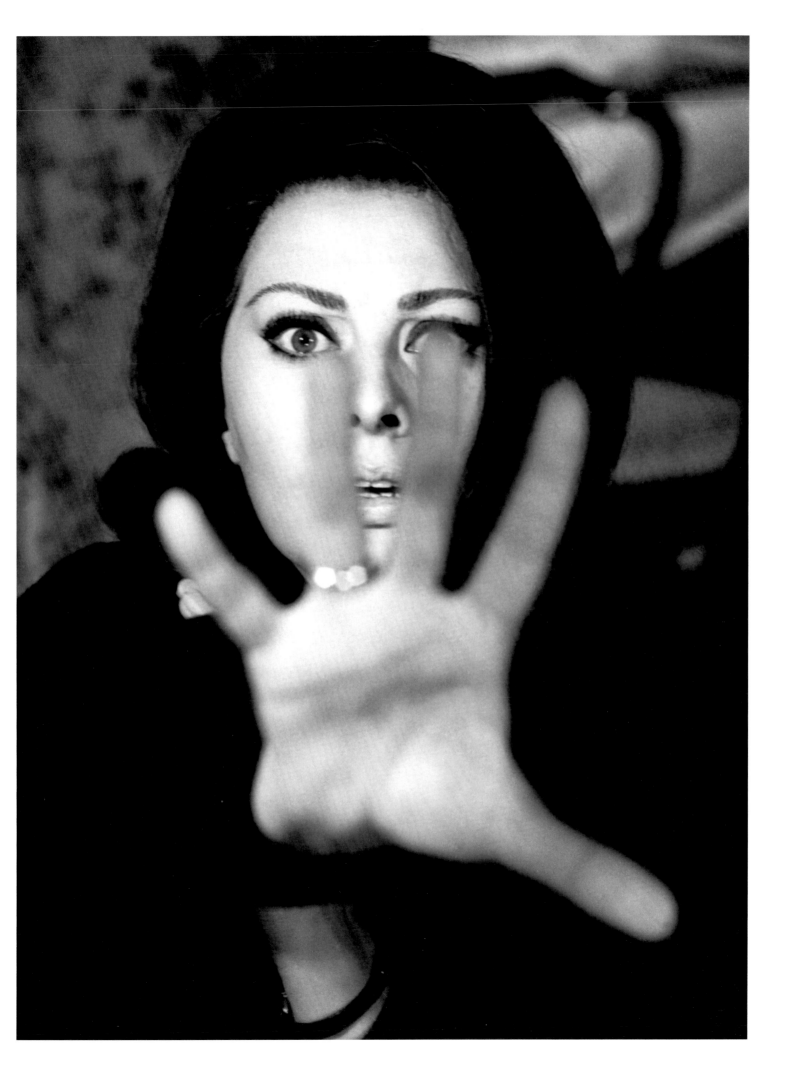

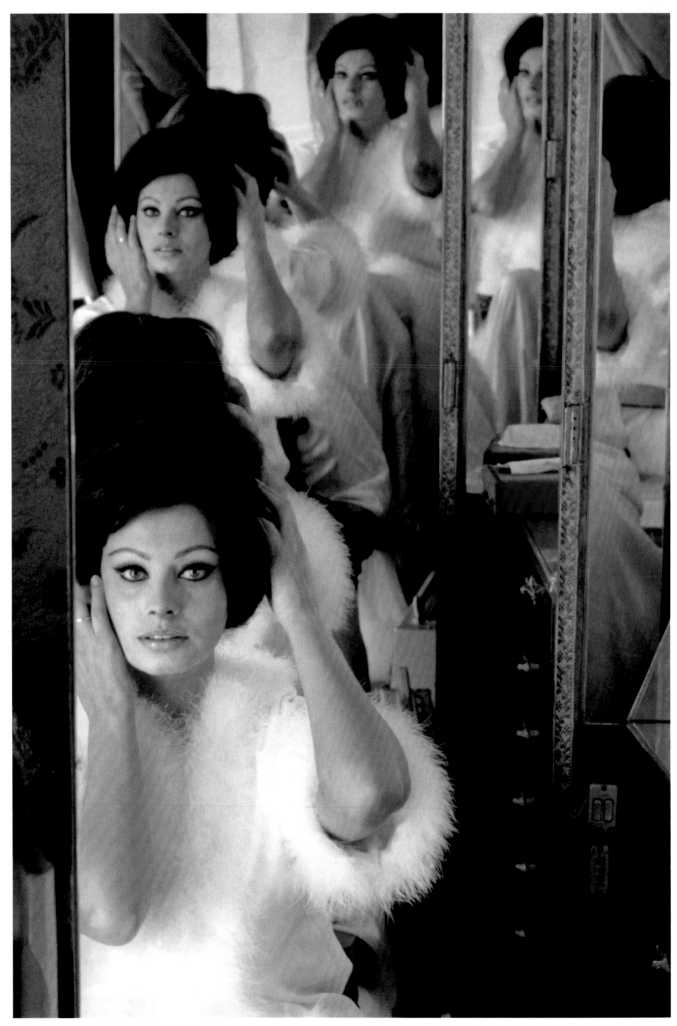

1963 / Sophia Loren at home in Rome.

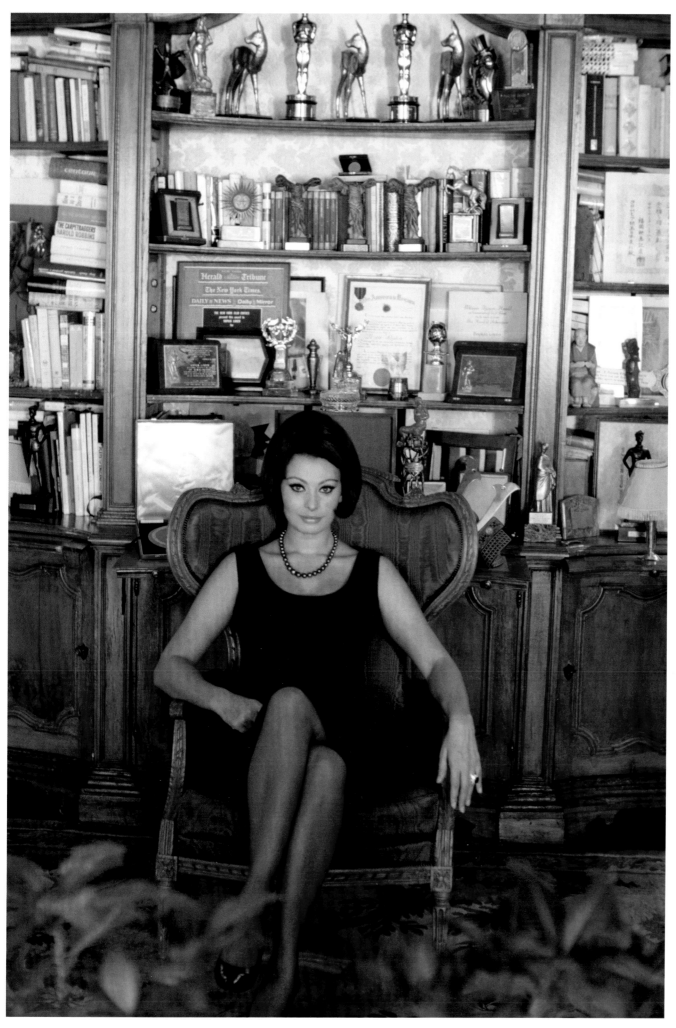

1963 / Sophia Loren pictured in front of the bookcase where she kept her awards. She won more than 40 awards throughout her career, of which the most prestigious were the Best Actress Oscar, several Golden Globe Awards and awards from the Cannes, Venice and Berlin Film Festivals.

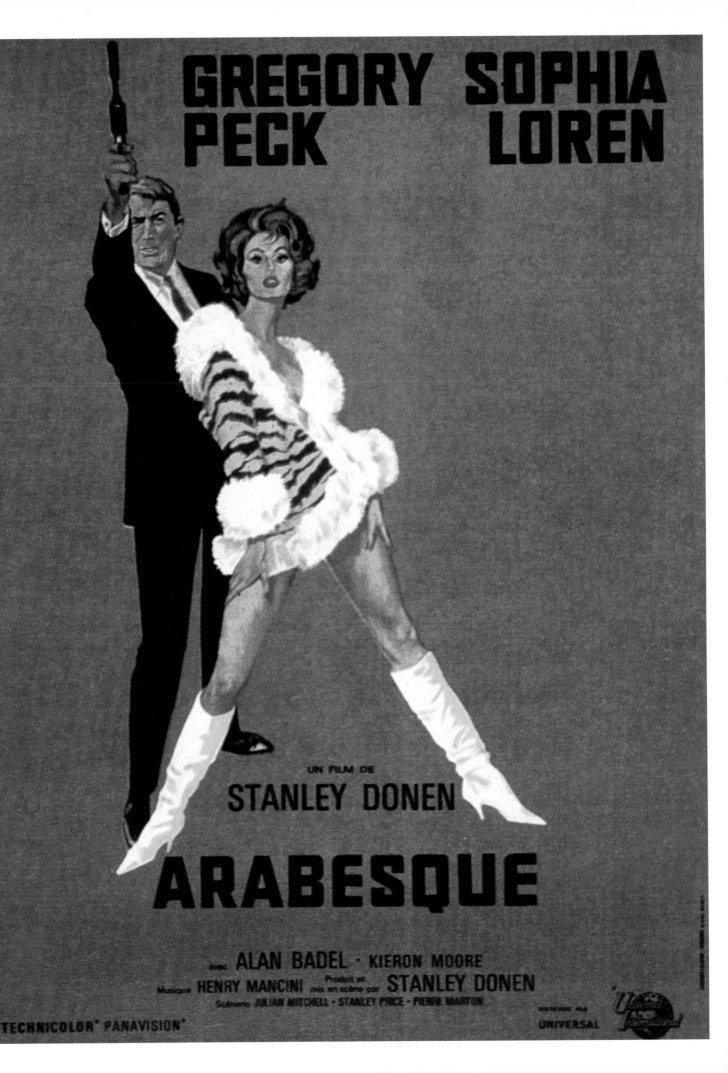

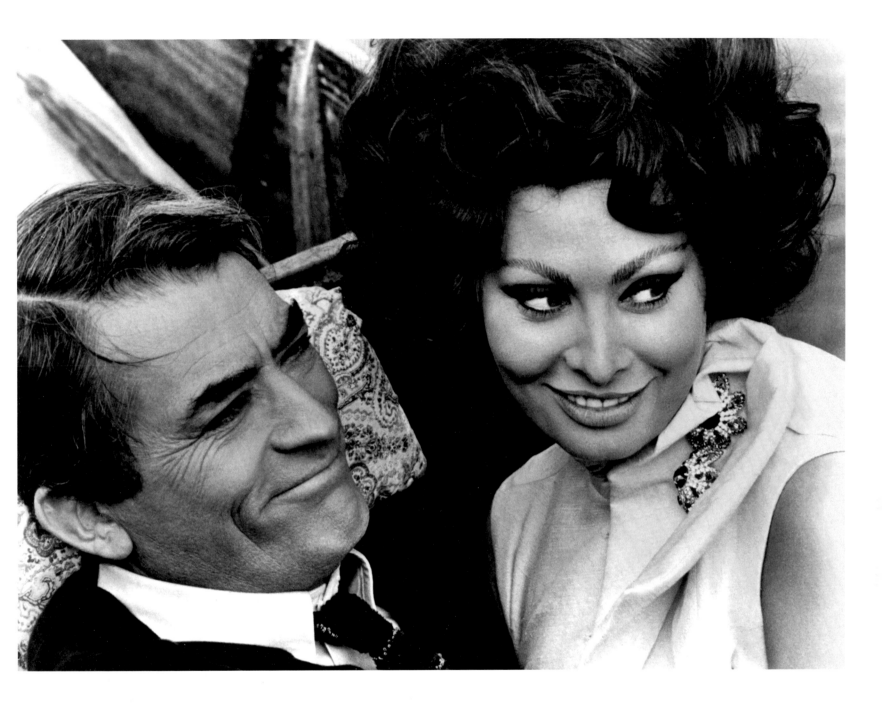

1966 / Poster for Stanley Donen's *Arabesque*, which won a BAFTA award for Best British Cinematography.

1966 / Sophia Loren and Gregory Peck shared billing for *Arabesque*. The film was adapted from Gordon Cotler's novel *The Cipher*.

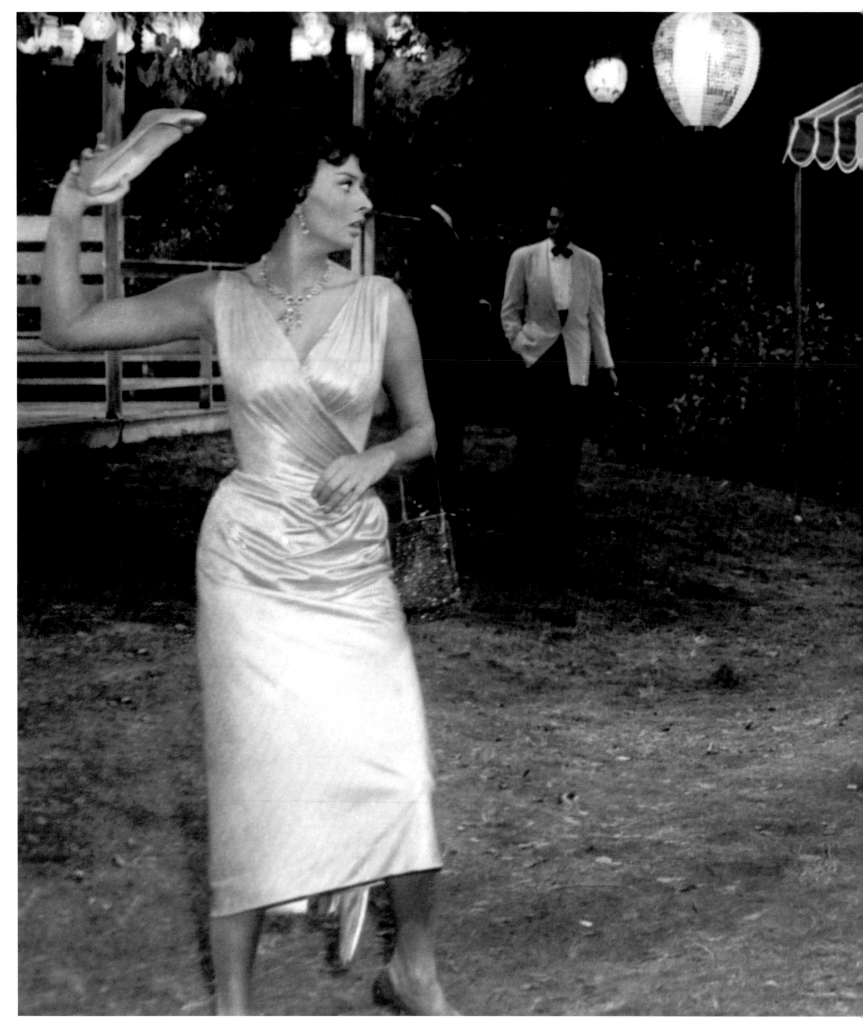

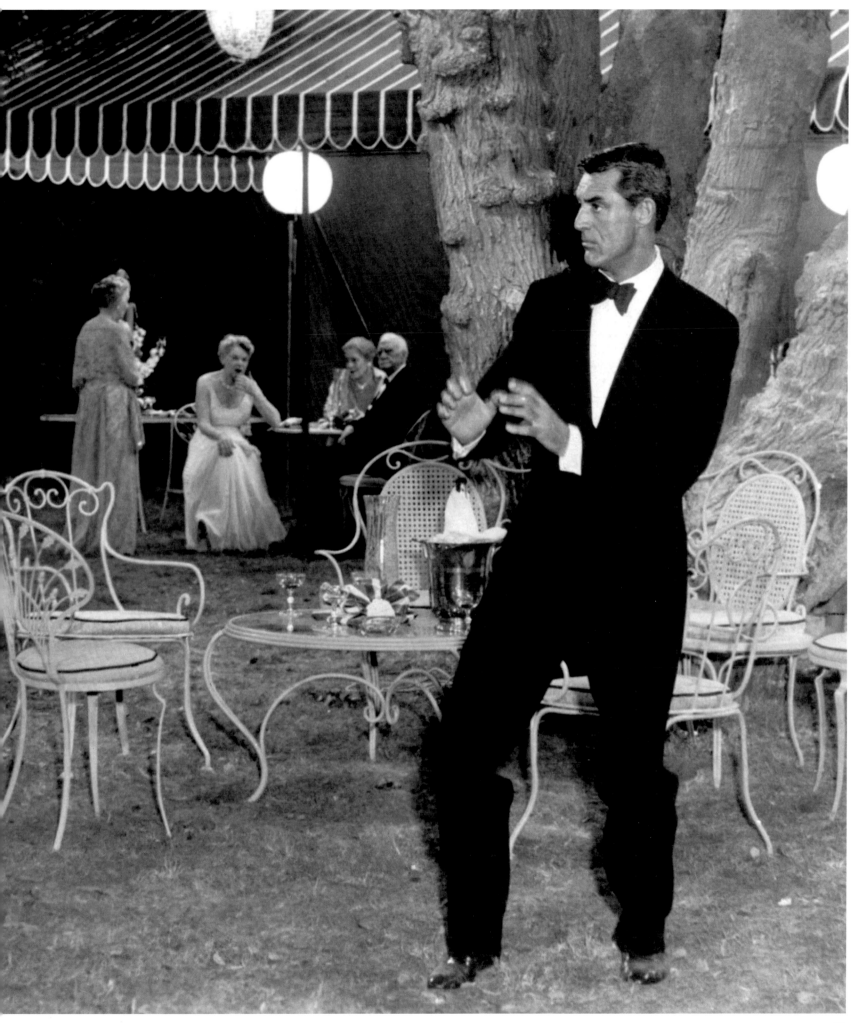

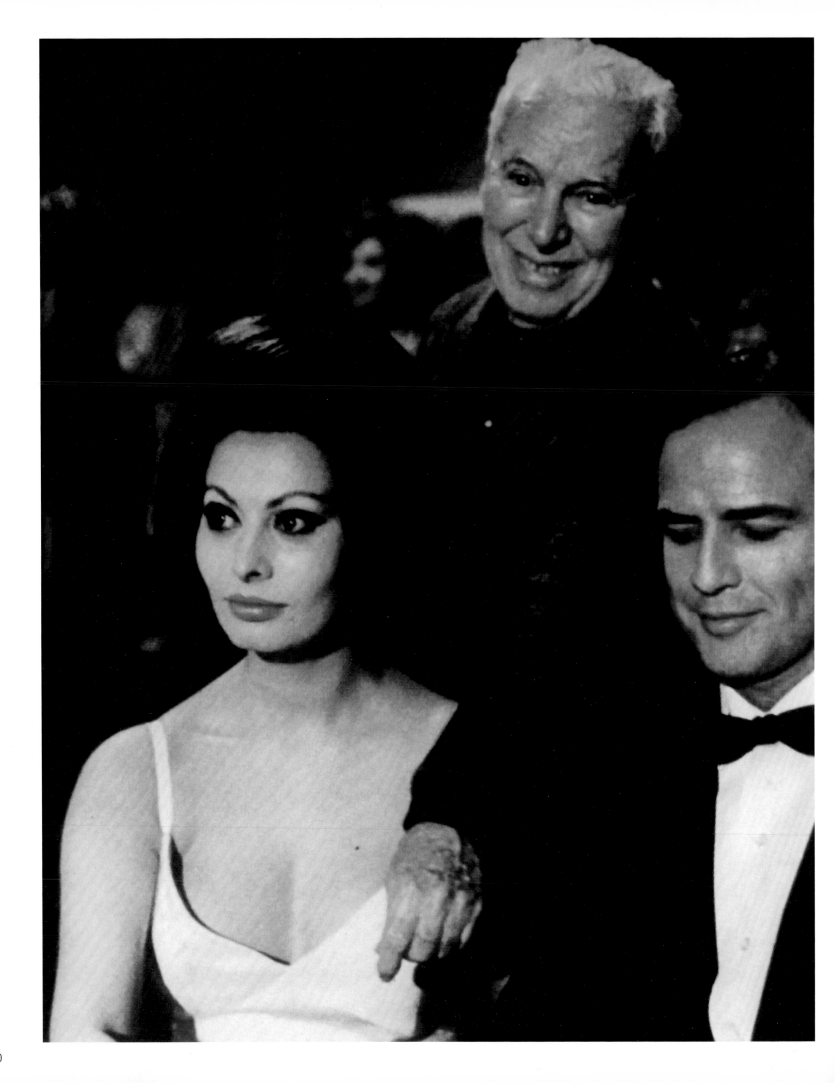

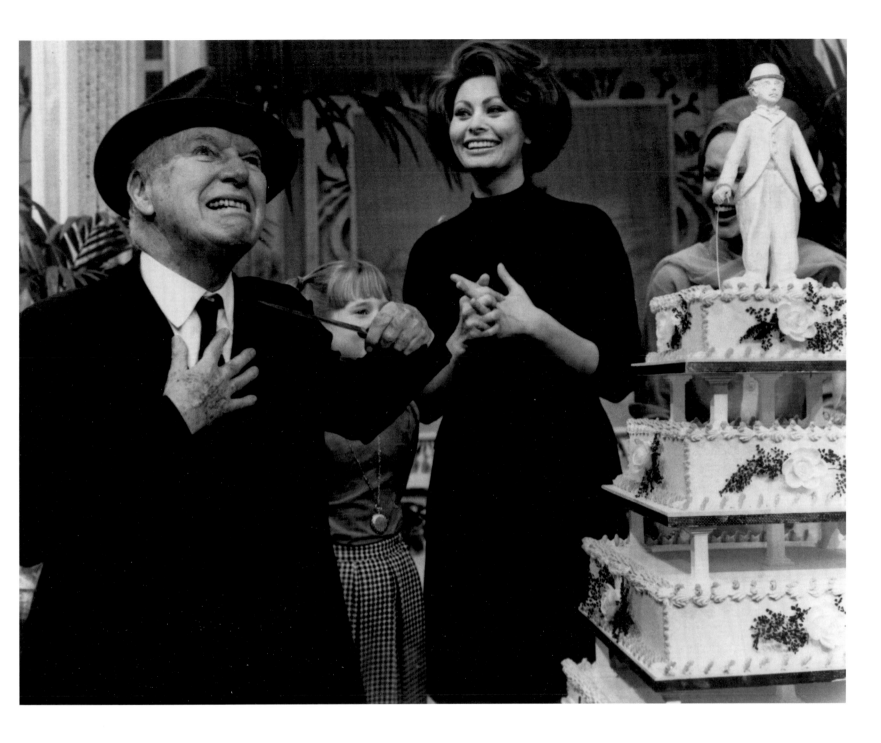

Previous pages :
1958 / Sophia Loren and Cary Grant in *Houseboat*, directed by Melville Shavelson.

1967 / *The Countess from Hong Kong* marked Charlie Chaplin's return to international cinema after ten years of absence. He offered the leading roles in his new film to Sophia Loren and Marlon Brando, but the two stars did not get on and barely spoke to each other during filming.

1966 / Charlie Chaplin and Sophia Loren became close friends. In April 1966 they celebrated the director's 77th birthday together.

"I always tell the truth.
I cannot be bothered
to lie – you need such
a good memory!"

Sophia Loren

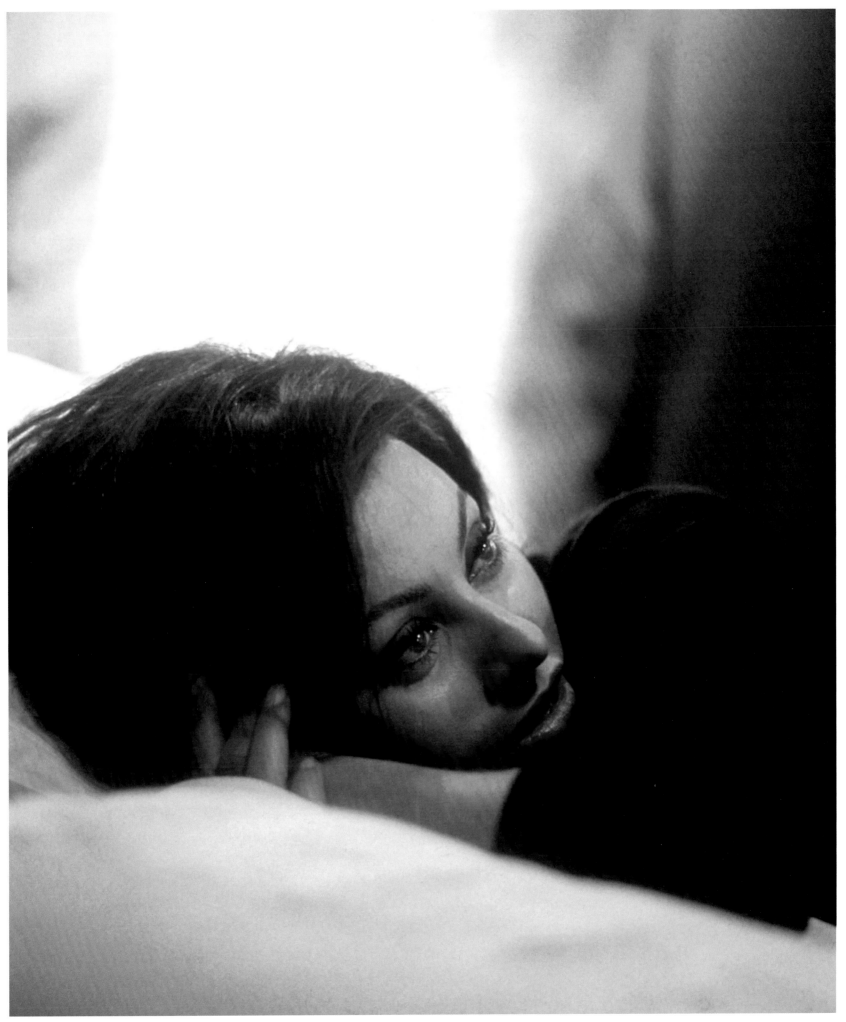

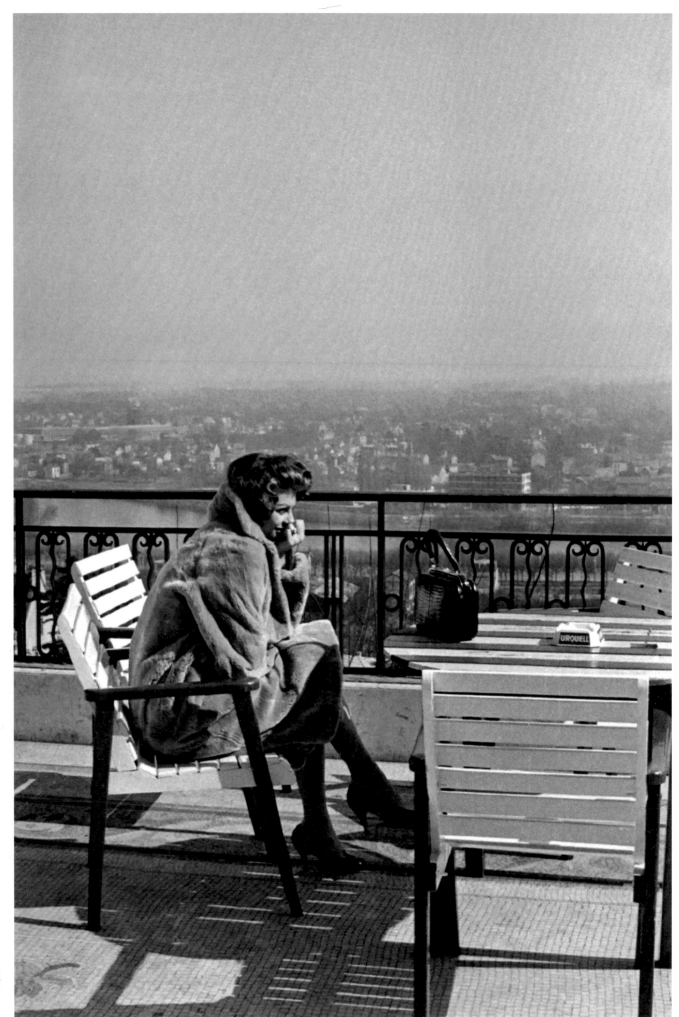

1956 / Sophia Loren in front of the chateau of Saint-Germain-en-Laye, in a western suburb of Paris.

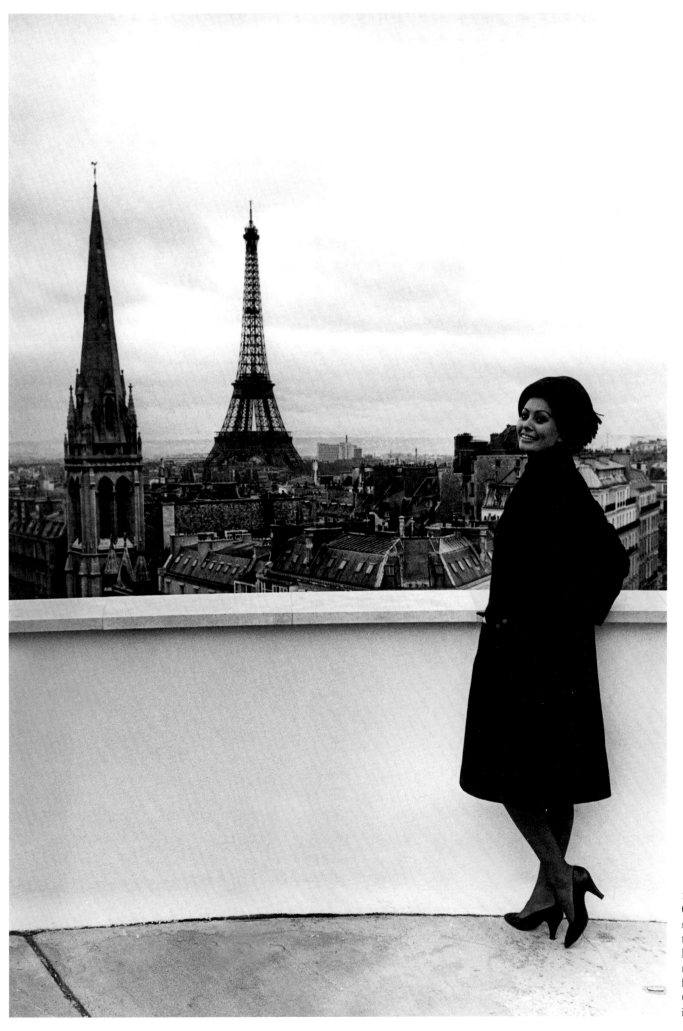

1964 / Sophia Loren and Carlo Ponti installed themselves in a splendid Parisian triplex near the Champs Elysées, in a bid to gain French nationality so that Carlo could finally divorce his ex-wife (which was impossible in Italy) and marry Sophia.

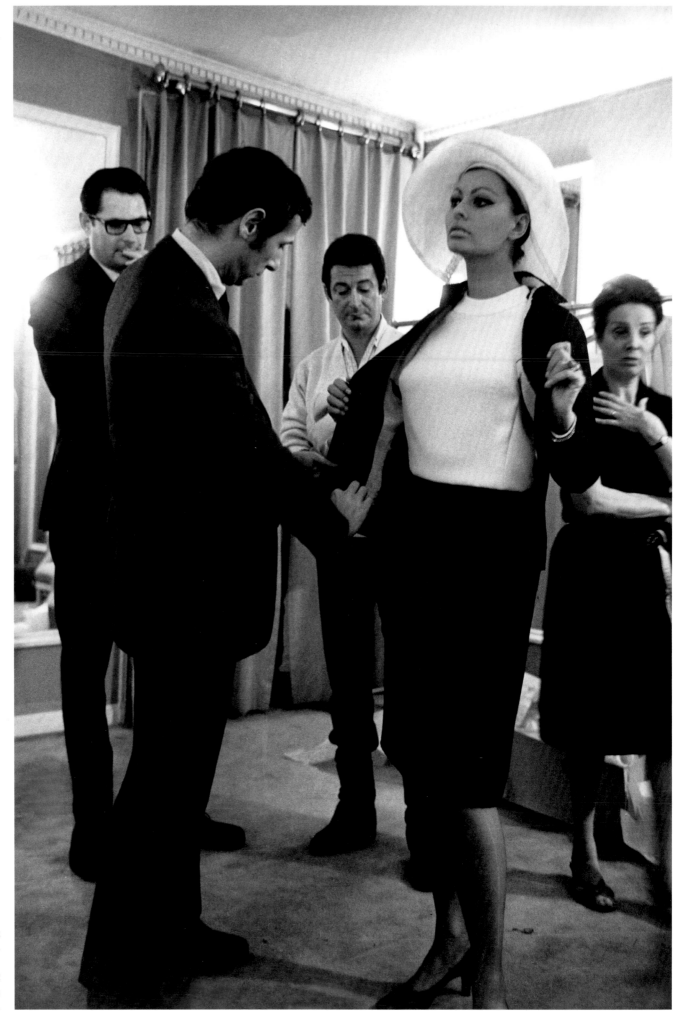

1960 / Sophia Loren has a fitting at Dior.

1966 / Sophia Loren in front of the Gucci boutique in Rome.

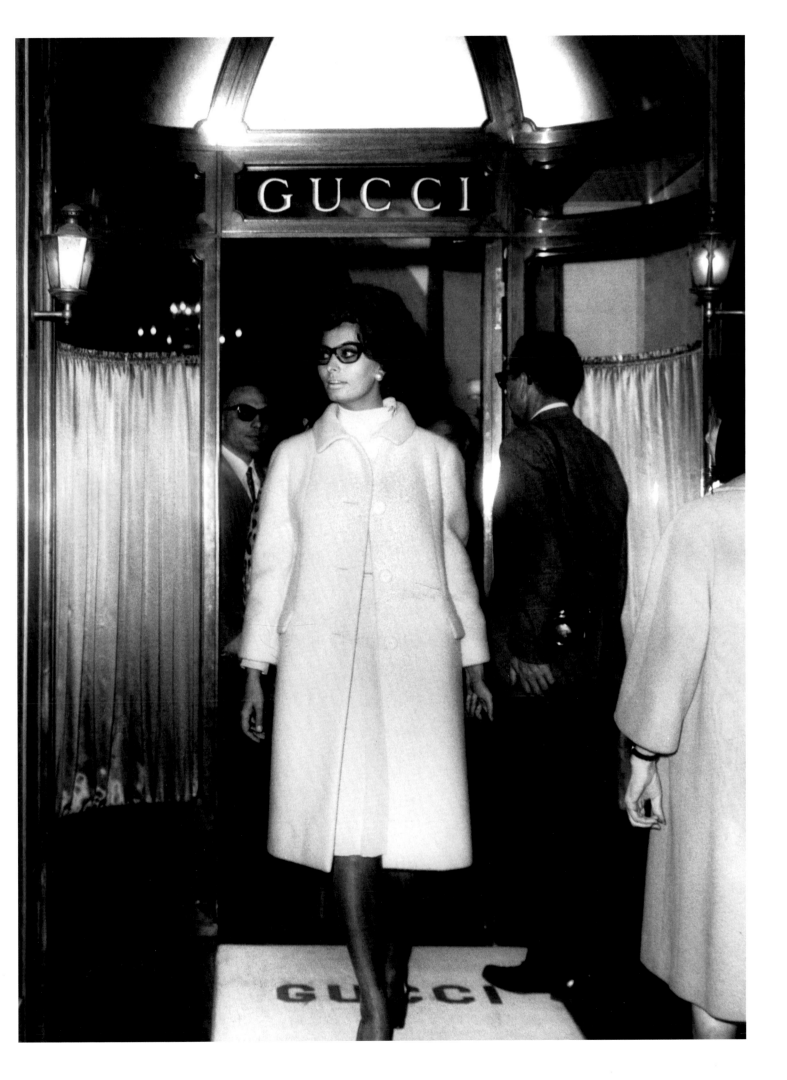

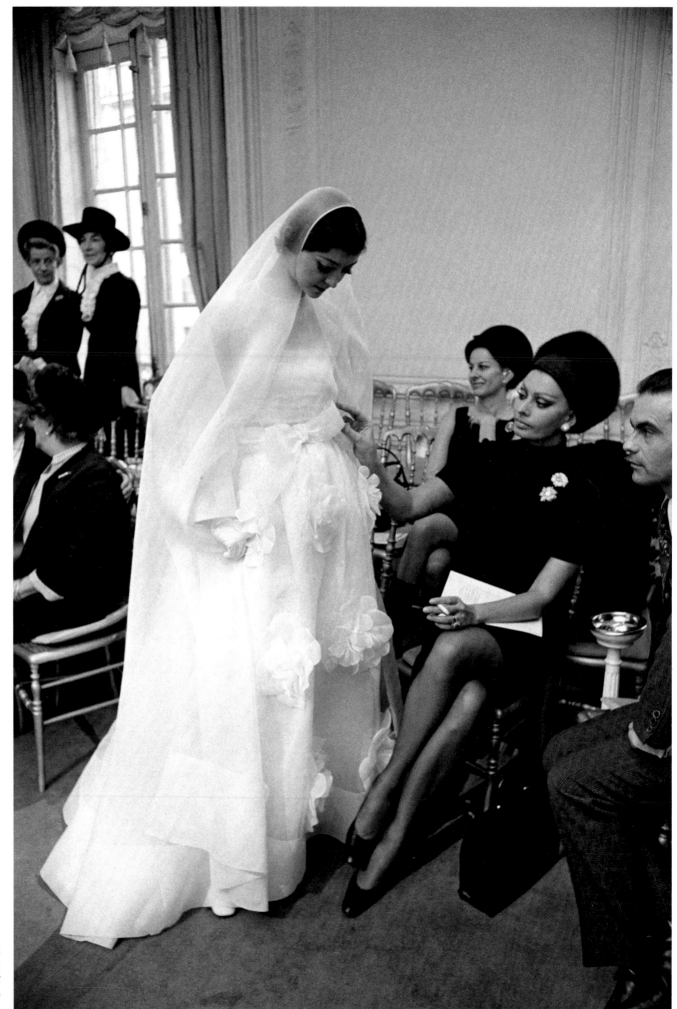

1968 / Sophia Loren at a Christian Dior couture show; she is paying particular attention to the collection's wedding dress.

"I often call her 'the last true diva'. (...) Sophia isn't loved because she is beautiful. She is loved because she is real."

Gianfranco Ferré, couturier

1972 / Sophia Loren during the filming of Alberto Lattuada's *The Sin* (aka *White Sisters*).

160

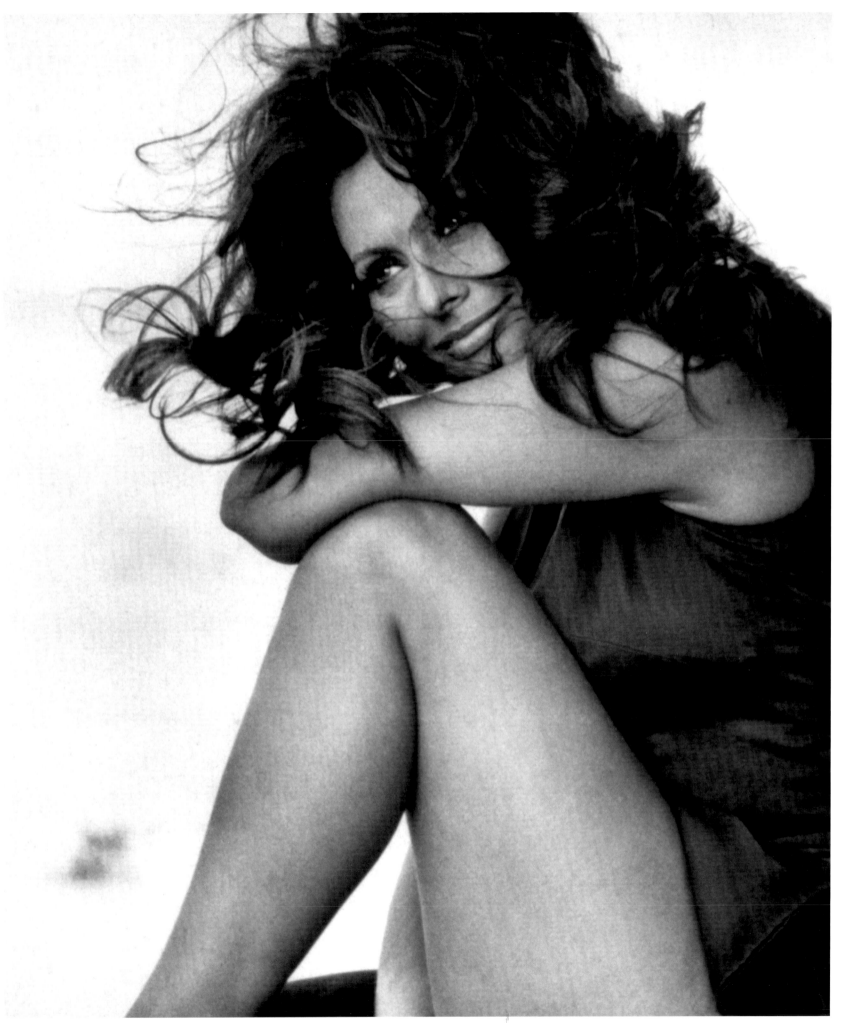

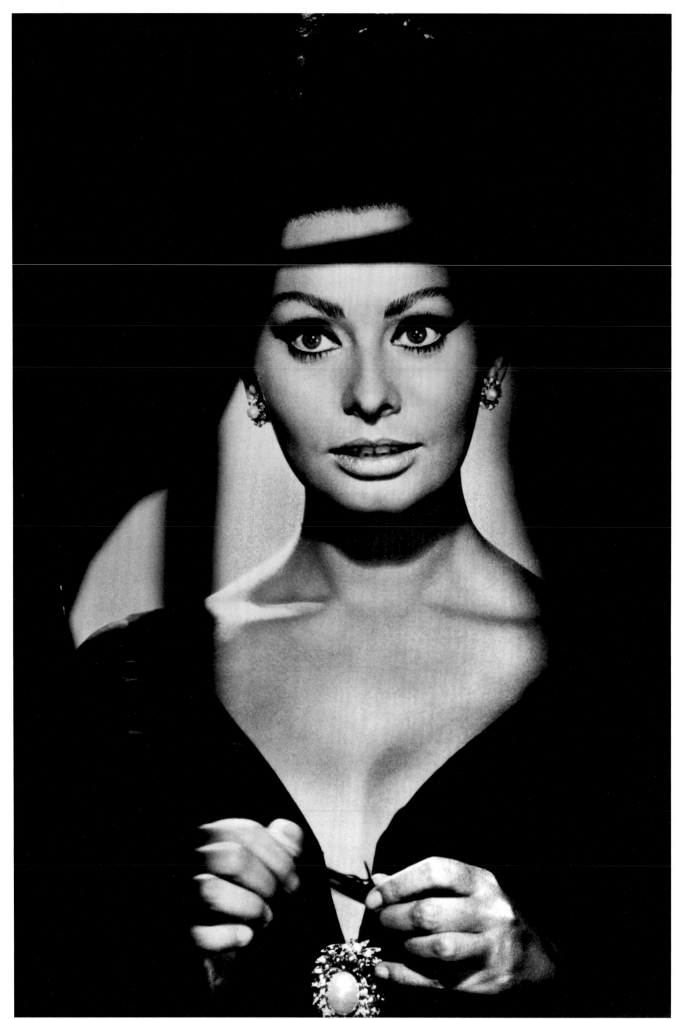

1966 / Sophia Loren on the set of Stanley Donen's *Arabesque*.

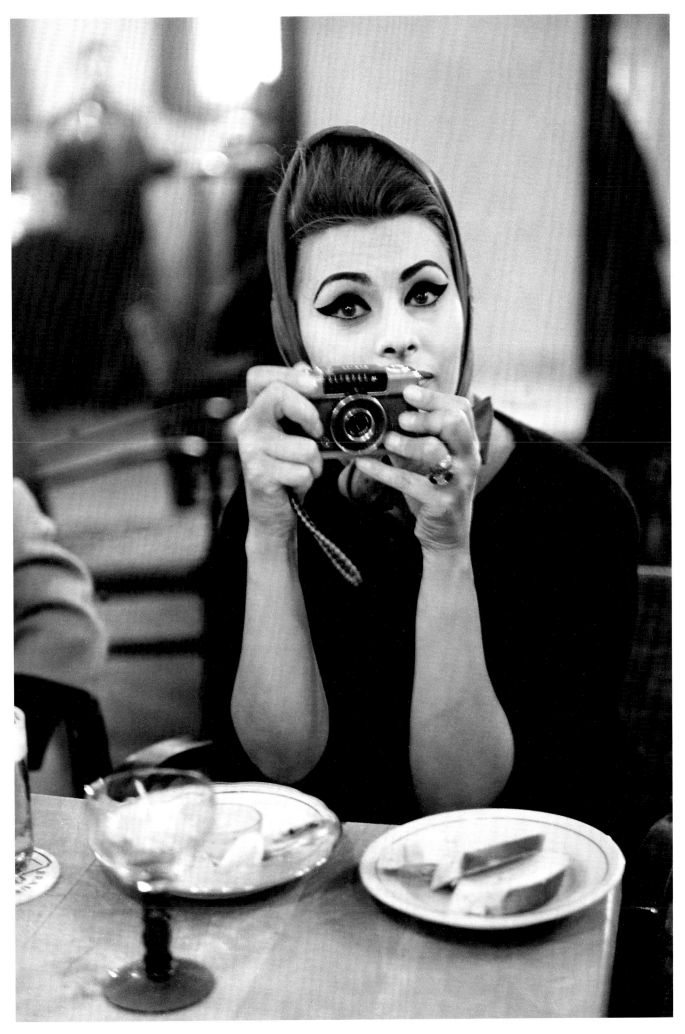

1963 / Sophia Loren, en route to Berlin.

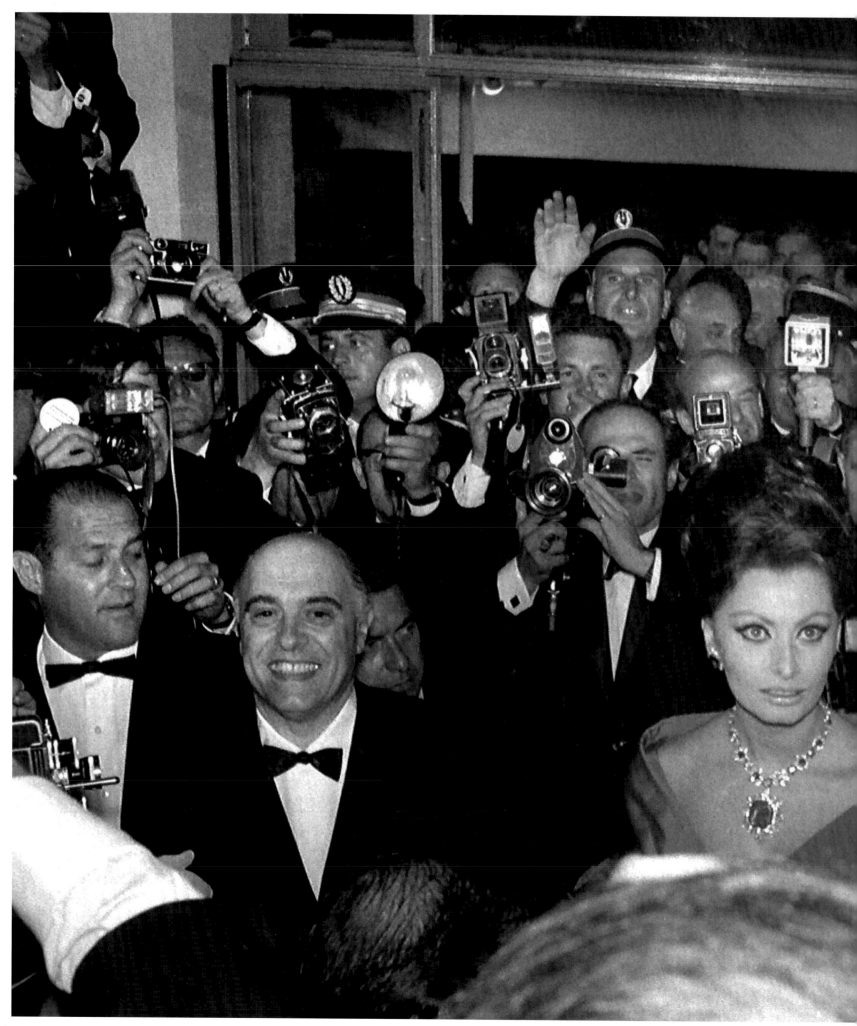

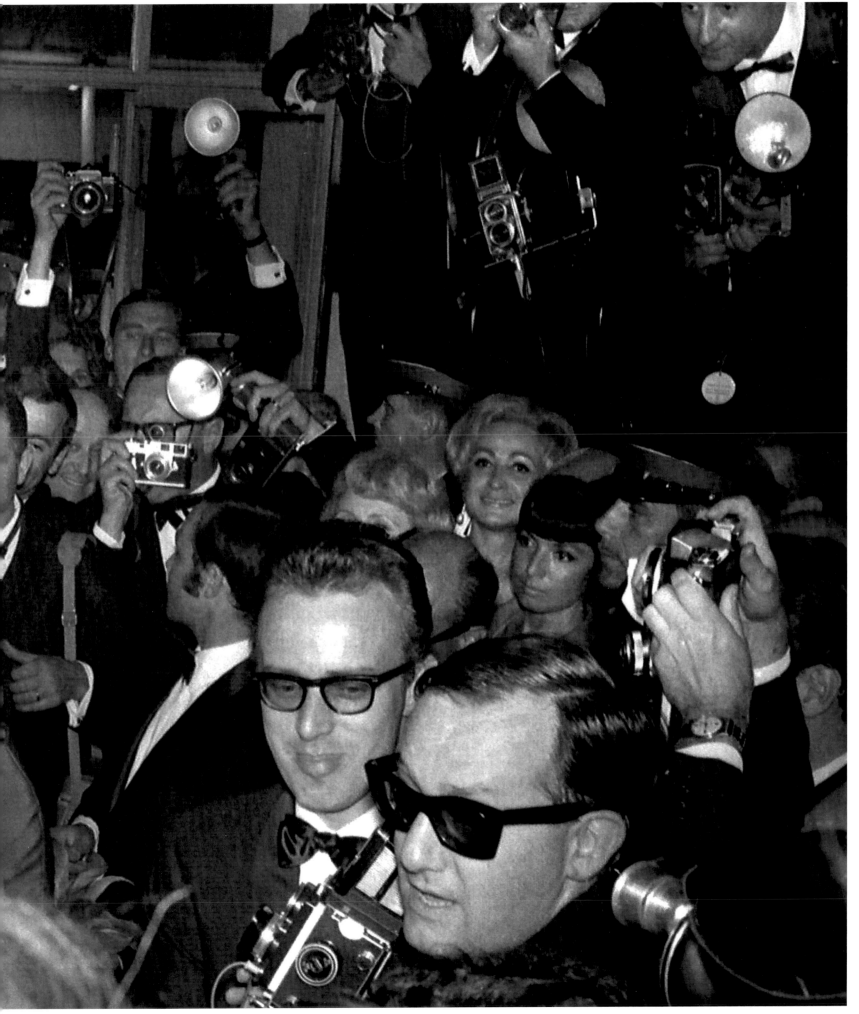

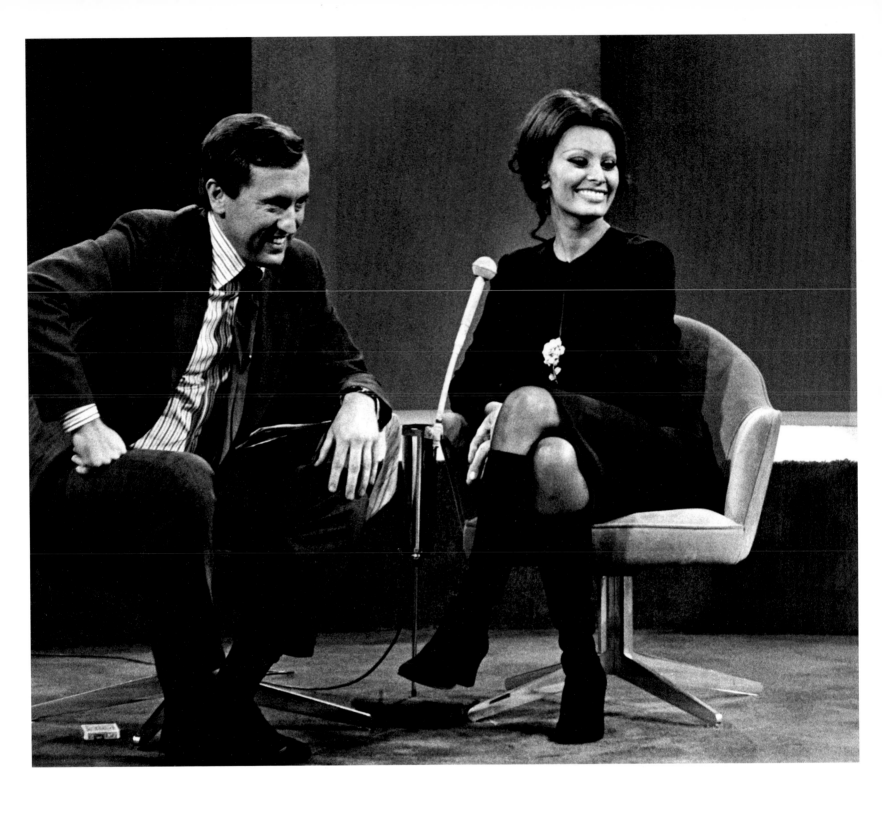

Previous pages :
1966 / Sophia Loren and her husband Carlo Ponti make their way through a crowd of journalists at the Cannes Film Festival for a showing of her latest film, *Judith*, directed by Daniel Mann.

1972 / Sophia Loren is interviewed by David Frost at the ABC studios for *The David Frost Show*.

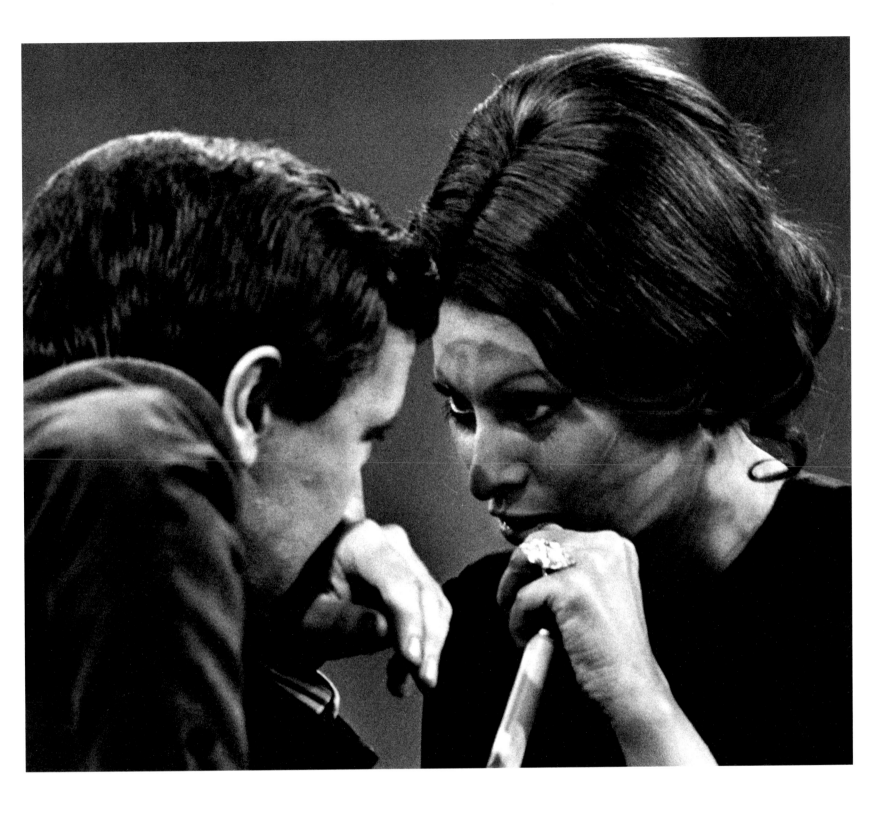

"When you are a mother, you are never really alone in your thoughts. A mother always has to think twice, once for herself and once for her child."

Sophia Loren

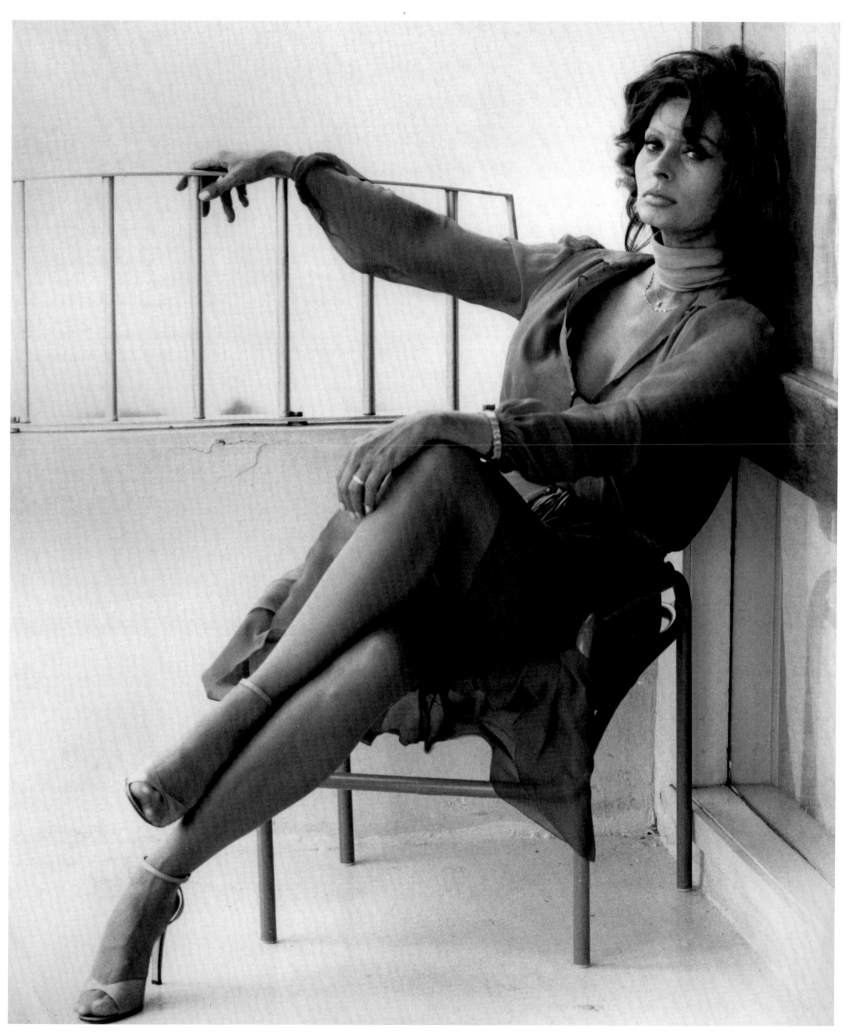

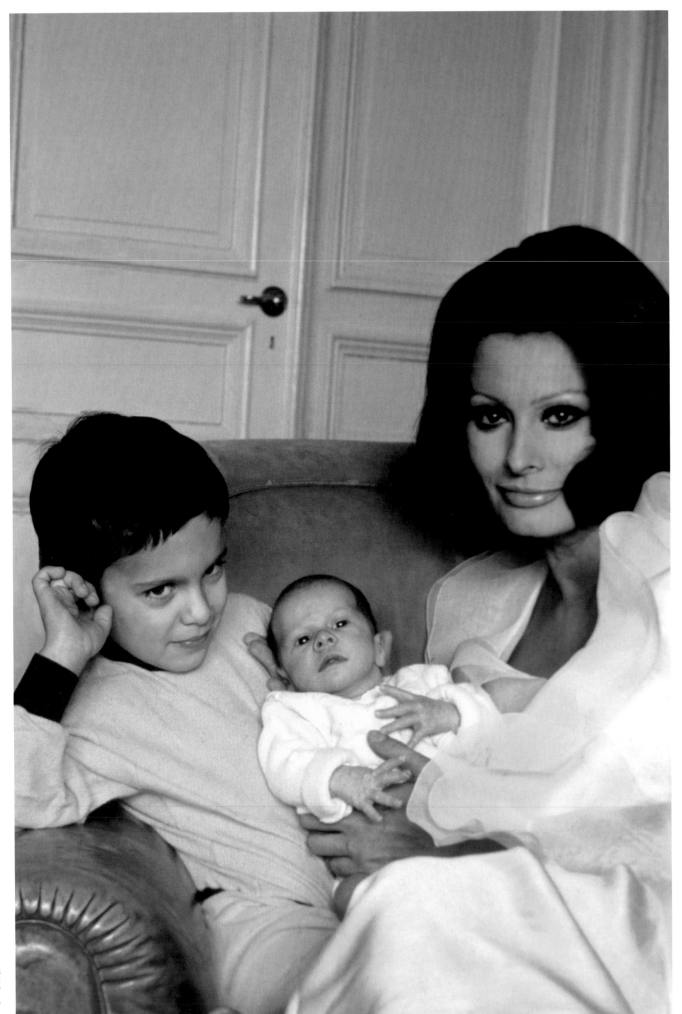

1973 / Sophia Loren with her two sons, five-year-old Carlo Jr. and Edoardo, a few months old.

170

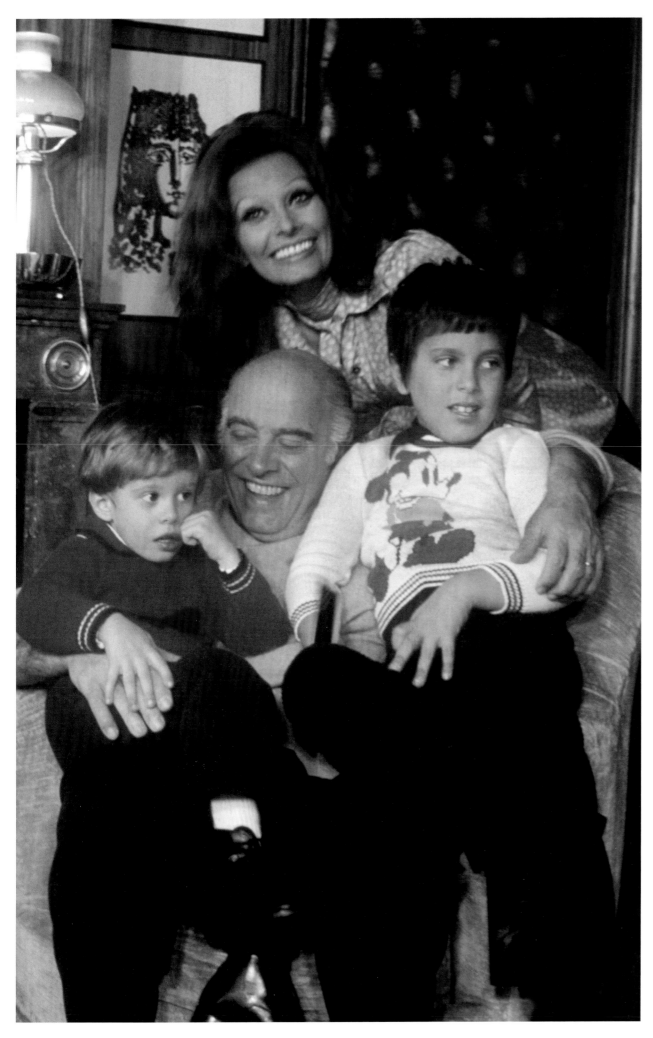

1976 / Family portrait:
Sophia, Carlo and their
children, Carlo Jr. aged eight
and Edoardo, three.

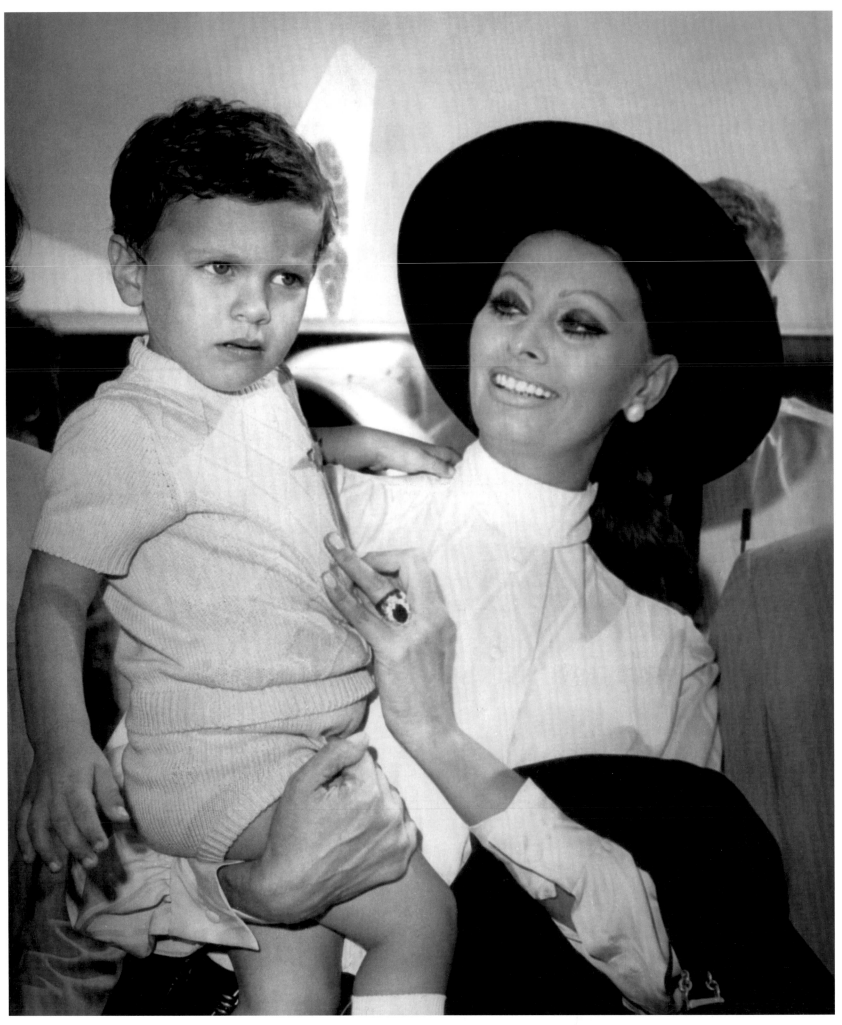

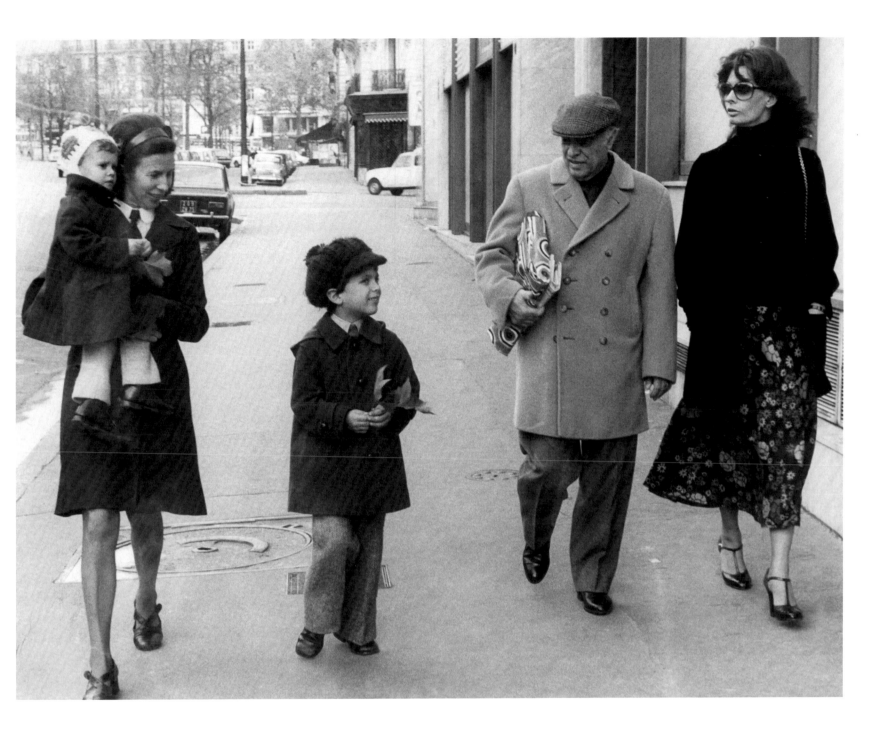

1972 / Sophia Loren arrives at Rome airport with her son Carlo Jr., aged four.

1976 / A family stroll through Paris: Sophia and Carlo with their children Carlo Jr and Edoardo, carried by his nanny.

"She's the mostest."

Frank Sinatra

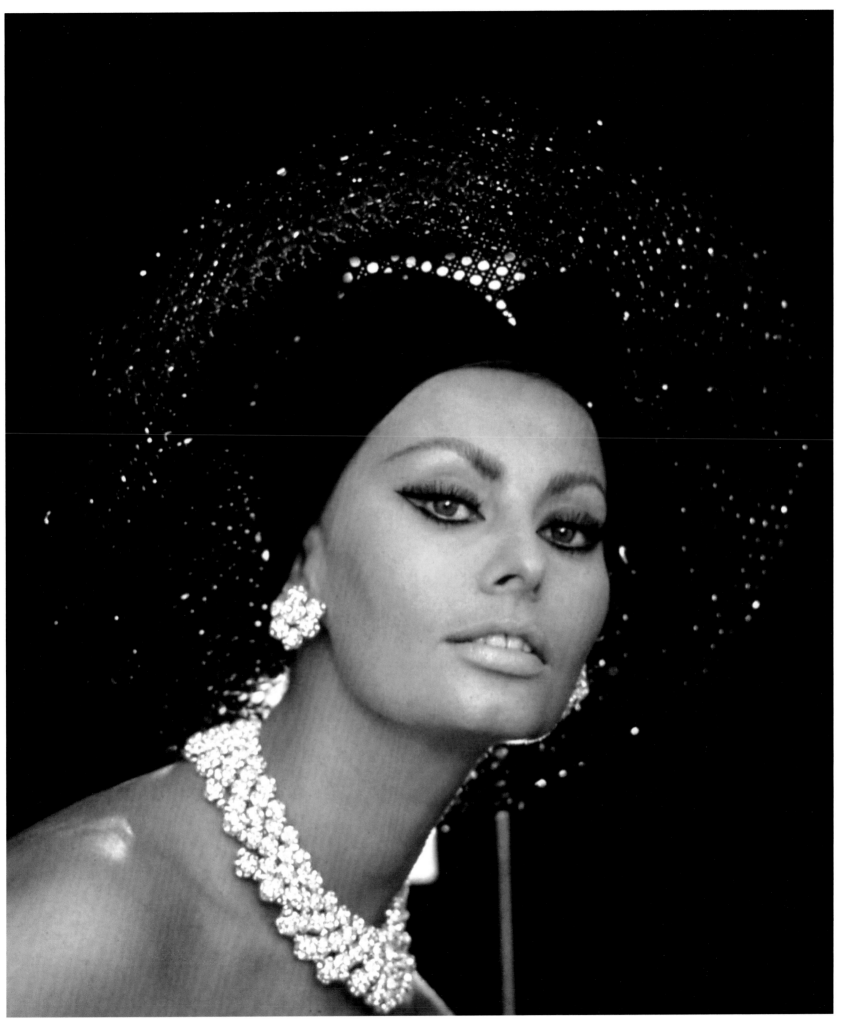

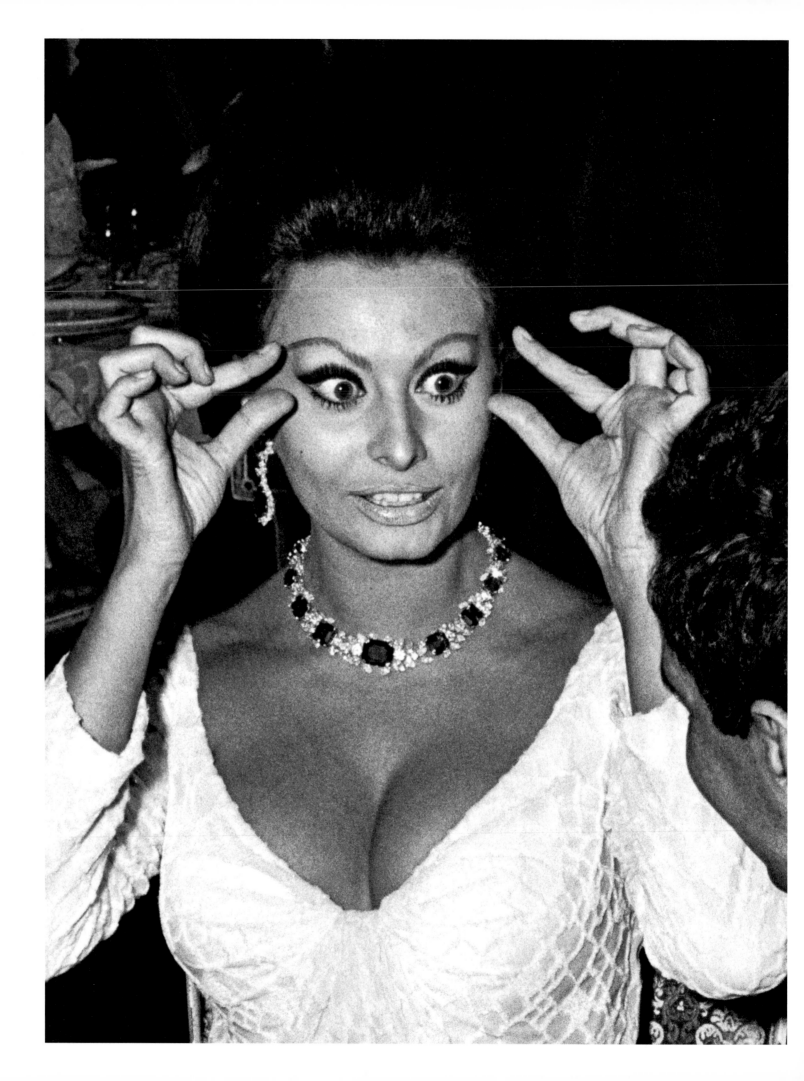

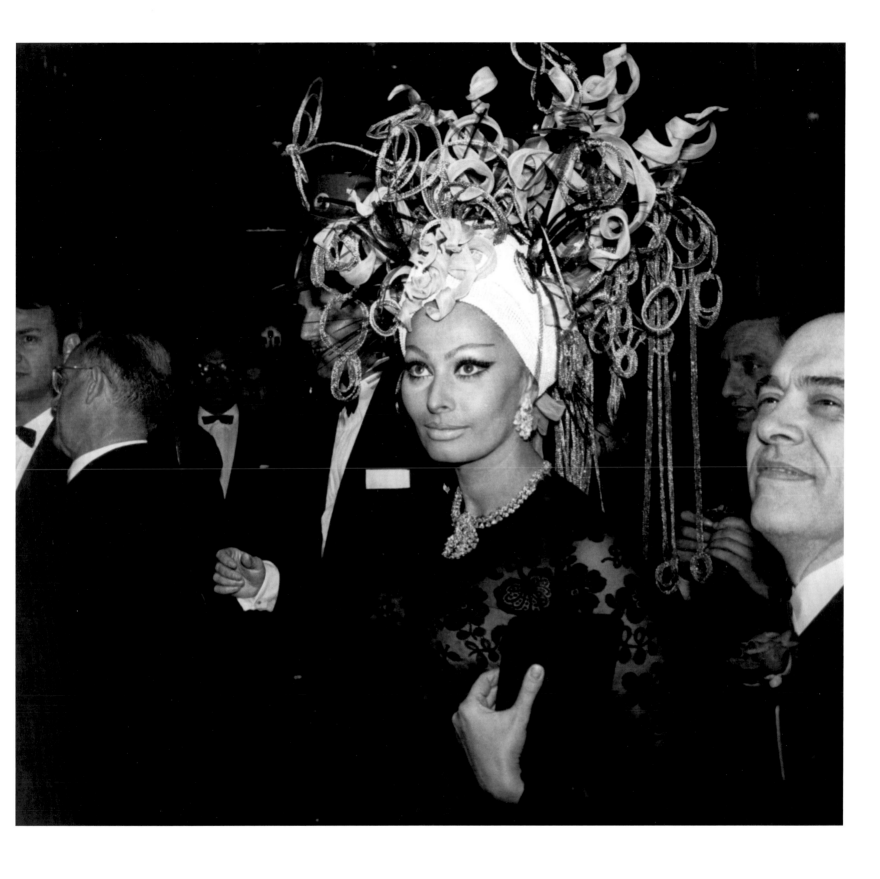

1965 / Sophia Loren attends a party organised in New York for the premiere of *Dr Zhivago*, by David Lean.

1969 / Sophia Loren, attired as Goddess of the Sea, and her husband, producer Carlo Ponti, attend a charity ball at the Monte Carlo Casino.

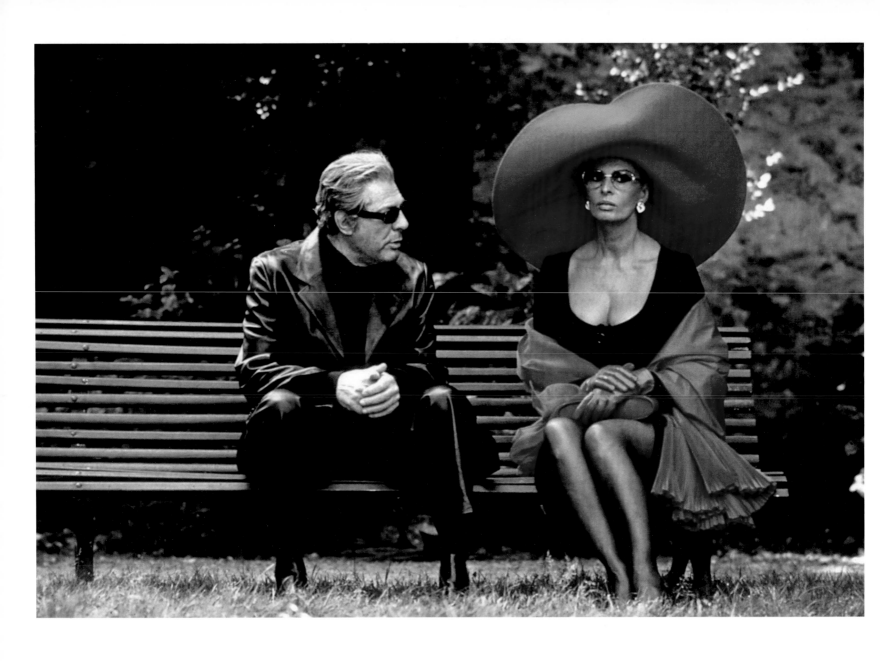

1994 / Robert Altman's film *Pret-à-Porter* is set in the world of Paris high fashion. As usual, the director assembled a galaxy of stars, including Marcello Mastroianni, Kim Basinger, Rupert Everett, Julia Roberts, Tim Robbins, Forest Whitaker, Lauren Bacall and Sophia Loren.

1994 / Sophia Loren at Christian Dior's haute couture presentation, Paris.

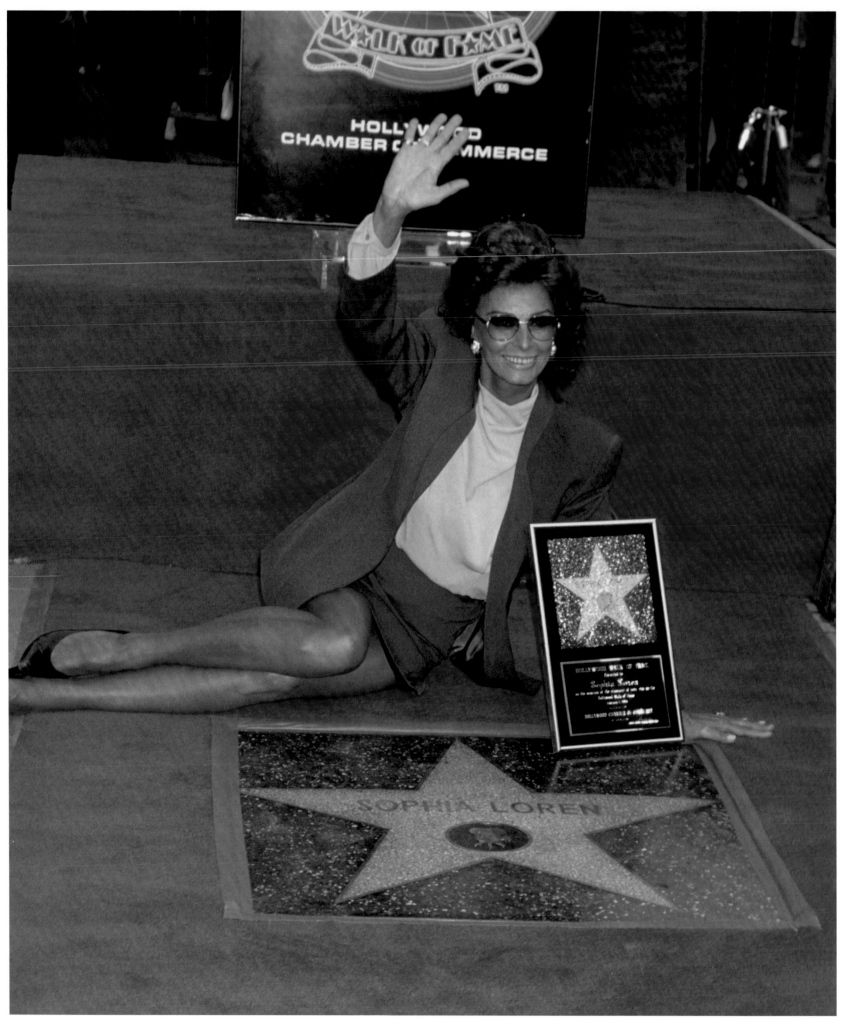

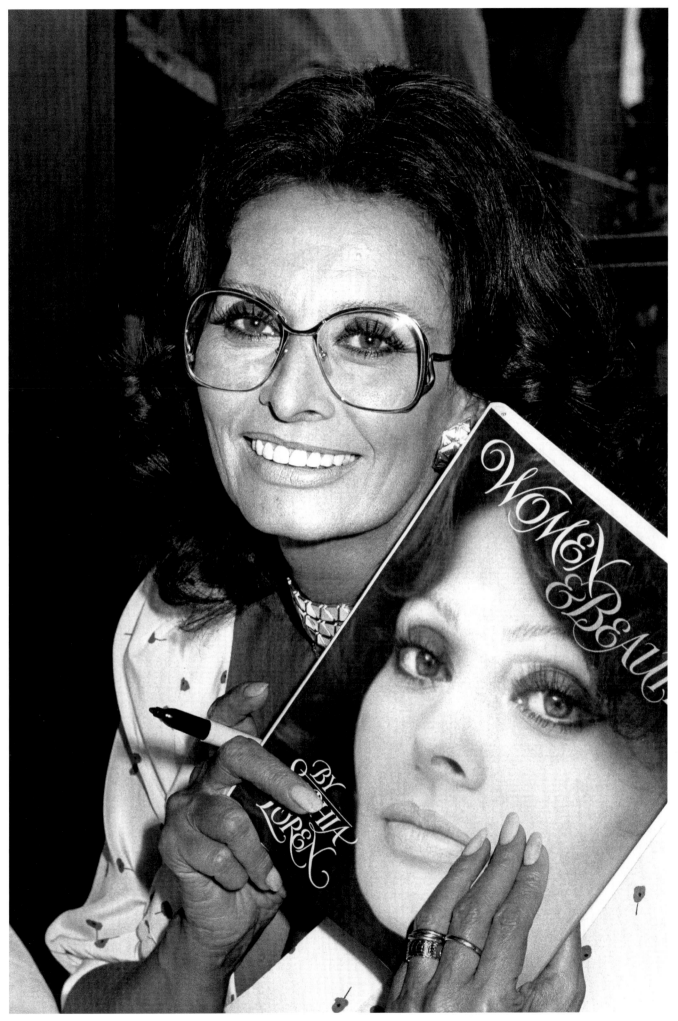

1994 / Sophia Loren unveils her star on the famous Walk of Fame on Hollywood Boulevard.

1984 / Sophia Loren signs her book *Women and Beauty* at the Beverly Wilshire Hotel.

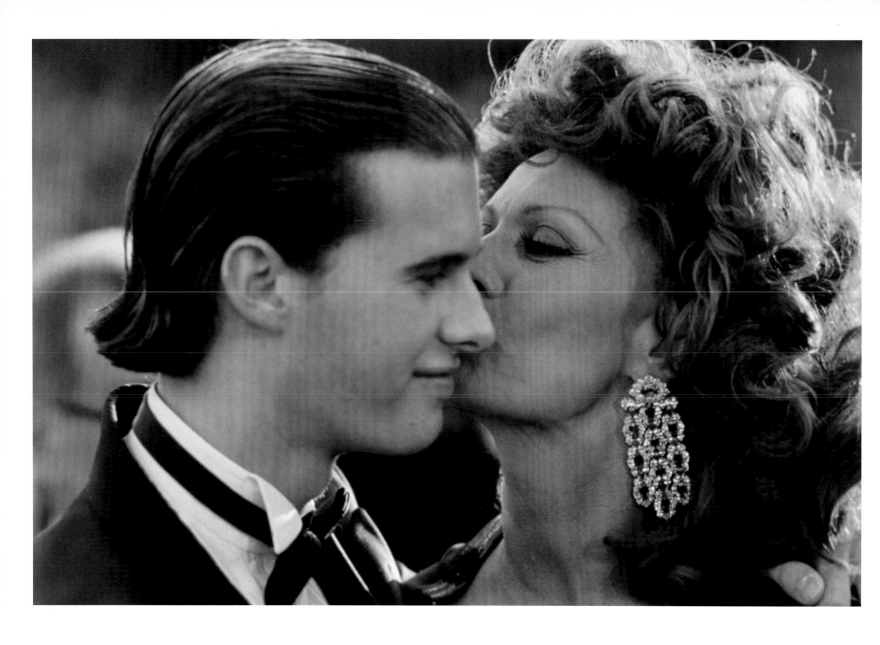

Previous pages :
1982 / Sophia Loren travels to New York to promote her perfume, 'Sophia'.

1991 / Sophia Loren and her son on their way to the Oscar ceremonies, where she will win an award.

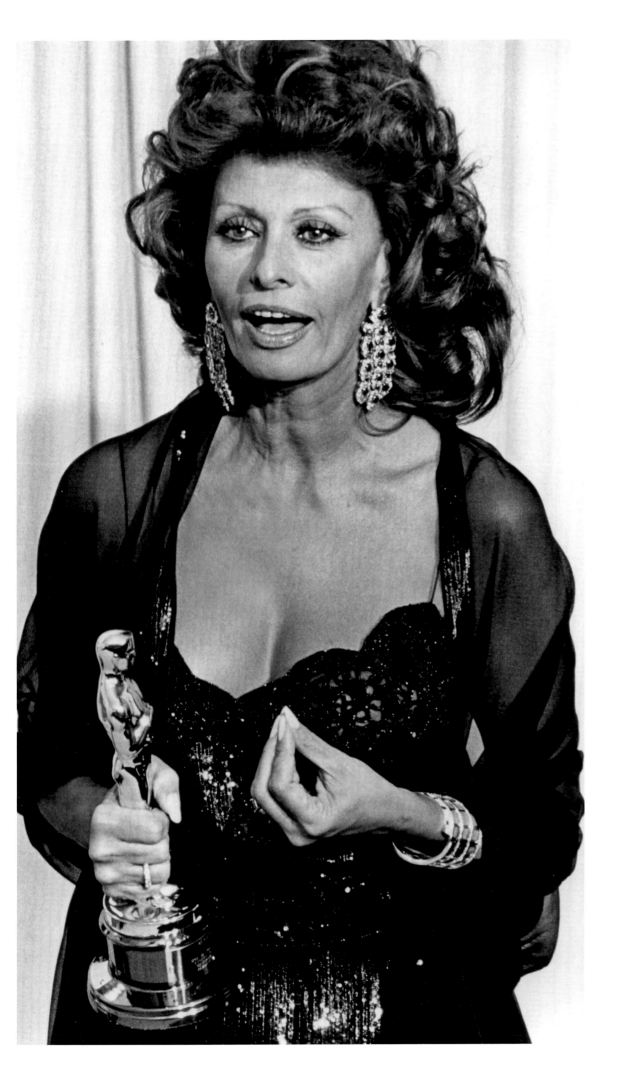

1991 / Sophia Loren received an honorary Oscar for being 'one of the genuine treasures of world cinema'. It came 29 years after the one she was awarded for her role in *Two Women*.

"I've never sold myself short. I have never judged myself by other peoples standards. I have alway's expected a great deal of myself, and if I fail, I fail myself."

Sophia Loren

1988 / Sophia Loren still poses alluringly for the world's best photographers. Italy's most famous actress is the epitome of Italian elegance and style.

186

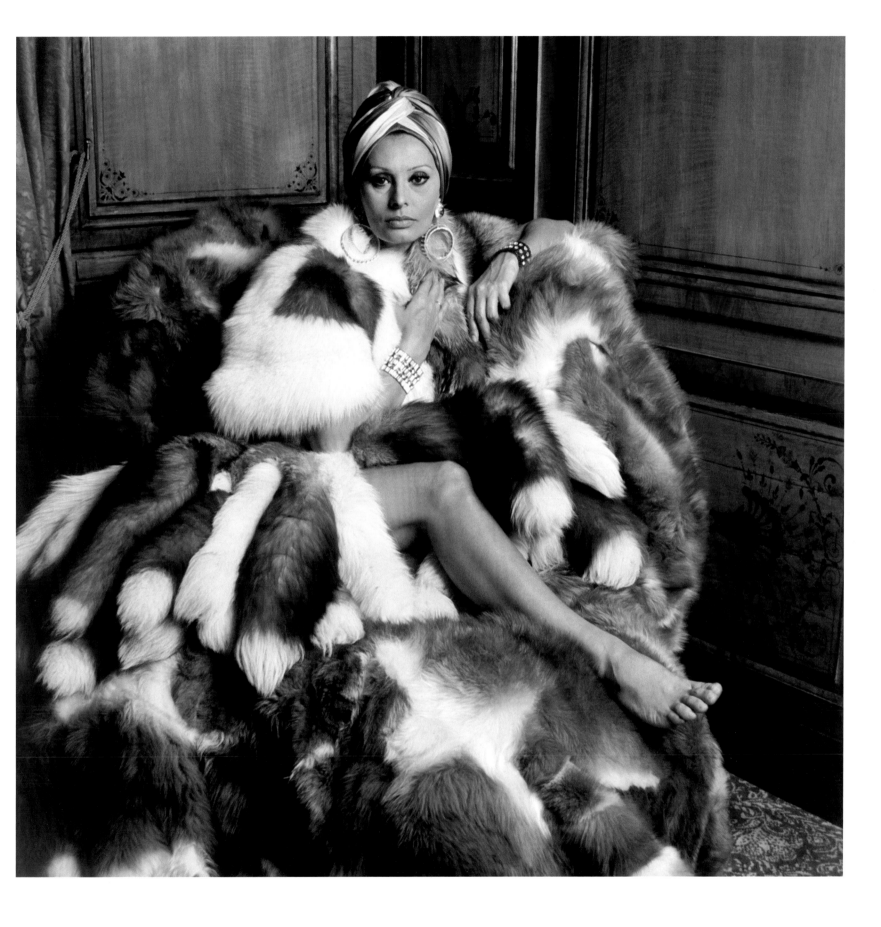

Important Dates

1930 – Aged 17, Sofia's mother wins a Greta Garbo lookalike contest organized by MGM. Her prize is a ticket to Hollywood and a chance to become Garbo's stand-in, but her mother refuses to let her go.

1934 – Sofia Scicolone is born in the Regina Margherita Clinic, Rome.

1935 – Her father abandons them. Destitute, Romilda Villani moves back to her parents' home with her daughter Sophia.

1938 – Birth of her sister Maria by the same father, Riccardo Scicolone, who refuses to recognize her as his daughter and disappears again.

1940 – War is raging. Sofia will always remember the hunger, thirst and fear.

1943 – During air-raids, Romilda and her two daughters, Sofia and Maria, leave Pozzuoli and take refuge with cousins in Naples.

1944 – Naples is liberated by Scottish troops. Sofia returns to Pozzuoli, where she finds the family home has been destroyed by the bombing.

1945 – Hollywood films are no longer banned by Italy's totalitarian regime. Sofia discovers the cinema and is enraptured.

1947 – Her gym teacher asks Sofia to marry him. Her mother refuses – she has other plans for her daughter, now grown into a splendid adolescent.

1948 – Romilda enters her daughter in a beauty contest. Sofia is one of twelve finalists and wins a train ticket to Rome and the equivalent of a labourer's pay for two months.

1949 – Sofia goes to film castings. The director of *Sogno*, a photo-romance publication, hires her and offers her a key role in a series of 80 episodes. He renames her Sofia Lazzaro; soon her face is known throughout Italy, but as yet she has only walk-on roles in the movies.

1950 – She gets her first small parts and meets Marcello Mastroianni, in *Cuori sul Mare (Hearts at Sea)*. Their movie careers will be linked.

1951 – Producer Carlo Ponti spots her at a beauty contest.

1952 – The producer of *Africa sotto I mari (Africa Under the Seas)* persuades her to change her name to Sophia Loren.

1953 – She gets her first big notices for *Aida* and signs a one-year contract with Carlo Ponti, with whom she soon embarks on a secret liaison: 22 years her senior, he is married and has two children.

1954 – Aged 20, Sophia Loren has her first international success with Vittorio De Sica's *L'Oro di Napoli (The Gold of Naples)*.

1956 – Stanley Kramer offers her $200,000 to star in *The Pride and the Passion* with two of her idols: Frank Sinatra and Cary Grant, who asks her to marry him. She turns him down.

1957 – She signs a four-film contract with Paramount. Her international career is launched. She reads in a newspaper that Carlo Ponti's lawyers have arranged a Mexican divorce for him, followed by his wedding to Sophia. The Italian church denounces the couple as bigamists.

1958 – Her first dramatic role in *Desire under the Elms*. She co-stars with Cary Grant, more in love than ever, in *Houseboat*, and wins the Best Actress Award at the Venice Film Festival for *The Black Orchid*.

1960 – Receives the Palme d'Or at Cannes and a Best Actress Oscar for her role in *La Ciociara (Two Women)*. The Mexican marriage is annulled on the grounds of irregularities.

1963 – Makes *Ieri, Oggi, Domani (Yesterday, Today and Tomorrow)* with Marcello Mastroianni. The striptease scene will become a cult. Sophia gets pregnant but loses her baby a few weeks later.

1964 – Sophia and Carlo settle in Paris and apply for French nationality.

1966 – Carlo Ponti gets a French divorce; in spring he marries Sophia, who is President of the Cannes Film Festival.

1967 – In his return to the cinema, Charlie Chaplin offers Sophia the lead in *A Countess from Hong Kong*, starring opposite Marlon Brando. At 33 Sophia has a second miscarriage.

1968 – Birth of her son Carlo Jr., 29 December. Sophia cuts back on films to spend more time with her family.

1973 – Birth of her second son, Edoardo.

1977 – Sophia works again with Mastroianni in *Una giornata particolare (A Special Day)*. The film wins a host of awards, including a Golden Globe and a César.

1994 – Inaugurates her star on Hollywood's Walk of Fame and acts in Robert Altman's *Prêt-à-porter*.

2002 – Films *Between Strangers*, directed by her son Edoardo Ponti.

2007 – Poses for the iconic Pirelli calendar.

2009 – Aged 75, Sophia films *Nine*, alongside Nicole Kidman, Penelope Cruz, Marion Cotillard and Daniel Day-Lewis.

Acknowledgements

To the two women in my life …

… To my daughter, Who was born as this book was being written. Forty-nine little centimetres that have filled me with extraordinary happiness, and have given a new meaning to my life.

… And to my wife, who has given me the finest role of my life: that of a father, Who every day inspires me to scale mountains, to give life to our dreams, and to accomplish projects and travels together as two, three … even four?

Yann-Brice Dherbier.

Credits

Filmography

1950 – *Il Voto* directed by Mario Bonnard

1950 – *Toto-Tarzan* directed by Mario Mattoli

1950 – *Le Sei Mogli di Barbablù* directed by Carlo Ludovico Bragaglia

1950 – *Hearts at Sea* (Italian: *Cuori Sul Mare*) directed by Giorgio Bianchi

1951 – *Il Padrone del Vapore* directed by Mario Mattoli

1951 – *Milano Miliardaria* directed by Vittorio Metz

1951 – *Il Mago per Forza* directed by Marino Girolami & Marcello Marchesi

1951 – *Brief Rapture* (Italian: *Lebbra Bianca*) directed by Enzo Trapani

1951 – *Io Sono il Capataz* directed by Giorgio Simonelli

1951 – *Quo Vadis* directed by Mervyn Leroy

1951 – *It's Him! ... Yes! Yes!* (Italian: *Era Lui ... Si! Si!*) directed by Marino Girolami & Marcello Marchesi

1951 – *Anna* directed by Alberto Lattuada

1952 – *The Favorite* (Italian: *La Favorita*) directed by Cesare Barlacchi

1952 – *The Piano Tuner Has Arrived* (Italian: *È arrivato L'Accordatore*) directed by Duilio Coletti

1952 – *Il Sogno di Zorro* directed by Mario Soldati

1952 – *The White Slave Trade* (US: *Girls Marked Danger*; Italian: *La Tratta Delle Bianche*) directed by Luigi Comencini

1953 – *Pilgrim of Love* (Italian: *Pellegrini D'Amore*) directed by Andrea Forzano

1953 – *The Country of the Campanelli* (Italian: *Il Paese Dei Campanelli*) directed by Jean Boyer

1953 – *Two Nights with Cleopatra* (Italian: *Due notti con Cleopatra*) directed by Mario Mattoli

1953 – *Good People's Sunday* (US: *Good Folk's Sunday*; Italian: *La Domenica Della Buona Gente*) directed by Anton Giulio Majano

1953 – *We'll Meet in the Gallery* (Italian: *Ci Troviamo in Galleria*) directed by Mauro Bolognini

1953 – *Africa Under the Seas* (Italian: *Africa Sotto i Mari*) directed by Giovanni Rocardi

1953 – *Aida* directed by Clemente Fracassi

1954 – *A Day in Court* (Italian: *Un Giorno in Pretura*) directed by Steno

1954 – *A Slice of Life* (US: *The Anatomy of Love*; Italian: *Tempi Nostri*) directed by Alessandro Blasetti

1954 – *Poverty and Nobility* (Italian: *Miseria e Nobiltà*) directed by Mario Mattoli

1954 – *Neapolitan Fantasy* (US: *Neapolitan Carousel*; Italian: *Carosello Napoletano*) directed by Ettore Giannini

1954 – *The Gold of Naples* (Italian: *L'Oro di Napoli*) directed by Vittorio De Sica

1954 – *Attila the Hun* (US: *Attila*; Italian: *Attila, il Flagello di Dio*) directed by Pietro Francisci

1954 – *Too Bad She's Bad* (Italian: *Peccato Che Sia Una Canaglia*) directed by Alessandro Blasetti

1955 – *The Sign of Venus* (Italian: *Segno di Venere*) directed by Dino Risi

1955 – *The Miller's Beautiful Wife* (Italian: *La Bella Mugnaia*) directed by Mario Camerini

1955 – *Woman of the River* (US: *The River Girl*; Italian: *La Donna del Fiume*) directed by Mario Soldati

1955 – *Scandal in Sorrento* (Italian: *Pane, Amore eo ...*) directed by Dino Risi

1956 – *Lucky to Be a Woman* (Italian: *Fortuna di Essere Donna*) directed by Alessandro Blasetti

1957 – *Boy on a Dolphin* directed by Jean Négulesco

1957 – *The Pride and the Passion* directed by Stanley Kramer

1957 – *Legend of the Lost* directed by Henry Hathaway

1958 – *Desire Under the Elms* directed by Delbert Mann

1958 – *The Key* directed by Carol Reed

1958 – *The Black Orchid* directed by Martin Ritt

1958 – *Houseboat* directed by Melville Shavelson

1959 – *That Kind of Woman* directed by Sidney Lumet

1960 – *Heller in Pink Tights* directed by George Cukor

1960 – *It Started in Naples* directed by Melville Shavelson

1960 – *The Millionairess* directed by Anthony Asquith

1960 – *A Breath of Scandal* directed by Michael Curtiz

1960 – *Two Women* (Italian: *La Ciociara*) directed by Vittorio De Sica

1961 – *El Cid* directed by Anthony Mann

1961 – *Boccaccio '70* directed by De Sica, Visconti & Fellini

1962 – *Madame Sans-Gêne* directed by Christian-Jaque

1962 – *The Condemned of Altona* (Italian: *Sequestrati di Altona*) directed by Vittorio De Sica

1962 – *Five Miles to Midnight* directed by Anatole Litvak

1963 – *Yesterday, Today and Tomorrow* (Italian: *Ieri, Oggi, Domani*) directed by Vittorio De Sica

1964 – *The Fall of the Roman Empire* directed by Anthony Mann

1964 – *Marriage Italian-Style* (Italian: *Matrimonio All'Italiana*) directed by Vittorio De Sica

1965 – *The Great Spy Mission* directed by Michael Anderson

1965 – *Lady L.* directed by Peter Ustinov

1966 – *Conflict* directed by Daniel Mann

1966 – *Arabesque* directed by Stanley Donen

1967 – *A Countess from Hong Kong* directed by Charles Chaplin

1967 – *More Than a Miracle* (Italian: *C'era una volta ...*) directed by Francesco Rosi

1968 – *Ghosts – Italian Style* (Italian: *Questi Fantasmi*) directed by Renato Castellani

1970 – *Sunflower* (Italian: *I Girasoli*) directed by Vittorio De Sica

1971 – *Lady Liberty* directed by Mario Monicelli

1971 – *The Priest's Wife* (Italian: *La Moglie Del Prete*) directed by Dino Risi

1972 – *The Sin/White Sisters* (Italian: *Bianco, Rosso e ...*) directed by Alberto Lattuada

1972 – *Man of La Mancha* directed by Arthur Miller

1974 – *The Journey* (US: *The Voyage*; Italian: *Il Viaggio*) directed by Vittorio De Sica

1974 – *The Verdict/Jury of One* directed by André Cayatte

1974 – *Brief Encounter* directed by Alan Bridges

1975 – *Poopsie/Lady of the Evening/Sex Pot/Poopsie & Co.* (Italian: *La PupaDel Gangster*) directed by Giorgio Capitani

1976 – *The Cassandra Crossing* directed by George Pan Cosmatos

1977 – *A Special Day* (Italian: *Una Giornata Particolare*) directed by Ettore Scola

1978 – *Angela* directed by Boris Sagal

1978 – *Blood Feud/Revenge* (Italian: *Fatto di Sangue Fra Due Uomini per Causa di Una Vedova ...*) directed by Lina Wertmuller

1978 – *Brass Target* directed by John Hough

1979 – *Firepower* directed by Michael Winner

1984 – *Encounter* (Italian: *Qualcosa di Biondo*) directed by Maurizio Ponzi

1994 – *Prêt-à-porter* (US: *Ready to Wear*) directed by Robert Altman

1995 – *Grumpier Old Men* directed by Howard Deutch

2002 – *Between Strangers* directed by Edoardo Ponti

2004 – *Too Much Romance ... It's Time for Stuffed Peppers* (Italian: *Peperoni Ripieni e Pesci in Faccia*) directed by Lina Wertmuller

2009 – *Nine* directed by Rob Marshall